ANAL PLEASURE

&

HEALTH

ANAL PLEASURE

&

HEALTH

Revised Third Edition

Jack Morin, Ph.D.

Down There Press
San Francisco

Anal Pleasure & Health, revised third edition, Copyright © 1998 by Jack Morin, Ph.D.

Library of Congress Cataloging-in-Publication Data

Morin, Jack, 1946–
 Anal pleasure & health: a guide for men and women / Jack Morin. - 3rd ed.
 p. cm
 Includes bibliographical references and index.
 ISBN 0-940208-20-2 (trade pbk.)
 1. Sex instruction. 2. Anal intercourse. 3. Anus (Psychology). 4. Sex customs—
United States. I. Title
HQ31.M719 1998
613.9′6—dc21 98-17372
 CIP

We offer librarians an Alternative CIP prepared by Sanford Berman,
Head Cataloger at Hennepin County Library, Minnetonka MN.

Alternative Cataloging-in-Publication Data
Morin, Jack 1946–
 Anal pleasure & health: a guide for men and women. 3rd ed. San Francisco, CA:
Down There Press, copyright 1998
 PARTIAL CONTENTS: Brief history of anal pleasure. -Confronting the anal taboo.
-Looking and touching: beginning self exploration. -Locating and exercising anal and
pelvic muscles. -Understanding how the anus and emotions interact. -Anal eroticism:
including the anus in masturbation. -Discovering the rectum. -Mutual exploration. -
Anal intercourse. -Realms of power: probing interpersonal dynamics. APPENDICES:
Health problems involving the anus and rectum. HIV and AIDS. Other STDs. Summary
of research and findings. -Bibliography.
 1. Anus. 2. Rectum. 3. Anal sex. 4. Sexual exercise. 5. Sex and health. 6. Body
awareness. 7. Masturbation. 8. Sadomasochism. 9. Sexually transmitted diseases. I.
Title. II. Title: Anal health & pleasure. III. Down There Press.

612.6

Additional copies of this book are available at your favorite bookstore
or directly from the publisher:

Down There Press, 938 Howard St., #101, San Francisco CA 94103

Please enclose $22.50 for each copy ordered, which includes $4.50 postage and
handling.

Cover Design by Jill Posener
Book design by Small World Productions

Printed in the United States of America 9 8 7 6 5 4 3 2 1
Visit our website: www.goodvibes.com/dtp/dtp.html

To Joani Blank
educator, visionary, friend

Without her determination
to overcome sexual ignorance and fear,
this book could never have been published.

Acknowledgments

I<small>T'S HARD TO IMAGINE</small> a book that's not a collaborative effort, especially when you're violating one of the most powerful of all taboos. My collaborators have been many and varied, beginning with the hundreds of clients who, through their intimate revelations, have grown personally, while enriching me at least as much. You know who you are; please accept my gratitude.

Early support means an enormous amount. Many of my oldest friends created an environment in which I could afford to be a little wacky—I prefer to think of it as inspired. Don Propstra, Michael Graves, Rachelle Goodfriend, Laurie Chorna, Liz Hudgin, Toni Ayres, and Tom Moon gave me encouragement and much needed laughs. The "Options" gang—Arthur Atlas, Marny Hall, JoAnn Loulan and Jan Zobel—have cheered me on for 25 years now. Phillip Mitchell was my professional mentor during the mid-'70s and helped me zero in on what I wanted to do, and how I could possibly do it. This book grew out of my doctoral research at Saybrook Institute where Don Polkinghorn was not only the institute's new president, but was also thrust into the position of chairman of my doctoral committee; some guys have all the luck. But without a hint of discomfort—and always with genuine respect—he pushed me to make the research better, and it worked.

Joani Blank, to whom this book is dedicated, made the whole thing happen. When many other publishers liked the book but eventually decided that their readers "couldn't handle it"—whatever that meant—Joani came through.

Leigh Davidson, at the helm of Down There Press, initiated and nurtured this third edition. Ann Whidden and Joani Blank gave me

the benefits of their excellent editing skills. Daniel Wolfe of the Gay Men's Health Crisis in New York was a wonderful resource and colleague, partly because we were both writing health-oriented books at the same time—yikes! Steven Gibson of the San Francisco Stop AIDS Project was kind enough to share some early findings from their study of the Reality "female" condom for anal intercourse. And Charles Moser's medical expertise was, as always, invaluable.

My soul mate and companion, Scott Madover, appreciated my nonconventional point of view from the first moment we met. After watching me go bonkers—sometimes only technical terminology will do—while writing my third book, *The Erotic Mind*, he rose to the occasion yet again for this project. I guess that's just the kind of guy he is.

Also by Jack Morin, Ph.D.
The Erotic Mind (HarperPerennial)

Contents

List of Illustrations

Introduction
A Quarter Century of Anal Exploration

I T WAS NEVER one of my career goals to be known as "Dr. Anal," as I am in some circles. Although I've always accepted the nickname as a playful compliment, it's only been during the past decade that the last vestiges of embarrassment have faded away. Like almost everyone else, my earliest attitudes toward the anal area were shaped— warped, more accurately—by the incredibly powerful anal taboo. Obediently, I thought about it as little as possible. The vast network of nerve endings that makes this area so sensitive was, for all practical purposes, out of commission. Once when I was obviously very anxious, a perceptive therapist asked what I was feeling in my anus. The revealing answer was, "absolutely nothing."

All of that changed radically in the early 1970s when a highly synchronous combination of events, both personal and professional, grabbed my attention and refused to let go. On the personal side, I had developed an excruciating case of hemorrhoids—swollen, stretched and inflamed anal tissues which sometimes bleed and can hurt like hell. It became so bad that I could hardly sit down without a donut-shaped cushion to protect me. I'll spare you the agonizing saga of my bowel movements. Two physicians had suggested surgery and I was seriously considering it. I figured, "What could be worse than this?" Yet a persistent inner voice whispered that surgery wasn't the way to go. Luckily I listened.

Around the same time, I was beginning my training in the exciting new field of sex therapy. All of us were enthusiastic and optimistic about the potential benefits of this active approach to sex problems.

Before long I was working with a wonderfully diverse group of men and women clients, all concerned about one aspect of their sexuality or another. These were also the heady days of the burgeoning "sexual revolution," especially in San Francisco, where the atmosphere pulsated with the promise of liberation; anything seemed possible.

In the context of this experimental atmosphere, a growing number of people began consulting me because they wanted to enjoy anal sex but couldn't due to discomfort or pain. Since I had learned absolutely nothing about treating such problems in my training, I conducted a literature search and talked with colleagues to see what I might uncover. To my surprise, nobody had much of anything to say about the subject except for a few physicians, virtually all of whom agreed that anal sex should be rigorously avoided—end of story.

I was simultaneously flabbergasted and challenged by this glaring gap in our sexual knowledge. The thrill of investigating uncharted territory—a rarity for any researcher—overruled my worries about what others might think. Before I knew it I was poring over anatomy books and for the first time in my life developing a fairly clear idea of how the anus and rectum are put together—muscles, nerves, blood vessels, the whole shebang. Then, after explaining my profession's collective ignorance, I invited some of my clients to collaborate with me in finding solutions; most eagerly accepted. They tried various relaxation and awareness-building experiments at home and reported their observations. This initial work spurred me on to intensive doctoral research and eventually to writing the first edition of this book in 1981.

Which brings me back to hemorrhoids. As I tried the same experiments on myself that my clients were trying at home—which seemed only fair—I was amazed to discover how much sensation I *hadn't* been feeling; I was hurting even more than I had realized! But gradually, instead of tensing up in response to the pain, I learned to relax into it. Before long, the tush cushion that had been my constant companion was gathering dust in a closet. In fact, within about two months of my first experiment, the hemorrhoids had cleared up completely—and they've never been back since.

Meanwhile my clients were amazed at their own remarkable results. The more attention they paid to the anal area, the more they noticed a growing comfort with it and, simultaneously, unmistakable increases in their enjoyment of whatever types of anal stimulation they desired. A deceptively simple combination of relaxation and self-awareness appeared to be as effective at promoting health as it was at enhancing pleasure.

I now see those horrid hemorrhoids as a strange sort of gift. My clients' discoveries about anal pleasure, combined with my own quest for self-healing, drove home the single most important lesson I've learned throughout my 25-year stint as Dr. Anal: *The widespread belief that one must choose between anal pleasure or anal health couldn't possibly be more off the mark.* In reality, a person who desires maximum anal enjoyment should follow virtually the same steps as anyone who seeks optimal anal wellness, because both require:

- deepening awareness of the anal area and its functioning
- total elimination of anal pain
- reduction of muscular tension
- replacing negative feelings and attitudes toward the anus and rectum with positive ones

Guiding you toward these objectives is what this book is all about. You can use most of its information and exercises effectively whether your specific goal is non-sexual self-healing, an expansion of your capacity for anal sensuality and eroticism, or a combination of the two. Chapters 1–7 are equally relevant for everyone. Starting with Chapter 8 you'll notice an increasing emphasis on pleasure and sexuality. But note that only Chapter 12 is exclusively concerned with anal intercourse. Men and women of all sexual orientations can benefit from reading all other chapters, even if they have little or no interest in intercourse.

Response to the book has been unexpectedly strong. Even though it was published by a small press, rejected by skittish printers and binders, coaxed along with minimal promotion, conspicuously absent from the shelves of the vast majority of bookstores and libraries, and with precious few media willing to come anywhere near it, the book's suc-

cess has steadily grown for seventeen years. From around the world letters of appreciation regularly grace my mailbox. It seems that the hunger for this information is almost as great as the prohibition against giving and receiving it. Just about anyone who wants to read about anal sexuality eventually finds their way to *Anal Pleasure & Health*. And I guess it doesn't hurt that there's been little else to choose from.

Very soon after publication the AIDS epidemic struck, sending us reeling and churning up an emotional smorgasbord of fear, anger, guilt, and eventually grief and despair. By the mid-1980s unprotected anal intercourse was identified as a major avenue for HIV transmission. Enemies of sexual freedom felt vindicated. "It's God's punishment," more than a few religious leaders declared in stunning displays of arrogance and unvarnished hatred.

As sex became linked with disease and death in the public consciousness, many people stopped having it altogether, or else became so anxious that it wasn't much fun. Others adopted a fatalistic attitude and spun out of control as if on a final binge—last call for sexual liberation. Seemingly overnight the freewheeling celebrations of the seventies turned into wistful anachronisms. Loss of sexual desire became the most widespread sex problem—and still is—and a new diagnosis of "sexual addiction" gave a name to deepening worries about the consequences of lust run amok. Those outside of the urban centers where HIV first took hold in the U.S. still had the option of blissful ignorance, but not for long. Soon everyone was affected, directly or indirectly. AIDS, after all, was and is a worldwide plague.

As I watched many people deteriorate and die in their prime, I privately anticipated the demise of my book as well. For a time I thought that anal sexuality, along with other erotic options, might slink back into the closet, beyond the reach of consciousness and choice. Surely, I mused, the anal taboo would reassert itself with a vengeance and crush any hope for open, non-judgmental discussion.

Boy, was I wrong. It turned out that alongside the unbelievable devastation, two positive trends emerged as tiny silver linings. Most important was a huge groundswell of focused determination, especially among gays, to beat this plague through political activism,

unprecedented changes in sexual behavior, non-stop fundraising, compassionate support for the sick, and sheer force of will.

The other bright spot was that people started looking more honestly, perhaps even more so than at the height of the sexual revolution, at all the myriad ways we express ourselves sexually, with or without social approval. For the first time in history the words "anal intercourse" were regularly heard on the evening news and seen in daily newspapers. True, it was never spoken of enthusiastically, but at least it was spoken of. The implicit message was that it was time to take off the blinders and get real.

Besides the increasing popularity of this book, I see other indicators that anal sexuality, while far from mainstream, is inching ever so slightly toward—dare I say it?—normalization. I see a hint of this change each time one of my mischievous friends happens to mention to people I've just met that I'm an author. Naturally people ask what I've written. I used to wince internally at such moments because the responses were quite predictable: uncomfortable utterances such as, "Ohhh…" trailing off into awkward silence, inordinate amounts of blushing or nervous giggling, or creative segues into more comfortable topics. Nowadays it's not unusual for people to seem genuinely interested, to ask questions, and—here's the biggest shocker—to share a personal anecdote or something they've heard or read about the subject. Frankly, I'm still adjusting to the change.

At the same time, staff at the San Francisco-based sex toy store and catalog Good Vibrations report a distinct upsurge in sales of toys for anal stimulation and questions about how to use them. In addition, this book is appearing much more frequently on bookstore shelves, whereas shoppers used to be too embarrassed even to pick it up. Ordering via online bookstores has also changed the book-buying landscape. Reflecting a similar trend, "respectable" collections of erotic stories and fantasies are now far more likely to include anal activities (a staple of raunchy porn). And I regularly receive calls from authors working on sexuality books who want to include accurate information about anal eroticism. However, I have yet to talk about anal sex on TV—the final frontier, I guess.

What better time to rewrite the book from top to bottom? I wrote a second edition in 1986 mainly to weave in safer sex awareness and generally spruce up the style. While reading it over in the mid-nineties, I saw opportunities for improvement and clarification everywhere. For one thing, I needed to address important new developments such as the Reality "female condom," especially considering its distinct advantages over traditional condoms for anal sex. I've expanded the discussion of such crucial topics as sexual dominance and s/m, a complex continuum of activities and fantasies that seems to have captured the public's imagination in recent years. Throughout this third edition hardly a paragraph has survived unchanged. And all of the references have been updated.

Also since the second edition, I've conducted extensive research on peak erotic experiences and the psychology of desire and arousal. My last book, *The Erotic Mind*, offers a radical new perspective on how our turn-ons work and what they mean. I mention this now because this research has profoundly affected the way I think and talk about every aspect of erotic life. Most notably I now understand more clearly than ever before that erotic life is inherently paradoxical. By this I mean that the very same dynamics that make sex so potentially exciting can also make it difficult and challenging, and vice versa. Eroticism both springs from *and* reflects all of the messy complexities of human existence. How could it be otherwise?

Although my fundamental suggestions for promoting relaxation and awareness remain essentially the same, I now place an even greater emphasis on how anal experiences are linked to practically everything else including self-concept, gender roles, cultural expectations and restrictions, and intimate relationships. Obviously, few things in life are more private than anal exploration, yet few are so revealing. Snooping around where we're not supposed to look is a great way to perceive who we are from a new perspective. In an evaluation of a recent seminar which included a substantial section on anal eroticism, one participant wrote, "I probably should have known before, but I now see that anal sex is about a whole lot more than sticking stuff up your butt." I couldn't have said it better.

A Brief History of Anal Pleasure

1

THIS BOOK IS UNUSUAL because it focuses on a part of the body that very few of us discuss openly. Because most of us are profoundly alienated from the anal area we typically experience it as hidden, dirty, disgusting, and certainly unworthy of our attention. As a result, it carries out its essential functions largely outside of conscious awareness except, of course, when pain erupts. To put it bluntly, the anus is either a source of too much sensation (pain) or hardly any at all (numbness).

It's different when we're infants and small children; we take delight in all parts of our bodies. But something terribly unfortunate happens to us in the course of growing up: We learn to mistrust or ignore our physical selves, perhaps viewing the mind or spirit as more important than and separate from our bodies. We are taught to view sensual play and self-exploration as immature and self-indulgent if not kept within strict limits.

This process of bodily self-alienation is especially pronounced in the anal area, which becomes the ultimate symbol of all that is unclean and revolting. Imagine how confusing it is to discover that a part of the body that is supposed to be so unsavory is also extremely sensitive and potentially among the most enjoyable. Especially for children, the gradual realization that the anus is considered bad and repulsive must be quite disconcerting because it contradicts their direct, pleasurable experience. This is the birth of an unspoken

conflict that can easily endure for a lifetime.

People cope with this contradiction in a variety of ways. Some make only the concessions necessary to meet social standards of appropriateness, and then go right on enjoying their anal sensations. Such people can use the information and suggestions in this book to reinforce and enhance their capacity for pleasure. Others have fully absorbed the prevailing cultural attitudes and are emotionally and sensually cut off from their anuses. Some of these men and women prefer *not* to become more familiar with this part of their bodies. Although they may be naturally inclined to avoid this book, they can benefit tremendously from confronting and undoing the damaging effects of their early training.

Another group of men and women are actively trying to overcome a long history of misinformation and negativity. They're discovering—or at least considering the possibility—that they've been missing something good which can only be found between the extremes of pain and numbness: pleasure. This book is primarily for these people. It is a practical guide, based on the experiences of men and women who have sought to rediscover the anal area as a positive part of themselves, something to be respected and intimately known.

Yet another group of people have much to gain from reading on, even though they have no particular interest in anal pleasure. These are the millions who live with annoying, often very painful, and sometimes chronic anal medical problems. Diseases like hemorrhoids, fissures (tears or scrapes), and constipation are among the most common medical problems in our society. Those who suffer from these and other conditions will find useful information and practical tools that can lead to permanent relief. Once freed from anal problems, many people are delighted to discover that the same nerve endings that once transmitted pain are available for transmitting pleasure. For some, this is a revelation.

Anal pleasure means different things to different people. Most fundamentally it's a private experience. Most men and women have occasionally experienced anal pleasure during bowel movements. Others may have spontaneously noticed pleasant sensations in the anal area

in the course of walking, dancing, or other activities. It's possible to provide oneself with pleasant external stimulation, as when wiping after a bowel movement, bathing, or simply touching oneself "down there." External anal stimulation is sometimes erotic, a part of deliberate self-pleasuring and masturbation. Self-stimulation may also be internal as when a finger or object, such as a vibrator or dildo, is inserted into the anus and rectum.

Anal pleasure can also be shared as part of sensual or sexual play with a partner. This may involve stimulation of the anal opening with fingers or mouth. The technical term for oral-anal stimulation is analingus, but it's popularly known as "rimming." In other instances, depending on personal preference and comfort, internal stimulation may be desired with an object or with another person's finger or penis. Rectal stimulation with a penis has been called a variety of names, including anal coitus, sodomy, buggery and the slang expressions "butt fucking" or "ass fucking." In this book I call it *anal intercourse*. I use the much broader term *anal sex* to refer to *any* erotic anal play, not necessarily intercourse.

Certainly this book will be of interest to those who want to explore anal intercourse. But many others, because of their sexual orientation or personal preferences, will have little or no interest in anal intercourse. This book is for these people, too, because anal pleasure—with or without intercourse—can be a comfortable part of the sensual and sexual experience of any man or woman who wants it, regardless of sexual orientation.

Anal Pleasure in the United States

We know relatively little about how many Americans experiment with anal sexuality, what kinds of stimulation they use, or how often they enjoy it. And the information that is available focuses almost exclusively on anal intercourse. This limitation is unfortunate but hardly surprising if we consider the prevailing inclination to view intercourse as the only "real" sex and to label everything else "foreplay."

In his pioneering studies of sexual behavior among men and women, Alfred Kinsey recognized the erotic potential of the anal area based on its high concentration of nerve endings, proximity to the genitals, and interconnection with other pelvic muscles. He noted, for example, that spontaneous anal contractions typically occur during arousal and orgasm. Of the men in his sample who had experienced homosexual sex play as preadolescents (which, incidentally, was reported more commonly than heterosexual play), 17% recalled trying anal intercourse (Kinsey et al., 1948; 1953).

Kinsey also noted that anal erotic activity was reported by some adults of all sexual orientations as part of masturbation and partner sex. He even found that a few people could be brought to orgasm by anal stimulation alone. Kinsey estimated that the anus had erotic significance for about half of the population, although no specific sexual activities involving the anus were included in his statistics. More recently published data shows that the Kinsey group had gathered more information about anal sex than they originally reported, suggesting an uncharacteristic reticence on Kinsey's part. Among married interviewees, 11% of both men and women had attempted anal intercourse. Premarital percentages ranged from 5% of black, college-educated men to a surprising 30% of white, non-college-educated women (Gebhard and Johnson, 1979).

In the early 1970s, a survey of over 2,000 American men and women conducted by Morton Hunt suggested that a significant relaxation in attitudes toward anal sexuality was under way. Over half of those surveyed *disagreed* with the statement: "Anal intercourse between men and women is wrong." Experimentation also appeared to be on the rise, especially among younger respondents. About a quarter of married couples under 35 had engaged in anal intercourse at least occasionally, while over half had tried anal fingering, and over a quarter had tried oral-anal stimulation (Hunt, 1974).

Also in the seventies, a *Redbook* magazine survey of 100,000 women reported that 43% of the women, most of them married, had tried anal intercourse at least once. Of these, about 40% described the experience as enjoyable, 42% found it unpleasant, and 7.5% found it

repulsive. Nineteen percent said they engaged in anal intercourse occasionally, and 2% did so often (Tavris and Sadd, 1977).

In the early 1980s, a *Playboy* survey of 100,000 readers indicated that the level of experimentation was even higher among some groups. Forty-seven percent of men and 61% of women had tried anal intercourse. Thirteen percent of married couples reported engaging in anal intercourse more than once a month and 63% had also tried other forms of anal stimulation (Peterson, 1983).

Many people are surprised when they hear about the prevalence of anal experimentation among heterosexuals; some even refuse to believe it. At the same time, it is widely assumed that anal intercourse is practically universal among gay men. This belief is a natural extension of an intercourse-centered view of sex, which goes like this: because intercourse *is* sex, and because the only intercourse available to gay men is anal, therefore anal intercourse must be the erotic focus for gays, just as vaginal intercourse is for most straights.

It's true that gay men in general are far more open to all forms of anal stimulation, including intercourse, than any other group. In one study of over 1,000 gay men, 76% said they enjoyed anal intercourse, over half as both inserter and receiver (Spada, 1979). In another study of 156 gay male couples together from 1–40 years, 71% had participated in anal intercourse within the year prior to the interviews, with equal percentages having tried it as receivers and as inserters. Also in the previous year, 41% had participated in oral-anal play. But compare these statistics to the more than 95% who reported giving and receiving oral sex during the same period, with mutual masturbation almost as prevalent (McWhirter and Mattison, 1984). Although anal sex is popular, the more central role of oral and manual stimulation has been confirmed in all studies of gay male sexuality.

A more recent study of 3,432 Americans showed that the proportion of respondents who had tried anal intercourse—as receivers or inserters—was strongly related to whether they'd had any same-gender sex partners and how recently they'd had them. Whereas about a quarter of the total sample had tried anal intercourse at least once since puberty, about half of those with any same-sex partners since age

18 had tried it. Among men and women who reported any same-sex partners in the previous five years, 60% had tried it. And for those with same-sex partners in the previous year, the proportion who had tried anal intercourse jumped to nearly 80% (Laumann, et al., 1994). The researchers didn't specify, however, whether respondents with more recent same-sex partners tended to report all of their anal sex experiences with those partners, or whether their same-sex experiences made them more open to anal experimentation in general, including with opposite-sex partners. After all, the majority of those who experiment with gay sex are by no means exclusively gay.

A 1994 sex survey of gay men conducted by *The Advocate* (Lever, 1994), a national gay magazine, asked refreshingly different questions, including what sexual activities respondents "loved." Hugging and caressing were loved by 85%, more than any other activity. Forty percent loved being the inserter in anal intercourse (almost as popular as having their ears licked), 45% loved receiving oral-anal stimulation, 43% were fans of receiving anal intercourse, and 28% loved giving oral-anal stimulation.

Twenty-six percent said their favorite way to have an orgasm was through a combination of masturbation (administered by themselves or their partners) and receiving intercourse, while 19% said their favorite way to orgasm was being the inserter. On the other hand, 14% didn't practice receptive anal intercourse at all and another 13% did, but didn't like it. Six percent didn't engage in intercourse as inserters while another 11% did so but didn't like it.

We know amazingly little about the frequency with which some groups, most notably lesbians, engage in anal activities. Frankly, I'm amazed that I can't find *any* surveys of lesbian sexuality that asked questions about anal stimulation. Nonetheless, I've talked with dozens of lesbians who said they liked anal fingering, oral-anal stimulation, and anal intercourse with dildos. Several lesbian therapists I interviewed have reported the same thing. But this is merely anecdotal, underscoring the need for more complete lesbian sex research in the future.

Other Times and Places

Information is even more scanty about the role of anal sexuality in other societies and throughout history. Just as studies of anal activities among Americans focus on intercourse, this tendency to ignore other forms of anal pleasure is even more pronounced in studies of other cultures. Throughout the world, cultural attitudes toward anal intercourse have ranged from harshly negative—sometimes with death prescribed as punishment—to apparently very permissive. In most cultures, as in our own, a split exists between accepted norms and the actual behavior of at least some members of society.

Historically, most attention has been given to the occurrence of anal intercourse in ancient Greece, where special significance was ascribed to anal intercourse between men and boys. Enthusiastically praised for its unmatched purity, especially by members of the upper classes, this form of anal eroticism was also thought to have educational value when practiced by teachers and their students. By receiving anal intercourse from his teacher, a young man's education was highly personalized, which many Greeks considered essential for learning, no matter what the subject. The act of receiving intercourse was believed to impart wisdom and masculinity (Dawson, 1963).

Oddly enough, at the same time that anal intercourse between men and boys received some degree of social approval, homosexual expression between adult males was viewed as "abnormal and impure" (Marrou, 1956). As a young man grew up, developing the appearance and behaviors considered more manly, he became less sought after by adult men. As the youthful receiver of intercourse aged he would typically begin taking a dominant role with other boys or with women. This type of arrangement was certainly not the only form of homosexuality in ancient Greece; but mainly the Greeks accepted both homosexuality and anal intercourse in the context of large age and power discrepancies between the partners.

Of course there's nothing unusual about viewing intercourse in terms of dominance and submission. Throughout most of the world, including our own society, this attitude prevails. In Mediterranean

cultures, acceptance or toleration of anal intercourse among males usually requires that one partner, usually the younger man or boy, be seen as womanly. Similarly, in Mexico, Central, and South America men frequently have anal intercourse with other men in spite of strong religious prohibitions. The inserter retains his heterosexual identity, but the receiver is considered homosexual and suffers a loss of status (Karlan, 1971). American men often express the same attitude: It is the receiver of anal intercourse who's *really* homosexual.

Some societies have developed a clearly-defined and accepted role which the French, and now all anthropologists, call the *berdache*. A transvestite of sorts, such a man would typically adopt the dress and mannerisms considered feminine in his culture. Some cultures have offered similar opportunities for gender role reversal for women, although not as many. Typically, berdaches were free to engage in receptive anal intercourse with other men, including married ones. As long as they assumed their appropriate gender roles, little or no social disapproval was directed against either partner. In fact, most, if not all, societies with berdaches imposed strict sanctions against homosexual behavior with anyone except a berdache.

Berdaches were especially common in societies that demanded high aggressiveness from males. Perhaps berdaches expressed the denied femininity of the other men. One of the most fascinating things about the various traditions is the special status as spiritual leaders and healers afforded to berdaches; many were shamans. It's as if their transcendence of gender roles—some have called them a "third sex"—gave berdaches access to mystical powers and insights valued by the larger group or tribe.*

Other societies, while not having a formal role like that of the berdache, nonetheless have had men whose social functions included receiving anal intercourse. In China, in contrast to current restrictive attitudes toward homosexuality and anal sexuality, there was a

* For a comprehensive examination of the rich berdache traditions among Native American tribes, both before and after the arrival of Europeans, see Walter Williams' *The Spirit and The Flesh: Sexual Diversity in American Culture.*

long tradition of institutionalized homosexuality with male prostitutes trained from a young age to receive anal intercourse. There are similar reports about Japan from the 17th to 19th centuries. In the revolution of 1868, Japan banned all homosexual acts along with other sexual variations.

Throughout the Middle East, homosexuality and anal intercourse have both flourished at times. From the Islamic world have come reports of widespread homosexuality and male-male anal intercourse, in spite of vehement restrictions against both, restrictions which are as explicit in Islam as they are in Christianity. In Persia (Iran today) during the Middle Ages, heterosexuals were encouraged to engage in anal intercourse by theological codes designed to limit rampant population growth (Edwardes, 1965). Similarly, the Manganians of the South Pacific frequently practiced anal intercourse during menstruation when vaginal intercourse was considered unclean (Marshall and Suggs, 1971).

Among the Siwan of Africa, all men and boys engage in anal intercourse. Apparently both partners retain a masculine identity and neither partner loses status. Those who do not participate are considered peculiar (Ford and Beach, 1951). The Kiraki of New Guinea universally practice anal intercourse as a part of initiation rites. They believe, like the ancient Greeks, that receiving intercourse from older men helps young men become strong. Similarly, among many Australian aborigines, anal intercourse is a custom between unmarried men and uninitiated boys. Among the Melanesians, homosexuality is condoned and openly discussed. Men do not even object to their sons receiving anal intercourse from their adult male friends as long as their friends are kind and generous (Davenport, 1965).

Cross-cultural and historical studies of anal sexuality are intriguing, yet spotty at best. Nonetheless, it's surprising that we know as much as we do. After all, relatively few historians and anthropologists have even bothered to inquire about anal sex, perhaps assuming it to be an aberration unworthy of serious study. The questions one asks—or avoids—not only skew one's findings, but also speak volumes about the attitudes of the questioner and the culture in which he or she was raised.

Confronting the Anal Taboo

2

THE AVAILABLE information makes it abundantly clear that anal sexuality is, and always has been, an important feature of the human erotic landscape. Yet when we compare this information with the plentiful and detailed data about other sexual activities, it's obvious that we are the heirs of an unmistakable and potent conspiracy of silence.

One major reason for our collective silence is the deeply ingrained belief that straightforward communication about such things is inappropriate or weird. Many people have complained to me that if they do try talking about anal sexuality, even with a close confidant, their comments are greeted with jokes or derision. The same phenomenon occurs in groups when anal sex is mentioned—an unusual amount of nervous laughter. This is not to say that the anus can't be a subject for humor; it most certainly can be. But so often it seems that the laughter is of the squeamish, let's-not-talk-about-*that* variety, intended more to squelch discussion than to vitalize it. The prevailing social consensus can best be described as, "Don't ask; don't tell."

There's no simple explanation for the intensity of our reticence. Looking at the law provides only a partial clue. Since the days of the colonies, almost every state has imposed strong legal sanctions against sodomy, usually defined as contact between the genitals of one person and the anus or mouth of another, although sometimes the term is used only for anal intercourse. Starting in the 1960s, and reaching a peak in the seventies, 18 states repealed their sodomy laws, and in

three additional states they were declared unconstitutional. Unfortunately, these reforms have since stalled, except in a few states where active legal challenges are under way. Today 25 states still have sodomy laws on the books which prescribe harsh penalties for anal intercourse, oral sex, or other sexual activities considered "crimes against nature." Five states prohibit homosexual acts only, while the other twenty apply equally to heterosexuals.

Enforcement of sodomy laws is rare these days. Yet powerful political forces continue to lobby, successfully for the most part, to keep these laws on the books as tools of intimidation or statements of moral principle, even though they have little or no influence on people's actual behavior. Surely these outdated laws contribute to an overall repressive atmosphere. But it is doubtful that our culture's negative attitudes toward the anal area and anal sexuality—especially our reluctance even to speak of it—are being maintained primarily by the legal system.

Ethical values and moral principles are potent behavior-shapers. Even people who value sexual freedom and experimentation still look to some moral code or ethical system to guide their actions. The current trend, countered by plenty of vociferous opposition, is towards allowing greater room for individual tastes and preferences. Needless to say, it is legitimate for anyone to participate in or avoid certain sexual behaviors or situations based on a sense of right or wrong. However, ethical or moral value systems do not themselves deter open discussion, turn faces red with embarrassment, or cause reflexive outbursts of nervous laughter. To understand these reactions we must open our eyes to the force of taboo.

In this era of sexual exploration our attitudes toward anal sexuality are still, to a large extent, governed by the phenomenon of taboo. Taboo is a form of psycho-social control more potent than the most rigid moral code or threatening law. Modern societies like to believe that the scientific method has eradicated taboos and that only "primitive" peoples are still affected by them. Unfortunately, this belief is inaccurate.

Science has been instrumental in freeing us from many irrational superstitions and fears. But every culture, no matter how advanced,

still has its taboos. A taboo is a prohibition—collectively shared by a society—with a force so strong that it is rarely, if ever, questioned or even discussed. *It just is.* Every society also has rules, laws or principles intended to guide or control behavior. These grow out of general systems of values shared by most members of the culture.

Taboos are different. Sigmund Freud made this key distinction:

> The taboo restrictions are different from religious or moral prohibitions; they are differentiated from moral prohibitions by failing to be included in a system which declares abstinence in general to be necessary and gives reasons for this necessity. The taboo prohibitions lack all justification and are of unknown origin. They are taken as a matter of course by those under their dominance (Freud, 1913).

Taboos, then, have an all-encompassing quality—like the air we breathe—which makes them highly resistant to logic, scientific inquiry or even first-hand experience. Although taboos develop from within a culture, it seems as if they are externally dictated from on high.

Some taboos are readily obeyed by virtually everyone in the culture with little or no ambivalence or emotional charge. The common taboo against eating the meat of dogs or cats is of this type. We're socialized to feel that this would be incredibly distasteful and the issue never arises again. If, however, we were to find ourselves in a situation where no other food was available except a dog or cat, we would be thrown into deep ambivalence. Some people would probably come close to death before violating the taboo.

Other taboos are accompanied by strong ambivalence and a high emotional charge. The incest taboo is the best example of this type. Because almost everyone has had at least mild erotic responses toward a parent or sibling, the taboo against acting upon or even acknowledging these desires takes on even greater psychological significance. The inevitable pleasure of such responses, versus the distress caused by the taboo, throws the person into a state of confusion, until the ambivalence itself is successfully repressed.

Both types of taboos have a chilling effect upon behavior and thought. However, taboos of the second type don't necessarily eliminate the impulses and behaviors they forbid. Instead, these desires go under-

ground, both individually and collectively, where they take on a larger-than-life, almost cosmic significance. In this way, a taboo gives the forbidden feeling or behavior an inflated significance. In some instances, the ambivalence and guilt which a person feels actually function as aphrodisiacs.* Freud pointed out that in Polynesian the root meaning of taboo is both sacred *and* forbidden or unclean. The opposite of taboo is simply ordinary, common, or readily accessible.

All of this applies to the feelings of most people in our culture toward the anal area and anal pleasure. There is no other way to understand the frequent responses of rational men and women, even scientists, when asked straightforward questions about the anus and anal pleasure, especially anal sex. More often than not they are totally unwilling to discuss the subject, or else begin to stammer or show other signs of intense embarrassment. Often the effects of the anal taboo are hidden under a few simplistic rational-sounding statements such as, "Anal intercourse is dangerous," which fail to meet even minimal standards of logic or science. If anal pleasure and eroticism were simply a bad idea, objections—moral, legal, or physiological—could be freely discussed without self-consciousness. In actuality, the vast majority of people can more readily talk about murder and rape than anal sexuality.

Like the incest taboo, the anal taboo tends to be highly charged, though usually not as strong. This is true because the sensitivity of the anal area assures that beginning early in life virtually everyone has received pleasurable sensations from the anus. To some degree, then, negative messages about the anus are bound to contradict actual experience. Because of the strength of the pleasurable sensations and the counteracting power of the negative messages, some degree of ambivalence is inevitable. For some the discomfort of mixed feelings can be partially avoided by suppressing *all* thoughts and feelings related to anal pleasure—the most common reaction. Others are clearly interested *and* repulsed, fascinated *and* guilty.

* For an in-depth discussion of how taboos and the accompanying guilt or anxiety can both inhibit *and* intensify arousal, see my book, *The Erotic Mind.*

Charged by the extra excitement of the forbidden, some people become anal enthusiasts, ascribing tremendous importance to anal sex. This can be a problem for those who feel that the more naughty a sexual behavior or fantasy is, the more important it becomes, almost as a matter of principle, to do it. Such men and women may engage in anal sex as a symbol of open-mindedness, whether they actually like it or not. This is yet another way that taboos exaggerate and distort the significance of prohibited behaviors.

Under the influence of taboo, clouded by the crossfire of conflicting extremes, it becomes very difficult to recognize the forbidden object or behavior for what it really is. Instead, the artificial but unavoidable intensity that fuels the taboo becomes the focus of our attention. The realities of the behavior behind the taboo are all but ignored in the struggle.

Social Functions of the Anal Taboo

Taboos aren't just psychological phenomena; they have social significance as well. The incest taboo, for example, helps to reduce severe conflict among family members and between generations. The taboo against eating dog and cat meat maintains the special feelings we wish to have about our pets. The functions of a taboo are not always clearly discernible because they become blurred as the taboo is passed on from generation to generation. Since taboos are intricately woven into the collective psyche, their original purpose may fade into obscurity.

Although the anal taboo has never been systematically studied by social scientists, it is possible to speculate about its social functions. Cross-cultural data about sexual mores and behavior strongly point to four likely functions. First, negative attitudes toward the anal area appear to be universally tied to concerns about cleanliness. All societies encourage cleanliness, though ideas about what is required vary widely. The idea that cleanliness is necessary for spiritual purity is not unusual. Often, specific substances like certain foods, mud, urine,

mucus and feces trigger strong feelings of revulsion, thereby symbolizing and enforcing much broader concern about avoiding contamination and disease. In short, the anal taboo fosters the emotion of disgust.

Second, the idea that an inherent conflict exists between the spirit and the body is prevalent. By intensifying negative emotions about one area of the body, the anal taboo expresses and perpetuates an overall lack of ease with the physical self. In this way, the taboo makes concrete the conflict between spirit and body, increases guilt, and thereby reinforces religious doctrine.

Third, almost all cultures associate receiving anal intercourse with femininity, in part because of its physiological similarity to vaginal intercourse. With few exceptions, a man who receives anal intercourse is viewed as less manly. Therefore, another possible function of the anal taboo is the maintenance of strict sex-role differentiation. Sexual receptivity—and all that it symbolizes—is expected of women and strongly discouraged in men. If anal pleasure is prohibited, then the chance of men receiving anal intercourse decreases considerably.

Finally, acceptance of anal sexual behavior is virtually always correlated with acceptance of at least some forms of homosexuality. It therefore seems reasonable to conclude that another function of the anal taboo is to bolster sanctions against homosexual contact, particularly between men.

This period of our history is ripe for challenging the anal taboo. Scientific advances in the study of health and disease make it more possible for decisions about cleanliness and health to be rational rather than emotional, although emotions still do and always will play an important part. The mind-body split is being directly challenged in philosophy, psychology and medicine. Similarly, the value of strict sex-role differentiation is being questioned by thoughtful women and men. At the same time, negative attitudes toward homosexuality are beginning slowly to soften. For all these reasons, the functions once served by the anal taboo are no longer so pressing.

Those who wish to counter the complex effects of the anal taboo must focus on two central questions: What is the potential of the

anal area for healthy, self-affirming sensuality and eroticism when freed from the stranglehold of taboo? And how can we go about freeing ourselves? This book is intended to help you investigate these questions and discover your own answers.

The Anal Taboo in the Helping Professions

Every culture has its experts who are believed to possess special knowledge or wisdom. In many cultures religious leaders and healers have been the most revered authorities. In our society we've increasingly turned to medical and mental health professionals. We hope that their research and experience will shed light on behaviors conducive to or incompatible with health and well-being.

Unfortunately, helping professionals are by no means immune to the power of taboos. Scientific inquiry is inherently slow, always incomplete, and subject to personal interpretation and bias. The tendency of taboos to function outside of consciousness assures that perspectives on reality supported by the taboo will be taken for granted and therefore not questioned. With relatively few exceptions, the anal taboo has had just this kind of influence on how helping professionals look at anal sexuality.

The Anal Taboo in Medicine

The most prestigious professional helpers in our society are physicians. The medical community has always been profoundly influenced by the anal taboo. In proctology, the branch of medicine specifically concerned with the anus and rectum, there has been an almost universal reluctance to acknowledge that these organs have potential erotic significance—especially for "normal" people.

The first proctologic study of the medical aspects of anal intercourse was published in the 1950s with the title, "Proctologic Disorders of Sex Deviates" (Feigen, 1954). Supposedly, this judgmental title was necessary for publication at that time. Even so, the article was rejected by several respected medical journals. While the article

was a breakthrough for its day—at least *someone* was willing to raise the subject—it confirmed the prevailing belief that anal intercourse is inherently dangerous. It described in detail the medical problems of men who received anal intercourse regularly. The sample was highly unrepresentative, consisting entirely of men who sought medical help, or those incarcerated in penal institutions where anal rape is often a ritual expression of an aggressive, sometimes violent pecking order.

The situation has improved somewhat since then. One turning point came in the 1970s when increasing numbers of openly gay physicians set up practices in major urban centers. Gradually sexual experimenters of all sexual orientations heard about doctors with whom they could talk honestly about anal pleasure and problems. Consequently, some of these physicians became experts on the subject. A few actually shared their knowledge with professional and lay audiences.

Nowadays, physicians receive at least basic training in sexuality and may have some awareness about anal sex. But for the most part, anal activities, especially intercourse, are still viewed as highly problematic. That so few doctors, including proctologists, have transcended the anal taboo is understandable in light of the fact that they have had to treat, usually with little or no discussion, medical problems caused by uninformed, painful, sometimes forced, and often reckless anal experimentation. It's hardly surprising that they would tend to view anal sex as unhealthy.

In addition, physicians are unlikely to be aware of the experiences of those who enjoy anal stimulation comfortably and safely. Even after a lifetime of clinical practice it is quite possible for a doctor never to meet (or know that he or she has met) such a person. Of course, acquiring a distorted view of human experience is a problem inherent in all the helping professions, and is not exclusively the result of taboo influences. After all, people rarely consult professionals to tell them how good they feel or how much fun they're having.

For these reasons, the medical community, which could be a valuable source of information, experience and expertise about the anus, has had little to say except, "Don't do it!" It's not unusual for people who enjoy anal intercourse and who seek help for anal medical prob-

lems to be told that they must give up this form of pleasure in order to have a healthy anus. I've heard dozens of reports of doctors saying, especially to gay men, "If you'd use your anus for what it's intended you wouldn't be seeing me," when they know that the vast majority of their patients with identical symptoms aren't practicing anal sex. Freed from the blinders imposed by the anal taboo, physicians could better hear the concerns of their patients and offer constructive suggestions on how the anus can be experienced pleasurably and with a minimum of risk.

Of equal importance, physicians could become much more effective in helping all of their patients to resolve anal medical problems. This is because the majority of common anal problems—especially chronic or recurring ones—are exacerbated and perpetuated, if not caused, by negative attitudes toward the anus, lack of anal awareness, and chronic muscle tension—the exact same conditions that limit anal pleasure. Nothing can help a person develop and maintain anal health more than a comfortable, relaxed sensitivity to the anal area, including a willingness to explore it. There's no question about it: *The anal taboo is dangerous to your health!*

It's not my intention to indict the entire medical profession. Almost as amazing as the pervasiveness of the anal taboo is the ability of some doctors to look beyond it and listen respectfully to their patients. These are the gifted healers who continue to believe—in spite of a doctor-knows-best ethos and now the impossible demands of managed care—that they have as much to learn from their patients as they have to offer. They know that the path toward optimal health is a collaborative effort.

The Anal Taboo in Psychology

Just as the anal taboo has inhibited the medical community from offering any more than incidental information and support to those who want to explore anal pleasure, similar pressures have blocked many potential positive contributions from within the field of psychology. Freud at least discussed the erogenous qualities of the anus. In fact he saw it as the strongest focus of pleasure throughout one

period of each person's life. He called this period the "anal phase" and to it he ascribed enormous power to shape our personalities. Although his ideas brought phrases such as "anal retentive" and "anal fixation" into popular parlance, the overall impact of his theories has been to legitimize anal pleasure as a developmental necessity for small children while labeling it infantile for adults.

Freud viewed all mature sexual activity as having reproductive potential as its aim. As a result, he oriented his theories toward penis-vagina intercourse and male orgasm. He tended to view all sensual "lingering" at non-genital body zones as perverted if it didn't further the aim of reproduction. Thus, he believed that most human erotic activities—masturbation, clitoral stimulation, general body stimulation, and oral stimulation—were immature if they didn't lead to vaginal intercourse. So while Freud introduced anal eroticism into psychology, and was considered scandalous for doing so, his theories may now be more influential than religious dogma in convincing adults that they can enjoy their anuses only at the risk of being harshly judged. With this ironic twist Freudian psychology has actually bolstered the anal taboo.

Psychology has evolved in literally hundreds of directions since Freud. It's now difficult to find anyone who still believes that sex is primarily for reproduction. Most, but by no means all, of today's psychotherapists take a far less dogmatic view of sexual behavior and accept a wider range of activities as potentially healthy and mature. It's one thing, however, to broaden one's ideas about sexuality, but quite another to translate these ideas into professional action.

The anal taboo still thrives among therapists and researchers, in spite of our open-mindedness. To gauge just how bad it is I hired a research specialist from the American Psychological Association to search their enormous database known as PsycINFO. Our mission: to find all references to anal sexuality in well over 1,300 professional journals as well as tens of thousands of book chapters published between 1967 and July, 1997—totaling many hundreds of thousands of potential citations. After screening out references to anal sexuality focused on HIV transmission or education, we found a measly 23

citations, consisting primarily of very small surveys of college students and discussions of psychoanalytic theories about anality.

In addition, I peruse hundreds of programs for professional meetings and conferences every year, and anal sexuality is virtually never discussed—except in the context of AIDS transmission and prevention. It's as if one whole dimension of human experience has been banished from professional discussion and inquiry. I can't think of any other subject that has been so systematically ignored.

One of the most common reasons people write to me is to express their frustration that anal sexuality feels like a forbidden subject in their psychotherapy, regardless of its duration or how helpful it is in other ways. When they have followed my suggestion to initiate a discussion—or at least mention their discomfort in doing so—some have reported positive results. But in most cases, brief discussions have quickly fizzled, often with the topic never being raised again.

My hunch about the dynamics at work here is that the discomforts of therapist and client join forces to create an unspoken, semiconscious consensus to avoid anxiety and embarrassment, especially on the part of the therapist. Clients don't want their therapists to be anxious while discussing difficult material. How paradoxical that in a setting specifically designed to promote honesty and deepening levels of self-disclosure, a deafening silence infuses the anal taboo with even more power than it may have had before.

There's reason for optimism, however. In recent years I've noticed an unmistakable opening among a significant group of therapists. More frequently than ever before I'm asked detailed questions at seminars about clients' problems with anal sexuality. One of the first signs that a taboo is loosening its grip is an increasing ability to perceive and admit its strength. That's why I'm so pleased when a therapist acknowledges his or her discomfort, and then forges ahead in spite of it.

Sex Therapy and Anal Concerns

Sparked by the publication in 1970 of Masters and Johnson's pioneering book on sexual problems, the fields of sex research and therapy

have grown rapidly. With the growing acceptance of modern sex therapy has come greater awareness that sexual difficulties, far from being rare, actually affect large numbers of people. Men seeking sex therapy are usually concerned about getting or maintaining erections under various conditions, or else they are concerned that they ejaculate too fast (premature ejaculation) or take too long (inhibited ejaculation). Women are usually concerned about lack of arousal or not being able to experience orgasm. Both men and women who have little or no interest in sex are increasingly likely to consider this a problem.

Although theories and techniques for dealing with these concerns vary widely, all sex therapists view sexual behavior, whether positive or problematic, as complex phenomena in which psychosocial learning plays a major role along with biology. Appreciating the lifelong process of sexual learning opens up the possibility for *un*learning attitudes, beliefs and behaviors that undermine satisfying sex and *re*learning better alternatives. But just how much sexual change is possible and how it can be facilitated is still, and probably always will be, a subject of intense debate.

Aspects of a person's sexuality that are established early in life and generate high arousal are strongly resistant to change. And fundamental elements of sexual self-image such as core gender identity (the inner conviction of being male or female) are so thoroughly woven into a person's entire psyche that change is virtually always impossible—even when this identity is out of synch with one's genitals, as is the case with transsexuals. Sexual orientation also tends to be very stable, although humans are noted for experimentation. Furthermore, it's crucial to keep in mind that long-established turn-ons tend to become intertwined with a person's self-image.

Sex therapists are most successful at helping clients create the conditions for learning new sexual behaviors, overcoming performance anxieties, improving communication, and expanding their preferences somewhat, but usually not dramatically. If new discoveries turn out to be more pleasurable and fulfilling or less anxiety-provoking, then they'll gradually supplement or supplant older behavior patterns— unless the old patterns produce stronger rewards of their own, which

is sometimes the case, even with problematic behaviors. Sex thera-
pists are least successful at helping clients get rid of behavior or alter
preferences that bring them high excitement, regardless of whether
the client expresses a desire to change.

Today's sex therapists are initially concerned with: (1) providing
accurate information and confronting destructive beliefs, (2) suggest-
ing experiential exercises (sometimes called "homework") free of
pressure to perform, (3) teaching practical techniques for coping with
and reducing anxiety and tension, and (4) improving interpersonal
skills, especially the ability to discuss sex openly and to be more as-
sertive in asking for what one wants. Usually, the development of
new behaviors—or avoidance of them—evokes emotional reactions
and sometimes insights into how past experiences are still getting in
the way. As these emotions and insights are explored in depth, fur-
ther experimentation provides additional opportunities for both learn-
ing and self-awareness.

Sex therapists base their work on the assumption that sensual and
sexual pleasure is a positive and healthful human experience as long
as it is accompanied by a sensitivity to the rights of others. Sex is seen
as having the potential to enhance a person's self-esteem as well as
his or her relationships with others. Cognizant of the tremendous
range and variety of sexual behavior among human beings, sex thera-
pists usually feel less compelled than traditional psychotherapists to
formulate universal ideals of how people should behave. These basic
attitudes may well be responsible for the successes of sex therapy,
probably more so even than the specific techniques that have re-
ceived so much publicity.*

Notwithstanding the overall atmosphere of openness that perme-
ates much of the field of sex therapy today, sex therapists have not
escaped the effects of the anal taboo, and therefore are rarely as open

* Those who wish to learn more about sexual problems and therapy should see
Zilbergeld's *The New Male Sexuality* or Barbach's *For Yourself: The Fulfillment of
Female Sexuality*. An excellent source for professionals is Leiblum and Rosen's
Principles and Practice of Sex Therapy. Schnarch's *Constructing the Sexual Crucible*
explores the integration of sex and marital therapy.

about anal sexuality as they are about other sexual activities. Many are quite willing to discuss anal pleasure with their clients. However, few know how to deal with the concerns of clients who want to enjoy anal stimulation but whose attempts have resulted in pain and discomfort rather than pleasure. Most therapists have had few, if any, opportunities to learn about or discuss anal pleasure with their colleagues—or anybody else, for that matter.

Some therapists consider the ability to enjoy anal stimulation, especially intercourse, as a special skill which, because of anatomical or psychological factors, is available only to a relatively small number of people. Their usual tendency to view anal sexuality as an ongoing developmental process gives way to a far less flexible perspective than they would ever apply to other sexual behaviors. Given the atmosphere of secrecy and misinformation created by the anal taboo, this is understandable.

One reason why so few sex therapists have made any systematic attempts to apply their skills and techniques to the problems of blocked anal pleasure is the fact that such problems haven't traditionally been defined as concerns worthy of serious therapeutic intervention. To a person who desires anal pleasure, the inability to relax the anal muscles is as much a problem as a man's concerns about his erections or ejaculations, or a woman's concerns about her arousal or orgasms. Wanted but inhibited anal pleasure can have the same negative effects on a person's self-esteem and vitality as any other sexual concern.

I have named this problem *anal spasm* because involuntary contractions of the anal sphincter muscles—and, to some degree, rectal muscles as well—is the primary physiological mechanism blocking anal enjoyment, especially the pleasure that can be derived from internal stimulation of the anus and rectum.* Physiologically, anal spasm is similar to *vaginismus*, which involves an involuntary spasm of the muscles sur-

* I have always been reluctant to define yet another sexual problem to worry about. The *last* thing we need is an extra expectation to live up to, or condition to feel inadequate about. In fact, any time we explicitly define a problem, especially in the sexual realm, we create trouble for some people. Not only can the new label

rounding the outer vagina, making insertion of a penis, gynecologist's speculum, or sometimes even a finger painful, difficult, or impossible. Like anal spasm, vaginismus not only prevents insertion, but over time it also tends to reduce all pleasurable sensations—or at least the ability to enjoy them—in the surrounding areas.

After working with dozens of clients with anal spasm in the early seventies and with their help developing an approach that seemed to help, in the mid-seventies I began testing my discoveries through formal research in which 143 people (114 men and 29 women) participated in an eight-week therapy process developed and refined during my earlier work. Participants ranged in age from 21 to 62 years old. Represented among the participants were men and women of all sexual orientations and a variety of backgrounds and lifestyles. All wanted to experience less pain and more pleasure from anal erotic stimulation. Eighty percent wished specifically to be able to enjoy anal intercourse. A detailed description of the participants, the research methodology, and the findings can be found in Appendix B. In nearly twenty years since that research was completed, I've worked in my psychotherapy practice with hundreds of additional men and women with similar concerns, although I stopped doing the groups in the 1980s.

For the reader desiring to enhance the capacity for anal pleasure, it's only important to be aware that this is not an impossible or even difficult goal. Among the 143 participants in the research, 71% learned to enjoy anal stimulation in the ways they desired by the time the eight weeks of therapy had ended. An additional 12% were able to do this within four months after therapy. For the total of 83% who reached their goals, many factors contributed to their success. Most important was the willingness to devote regular time and attention

be used for self-deprecation and criticism, it can also be employed in interpersonal power struggles. For example, some men might use this idea to pressure a partner into accepting anal intercourse, with little regard for the actual desire of the partner. But since defining sexual problems also has many benefits, about the best we can do is to be aware of the potential negative implications and conscientiously try to avoid them.

to anal exploration, and to carry it out with calm persistence.

Virtually anyone, regardless of gender or sexual orientation, can become more aware of the anal area, learn to relax anal-rectal muscles, and expand their capacity to enjoy whichever types of anal stimulation may be desired. Required, however, is sufficient motivation, a little patience and a clear idea of how to proceed. It is also necessary to become aware of and to challenge the effects of anal taboo. Almost everyone with whom I have worked has found that the rewards—anal pleasure and health—are well worth the effort.

How to Use This Book

<div style="text-align: right; font-size: 2em;">3</div>

THIS BOOK IS DESIGNED not just to be read, but also to be *experienced*. It's not intended for passive consumption, but rather for active use. As you move through each chapter you'll be following essentially the same process of anal exploration that my clients have found to be highly effective.

I've communicated with many people who live in other parts of the country, guiding them in their anal exploration processes via letter, telephone, e-mail, or one or two visits to my office. Their reports indicate that most of them are able to make significant and welcome changes without the regular involvement of a therapist. A therapist offers clients opportunities to clarify their feelings and needs, as well as support and guidance in working through any rough spots. These therapeutic functions can't be replaced by a book. Nonetheless it's possible to provide yourself with support and feedback by taking the risk of honestly discussing your feelings and activities with a close friend or lover. With adequate motivation and persistence most people are capable of initiating and directing their own self-exploration, using this book as a guide.

How the Book is Structured

Anal awareness has two dimensions. First, there's the individual pro-

cess of self-exploration. The second dimension involves sharing anal exploration and stimulation with a partner. The first part of this book deals with the more private aspects of anal exploration. Other people participate only through your memory, imagination or fantasies. The latter part deals with how to include the anal area comfortably and safely in sensual and sexual play with others.

Each chapter begins with relevant information from the fields of anatomy and physiology, medicine or psychology. Then a section entitled "experience" presents simple things to do. This section is intended to help you apply new information, in concrete and practical ways, to your own behavior. The "response" section should help you integrate new information and experience into your life. Here I discuss *feelings* you might have as a result of your experiences, *blocks* that might get in your way, and *possibilities* for positive change.

Unlike some books that encourage flipping pages randomly, this one is designed to be read in sequence. Each chapter builds on the previous ones and assumes you have at least thought about their content, and perhaps tried some of the suggestions.

When you read the experiences or actual words of my clients, it's important to keep in mind that these aren't offered as norms or standards for what you should experience or feel. Instead, consider whether they're helpful in understanding yourself. If some statements aren't relevant, feel free to move on. But before dismissing anything as irrelevant, take a moment to ask yourself if possibly the material is in fact *very* relevant, and thus somewhat threatening. If you have a particularly strong negative reaction to something you read, consider it a good indication that you could benefit from spending more time with that section.

Working With a Partner

Some people want to include a partner in their anal exploration right from the start. If this is true for you be sure to spend at least as much time exploring alone as you spend with your partner. Ideally your partner should spend time exploring alone, too. If you don't have an appropriate partner right now or aren't ready to talk with him or her about anal pleasure, you can still accomplish a great deal on your

own. Later, when you feel more comfortable, you can think about your options for including a partner.

Setting Aside Time

How much you get out of this book will depend on your motivation which, to a great extent, is reflected in how much time and energy you're willing to devote to learning about yourself. Most people do best if they set aside one or two exploratory periods each week. These periods should be during "prime time" when you're not tired, preoccupied or in a hurry. If you're like most people, you'll have to guard your private time militantly against encroachment by other pressures and demands. Avoid becoming too rigid about it, though, because this won't be conducive to relaxation. Whatever you do, don't turn anal exploration into a task or obligation. If you don't feel like doing it, then don't. Sometimes, however, a gentle push is necessary to overcome discomfort with the unfamiliar.

Keeping a Journal

Your progress will be greatly enhanced if you keep a journal. This is a notebook in which you write about experiences, thoughts, and feelings as you move through the book. Many of us have trouble finding even a few minutes to be quiet and attuned with ourselves; the practical demands of life are always clamoring for our attention. However, I have yet to find a person who kept a journal who didn't say it was tremendously valuable.

Goals and Expectations

Perhaps you're reading this book without any preconceived ideas about what you'd like to get out of it—just browsing to see if there's anything useful here. On the other hand you may already have specific ideas about how you'd like to grow and change. If you do have goals or expectations in mind, even if they're not very clear, it's worthwhile to state them explicitly at least to yourself, maybe to a friend or a lover, or write them in your journal.

My work has shown unmistakably that the way a person approaches

anal exploration is significantly related to how beneficial the process turns out to be. Those who want to *perform* better as a result of therapy (that is, their main motivation is to please someone else) are far less likely to reach their goals than those who wish to develop new pleasure options for themselves. If you're coming into this with performance-oriented goals such as, "I want to satisfy my lover by being able to receive anal intercourse," consider a more pleasure-oriented approach. What if you put the emphasis on getting more in touch with yourself?

Unfortunately, clients with all types of sexual concerns frequently have trouble distinguishing between these two types of goals. Many people become so performance oriented that their partner's pleasure is seen as synonymous with their own. If the importance of this distinction is not clear to you now, keep thinking about it as you move through the book. Changing your motivation may not be so easy, especially if you're used to putting a partner's needs and desires ahead of your own. So it's a good idea to start now.

Your goals may have little or nothing to do with enjoying the anus sensually or erotically. You may simply want to restore or maintain anal health. Perhaps you're trying to resolve a chronic medical problem that hasn't responded to traditional treatment. If so, be as clear as you can about what you're looking for. Doing so will help you get the most out of this book.

Making a No-Pain-Ever Commitment

Whether or not you have specific goals, the positive results of any anal exploration will be greatly enhanced if you make one fundamental commitment to yourself: *From now on, I will do everything within my power to protect my anus from any pain or discomfort whatsoever.* If you're worried about the possibility of pain, your enjoyment of anal stimulation will be greatly limited and your anal muscles will refuse to relax completely.

Don't make this commitment flippantly because it won't do any good. Understand that honoring this agreement may require you to place the comfort of your anus ahead of the desire of a sex partner.

To say "yes" to your own body you may have to say "no" to somebody else. If you are currently grinning and bearing anal pain in deference to your partner—or in the hope you'll learn to like it—you may find this commitment a difficult one to make. It's better to admit that you're not ready to make this commitment than it is to make it and then break it. Luckily, the vast majority of people seem more than happy to remove pain from their repertoire of anal experiences.

Timing and Rhythm

Each individual has his or her own pace for self-discovery and change. Some people find that things move smoothly and quickly from the moment they start. For others the process unfolds much more gradually. Honor how it is for you.

There is even more diversity when it comes to people's *styles* of changing and growing. Some progress step-by-step. Most, however, experience spurts of self-exploration, out of which they may report breakthroughs, followed by periods when nothing much seems to be happening. For some, these ups and downs are dramatic and charged with emotion. Others take their rhythms more in stride.

Expecting yourself to grow according to an ideal schedule and style is just another way of putting pressure on yourself and thereby inhibiting relaxation and pleasure. The more you can follow your natural timing and rhythm, the more you'll accept yourself and, consequently, the more good things will unfold.

<div style="text-align: right; font-size: 3em;">4</div>

Looking and Touching
Beginning Anal Self-Exploration

THERE'S NO BETTER way to gather crucial information about your anus than by using the senses of sight and touch. In spite of the strong prohibitions against body exploration many of us received while growing up, we readily look at and touch ourselves during everyday activities such as bathing and grooming—with at least one notable exception. Nobody just happens to bend over, back side toward the light, mirror in hand, to sneak a peek between their buns.

All but the most haphazard anal exploration requires a conscious decision to do it. A lack of first-hand knowledge may have left you susceptible to a wide range of negative ideas and feelings about your anus, most of which would never have developed if you'd been allowed free visual and tactile exploration of this hidden body zone.

The Anal Opening

The anus is the external opening into the short anal canal and the larger rectum. Hidden by the buttocks, the anal opening is formed by folds of soft tissue which give it a puckered appearance. Anal tissue is pink-red in color unless it is irritated, in which case it may appear bright red. Within the anal tissue are a vast array of tiny blood

vessels and nerve endings, making it one of the body's most sensitive zones. These same nerve endings also let you know in no uncertain terms when your anus is hurting.

The area surrounding the anal opening contains many hair follicles. The hairs growing here may be too light and too fine to notice, or they may be coarser and darker. But everybody has hair growing in this area.

To a large extent the appearance of the anus reflects something of your past and current experiences, though you may not realize it. It may look comfortable and relaxed. Or it might look irritated, mistreated, and chronically tense.

Contrary to nearly universal opinion, there is nothing inherently dirty about the anal area. Regular washing leaves your anus fresh and clean. It's true that small particles of feces can contain bacteria that aren't found elsewhere—the vagina for example. Because the vagina can be a hospitable environment for infections, most sex therapists recommend that a woman not insert her finger (or any object) into her vagina after it's had contact with her anus without washing it first. An additional approach to external anal touching is to wash your anus first. If you follow these simple precautions there's absolutely no risk in exploring your own anus. Unwarranted concern about anal germs is yet another unfortunate legacy of the anal taboo.

Experience

Begin by taking a leisurely bath or shower, whichever is more relaxing and enjoyable for you. Think of this as doing something nice for yourself—not just getting clean. It may help to reflect this mood in your environment by lowering the lights, playing music, or using bubble bath or bath oil.

As you settle in, feel the warm water against your skin. When you wash, make each stroke slow and sensuous. Gently caress your anal area, giving it a little extra attention. Take as long as you want; there's no rush. But stop right away if you start to get bored. Dry yourself in

the same slow, deliberate way.

When you're ready, turn up the lights and look at yourself in a full length mirror. Move in closer to look at each part of your body in detail, from head to toe. Using your hand mirror, give the same attention to the back of your body. Obviously, some things will look better to you than others. When you come across something you don't like, acknowledge your feelings and how you would like it to be different—and then move on. Don't suppress any negative feelings but don't get caught up in them either. When you see something you like, let yourself feel good about it.

Using the hand mirror and plenty of light, take a close look at your anus. Find a comfortable position in which to do this. Figure 1 illustrates a variety of positions for anal self-examination; try them all. Find a position you can maintain without discomfort or fatigue. Remember you're not just sneaking a quick peek here. Carefully examine your buttocks and then move in for the details.

Whenever you decide to continue, go back to your full length mirror and begin another detailed self-exploration. Only this time touch each part as you look. Caress yourself in different ways to see which ones feel the most pleasant, relaxing, sensual or erotic.

Find a position in which you can easily touch your anus. Begin gently stroking your anus and the surrounding areas. Notice how your anal tissue feels compared to nearby tissue. At least part of the time, see if you can look at and touch your anus simultaneously. Do you notice any response in the anal area as you touch it? Does it seem to get more tense, less tense, or stay about the same? What difference does it make if you breathe deeply? Don't insert your finger in your anus at this point even if you've done it before; stay with the exterior for now.

As you continue investigating, note your feelings. And don't expect them to be logical either. See if you can just be aware of and accept whatever they are, without judgment or criticism. When you've finished looking and touching for now, write your reactions in your journal or simply sit back and think about them.

Figure 1. Positions for Anal Self-Examination.

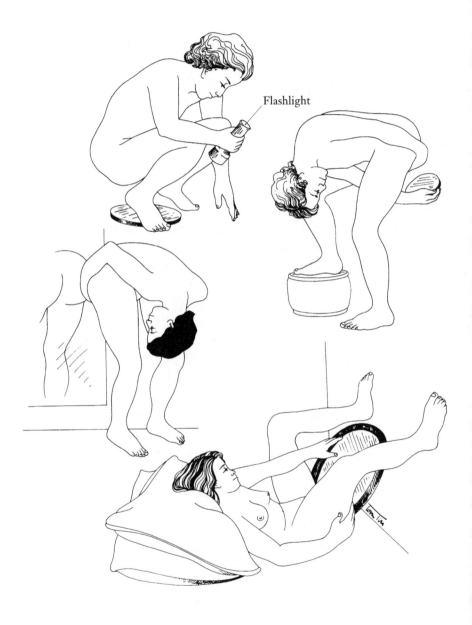

Flashlight

Response

Though you've no doubt seen and touched your anus before, you probably haven't done it in such a deliberate or intentional way. Some people get a sense of liberation from past restrictions, and a feeling of intimacy with the body. Some find the experience to be immediately sensual or even erotic. Others approach it almost as if conducting a scientific experiment. Still others find themselves turned off, bored or even repulsed. Any of these reactions—or a combination— is fine. As much as possible, see if you can avoid predetermined ideas of what you should or shouldn't feel. For example, some people who want to enjoy anal sex become dissatisfied when their own touch is not immediately experienced as erotic. See if you can relax without trying to force yourself in any particular direction.

Some distressing feelings commonly accompany anal exploration. Acknowledging negative as well as positive reactions provides opportunities for self-awareness and change, though you may have to tolerate some uneasiness in the process. One of the first things you may have to confront is the extent to which prohibitions against body exploration in general—and anal exploration in particular—have affected you.

Some women readers will have already dealt with similar prohibitions in learning to examine their genitals. The vulva, like the anus, simply cannot be thoroughly explored without conscious intent. Women who have overcome early injunctions against genital exploration tend to have gained a deeper awareness of themselves and can usually look at and touch their anuses with somewhat greater ease. On the other hand, women who haven't yet explored their genitals extensively may find this process more difficult.

A woman's vulva is somewhat hidden to her, but a man's penis and scrotum require persistent effort to ignore. Consequently, most men have explored their genitals quite a bit, especially during masturbation. But these experiences don't automatically transfer to the anal area. However, men who have learned to thoroughly enjoy slow masturbation sessions do seem more open to anal exploration; many, in fact, have already experimented with it.

While contemplating lingering prohibitions against extended body exploration and self-pleasuring, most people discover that early prohibitions usually weren't stated directly by parents and other role models. Rather, mistrust of the body is communicated more subtly. In my work I regularly see how such messages are passed along subconsciously. For instance, relatively few clients remember being told overtly not to masturbate. Yet virtually all knew, in no uncertain terms, that they should hide it at all costs. Indirect parental injunctions can be far more potent than direct orders because they operate largely outside of our conscious awareness, leaving us powerless to do anything about them.

Prohibitions against body awareness and pleasure are most likely to enter consciousness when you consider violating them. Just *thinking* about exploring forbidden areas can trigger strong avoidance reactions. It's not unusual for people to find endless reasons why they can't look at or touch their anuses. Rarely do they notice any obvious thoughts such as, "Don't do that!" Such thoughts would be relatively easy to deal with. More commonly there are only vague feelings of guilt or anxiety—almost too subtle to notice.

Dorothea wondered, "Why do I feel like a bad girl when I look at my anus? It's the same way I feel when I give myself intense orgasms." Although Dorothea didn't remember the actual prohibitions passed along to her, she was able to observe their effects.

George dealt with his feelings in a different way: "Well, you know, I don't get all this talk about guilt and all that. I look at and touch my anus and it just *bores* me. That's all!" It took George several weeks to admit, even to himself, that he was being affected by anti-anal messages he had received as a child. Feeling bored is often preferable to feeling anxious.

Some people protect themselves from all these messy complexities with a trickier strategy. They're quick to agree with everything— "Yes, I feel guilty. Yes, I'm responding to prohibitions from childhood,"—but they're unwilling to explore anything more deeply, side-stepping every suggestion with "I already know that." Such people have a very hard time getting anywhere. They're intellectu-

ally committed to the idea of personal growth, but unwilling to take any concrete steps to promote it.

Also limiting anal awareness are the visceral feelings of disgust or revulsion that often accompany anal exploration. Of course, such feelings aren't limited to the anus, but often include other "dirty" areas such as armpits or genitals. Often these feelings are subtly and carefully concealed. You may, for instance, be willing to touch your anus for a brief moment, but be unable to spend much time experiencing the touch fully.

It can be difficult to separate legitimate hygienic concerns from unrealistic feelings of revulsion. With rare exceptions, legitimate cleanliness concerns are dealt with easily, with little or no emotional intensity. When concerns about cleanliness are highly charged emotionally, it's clear that irrational fears are at work. These need to be acknowledged and then challenged by accurate information and new experiences. In the beginning it helps if anal contact occurs after bathing so that cleanliness is assured.

Other less common reactions include frustration, resentment and anger. Russ said:

> When I looked at my asshole, I thought it looked OK but then I got really mad. At first this surprised and embarrassed me. I thought to myself, 'Now, what did your anus ever do to you?' Then I realized it's done *a lot* to me, like right in the middle of sex when I wanted to have a good time it made me shiver with pain. My butthole has been a royal pain in the ass!

Jean expressed her frustration differently: "Why do I have to go through all this effort and spend all this money? It's not fair! All I want is a little pleasure, for Pete's sake. And some of my friends seem to get it naturally. What the hell's wrong with me anyhow?"

When Russ and Jean received support for feeling as they did, they soon could see that there was nothing wrong with them. They had simply been diverted from the self-exploration necessary for anal relaxation and enjoyment. They also realized that people are different; what one person takes for granted can be quite a challenge for someone else.

Sometimes anger that is at first directed toward the anal area can be redirected toward its real objects—parents, teachers, religious doctrine, social mores, or institutions which have encouraged you to dislike or mistrust your body, especially your anus. Don't be surprised if anger comes out initially as general irritability. In groups we often have "bitch sessions" in which participants get mad at nearly everyone and everything. Of course, such complaining doesn't actually change anything but it can be quite helpful in releasing accumulated emotions. It can also be a lot of fun even if you do it by yourself.

Dialogue with and support from others can be useful for exploring your feelings and experiences. If you have a friend with whom you share trust and rapport, particularly if he or she has been doing anal exploration too, why not begin talking together and giving each other suggestions and encouragement? If you don't know such a person, or you feel uncomfortable raising the subject, then just continue exploring on your own. Later we'll focus on including others when the time is right.

Personifying the Anus

Many of my clients have found it helpful to imagine that their anus has a personality of its own. If you're unaware of your anus and it feels numb, as if it weren't there, you can picture your anus as a stranger whom you need to get to know better. If your anus has been the source of pain and frustration then your "relationship" has been one of tumult and conflict.

Although this may sound silly at first, it's a useful metaphor. Initially, the goal is for you and your anus to become acquainted. This involves listening to what your anus is trying to communicate to you through muscle tension, unpleasant sensations or irritated appearance. It also involves treating your anus with the same respect you would give a friend, protecting it from pain and discomfort, discovering what it needs to be healthy, and willingly changing any behavior to which your anus responds negatively.

People who adopt this perspective usually find that a sense of good will toward the anus is associated with relaxation, an increase in comfort and pleasurable sensations—whereas alienation and hostility breed tension. Once you establish an intimate friendship with your anus you can abandon the idea that you and your anus are separate. Bill said, "Since I've started paying attention to my anus, I've developed a 'buddy, buddy' feeling about it. It's the last part of my body I've gotten to know. My connection with myself is now more complete."

The power of tactile and visual anal self-exploration to counteract the anal taboo becomes increasingly pronounced through repetition. Don't be surprised if it takes a while just to get over the self-consciousness of doing what you may never have done before. Only when self-consciousness gives way to genuine curiosity can you derive maximum benefits. If you can build simplified versions of these looking and touching experiences into your everyday life, you will be richly rewarded.

Beneath the Skin
Locating and Exercising Anal and Pelvic Muscles

A S YOU CONTINUE LOOKING and touching, you'll gradually become more familiar and comfortable with your anal opening. But this is just a beginning. Below the surface lies a complex system of muscles and nerves. Developing a sense of intimate contact with these is crucial to anal discovery and pleasure. This chapter will help you identify and locate important pelvic muscles and then start a program of simple exercises to restore or enhance their tone, elasticity and sensitivity.

Anatomy of the Anal Muscles

You've probably heard of the anal sphincter—a ring-like muscle that surrounds the anal opening. You may not be aware that there are actually *two* anal sphincters: the *external sphincter* and the *internal sphincter*. As you can see in Figure 2, the two sphincters overlap somewhat.

Knowing that there are two anal sphincters is very important because each muscle can, and often does, function independently of the other. As you'll discover, each sphincter is controlled by different neurological mechanisms. For now it's enough to know where these

Figure 2. Diagram of Pelvic Muscles.

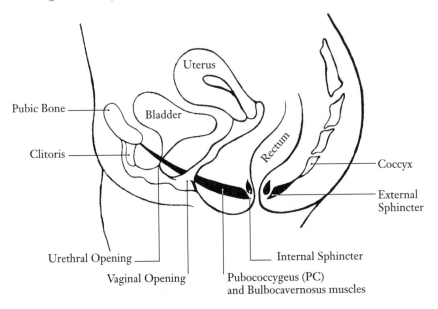

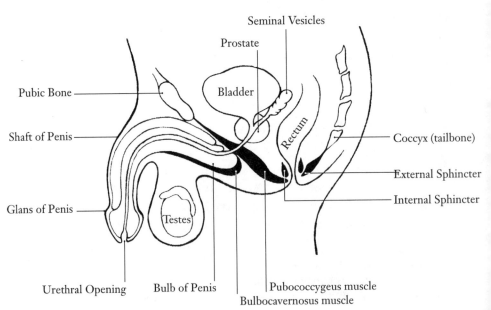

muscles are and that usually they work together; if one is tense, chances are the other is, too.

Other separate yet interrelated pelvic muscles are close to the anal sphincters and in direct or indirect contact with them. In general, these muscles are referred to as the *perineal* muscles. They support the tissues around the anus and in the area between the anus and the genitals. This area is called the *perineum*, after which the muscles are named.

Two specific perineal muscles deserve special comment. The first is called the *bulbocavernosus* muscle which, in men, envelops the bulb of the penis close to the anus and, in women, surrounds the outer portion of the vagina. Another important pelvic muscle is the *pubococcygeus* muscle (PC for short). It's part of a large, flat, supportive muscle system known as the *pelvic floor*. The PC muscle is so named because it is anchored at the front to the pubic bone and at the rear to the coccyx (tailbone). Look again at Figure 2 until you can visualize where these muscles are.

The late gynecologist Arnold Kegel is famous for his studies of the PC muscle in women. He realized that the PC muscle helps control urine flow and devised simple exercises—now called "Kegels"—to strengthen the PC in women bothered by stress incontinence (loss of urine when laughing, coughing, running, etc.). Many of his patients reported some welcome side effects of doing Kegels: increased sexual sensitivity and responsiveness. Kegel then became interested in the sexual functions of the PC muscle. He found that the fitness of the PC affects a woman's sensitivity to vaginal stimulation (Kegel, 1952).

In both men and women the PC muscle contracts randomly during arousal and rhythmically during orgasm. Improving its condition tends to increase the intensity of our pelvic erotic sensations. In addition, men and women can deliberately contract or relax the PC and other pelvic muscles in order to enhance the pleasure of orgasm or to influence its timing.

My clients have found Kegel exercises to be of value in improving anal sensitivity as well. When the PC muscle is contracted, many other pelvic muscles, including the anal sphincters, contract simultaneously.

In fact, it's unlikely that the improvements in sensitivity noted by Kegel were solely attributable to the PC muscle, but rather were a result of better fitness throughout the pelvis.

Doing Kegels builds sensitivity in a variety of ways. First, simply doing the exercises focuses our attention and thus enhances our awareness of pelvic sensations. Second, exercising any muscle increases blood flow into the area being exercised and causes a warm tingly feeling, similar to what you may have experienced following a workout or massage. Third, exercising improves the tone of soft muscle tissue. Mushy muscles are quite inefficient at transmitting sensations to the nerve endings embedded within them. Repeatedly contracting and relaxing muscle fibers improves their tone and helps them to transmit sensations to the nerve endings more effectively.

Well-exercised muscles are sometimes incorrectly assumed to be bulky, hard, and inflexible. The image of the muscle-bound bodybuilder contributes to this belief. Actually, the restoration of tone to muscles usually results in a lowering of baseline (normal) muscle tension and an increase in elasticity. Healthy muscles are able to do their job in a firm yet relaxed state. Conversely, mushy muscles require a great deal of excess tension just to make them do their job.

Most of the men and women I have worked with have reported improved anal and pelvic awareness and sensitivity after a few weeks of exercise. Most also felt that their anuses became more relaxed. Both of these changes probably result from a combination of paying attention, increased blood flow and improved tone.

Dr. Kegel didn't give particular attention to the impact of breathing patterns on the pelvic muscles, yet how we breathe plays an important role in body awareness and relaxation; this is why breathing lies at the heart of such disciplines as yoga and the martial arts. When we are threatened, afraid, or in pain, our breathing becomes shallow; we use only the upper portion of our lungs while the lower portion is highly constricted. To make up for reduced lung capacity we take faster, erratic breaths instead of long, slow ones. During times of stress we restrict our breathing to subdue unwanted feelings and sensations. Unfortunately, we can easily use the same mechanism to suppress or

limit our pleasure. Shallow breathing is the best way to obey parental and societal prohibitions against enjoying ourselves too much.

To reverse this it's necessary to breathe deeply and use your entire lung capacity, which depends on your diaphragm—a large, flat muscle below the lungs. During deep inhalation the diaphragm swings downward, creates a bellows effect, and your lungs fill with oxygen. Then when you exhale completely your diaphragm pushes upward against your lungs, expelling gaseous wastes. It's a good sign that you're inhaling fully if your abdomen expands noticeably; you can't breathe diaphragmatically and hold in your tummy at the same time. Whenever you consciously breathe deeply, even if only for a few minutes, your entire body will feel more open and alive.

Experience

If you want to exercise your pelvic muscles productively it's first necessary to locate the muscles. The best way to do this is to sit comfortably, feet flat on the floor, and imagine that you're urinating. Then tighten the muscles you'd use to stop the flow of urine. If you can't do this by imagining then actually stop and start the flow the next time you urinate. The PC muscle is the one you'll use. But all of your pelvic muscles tend to contract and relax in unison—as they do during orgasm.

Once you get a feel for the PC muscle, deliberately tense and relax it a few times while noticing exactly where in your pelvic area you feel the contractions. Place your fingers on your perineum—the area between your genitals and anus. You'll certainly feel the contractions there. Notice that your anus contracts simultaneously.

Now that you've located the pelvic muscles I suggest you try three different exercises. First, inhale deeply as you contract the muscles and hold them—and your breath—for a few moments. Then release your muscles as you exhale completely. When you contract do it as tightly as you comfortably can. When you relax, visualize the tension totally draining out with your breath. I suggest that you repeat this

contract-relax sequence approximately 25 times whenever you do it.

For the second exercise, inhale deeply as you tighten and release your pelvic muscles repeatedly, as rapidly as you can—sort of like pulsations—about ten contractions at a time. After a number of tense-release cycles, relax completely as you exhale.

The third exercise involves inhaling deeply as you gently push out and then pull in your anal and other pelvic muscles, almost as if you were sucking in and then expelling water through the anus. Exhale and release completely. Do about ten push out/pull in cycles at a time. This exercise can increase blood flow to the entire pelvic region, including the anus. And some women also find that it increases natural vaginal lubrication.

As with all effective fitness training, consistency is crucial. I recommend that you do about three sets of each exercise several times throughout the day, as often as you like. If one exercise doesn't appeal to you then emphasize the other two. Even concentrating on just one is far better than not doing any. Your muscles may feel a bit tired at first, which is a positive sign that your training is having an effect. However, if doing any of the exercises is actually painful, stop until you talk with your doctor about it.

You may wonder how you can possibly find time for yet another fitness regimen. But keep in mind that you can do these exercises virtually any time or any place—even while you're doing something else. Try them while reclining, sitting, or standing. Nobody has to know you're doing them, although at first you'll probably want to do them in private. Another advantage is that a set of all three exercises can be completed in just a few minutes.

Results will be better if you exercise most days. You're more likely to continue if you link these exercises with already established routines such as watching TV, eating, or driving. One of the best habits for maintaining optimal anal health throughout your lifetime is to exercise your pelvic muscles for a couple of minutes every time you shower or bathe. Try it; I think you'll like it.

Response

Some people find it difficult to locate and exercise these muscles. The rapid pulsations seem to be the hardest for most people. The more difficult it is for you to control these muscles, the more you are in need of the exercises. As you do them you'll find it increasingly easy and quite pleasurable. After all, you're making your muscles do the things they do spontaneously when you're sexually aroused. Best of all, the more you do the exercises the more you'll start noticing sensations in your pelvis and anus that you might have ignored before.

Others subconsciously avoid these exercises because they've become accustomed to maintaining a high level of pelvic rigidity. A variety of fears can make a person reluctant to loosen up. For instance, many boys are taught—in subtle, mostly nonverbal ways—that masculinity requires careful avoidance of swinging hips. As a result they drastically limit the range and ease of their pelvic movements, holding their muscles tight for fear of being seen as a sissy. Some girls are also taught to curtail free pelvic movement to avoid appearing sleazy, loose, or slutty.

To get an idea of how enjoyable pelvic relaxation and free movement can be, try gently tilting or thrusting your hips forward and back, side to side, and in a circular motion. Repeat these motions again after pelvic exercises. Notice any difference? The next time you're dancing, walking, or running, allow your pelvis to move more freely than usual as you breathe deeply and release all unnecessary muscle tension. There's little danger of becoming a sissy or a slut—except perhaps in the eyes of certain frightened and rigid people. As you move beyond such fears you'll notice, subtly at first, a graceful expansiveness emanating from your pelvis. Stay with it and soon you'll be taking a more confident and agile stance in the world.

Mind and Body

Understanding How the Anus and Emotions Interact

Now that you've located your anal and pelvic muscles, learned something about their structure, and launched a fitness program to build tone and elasticity, you're probably becoming more aware than ever before of the anal area and its sensations. Our goal in this chapter is to deepen this awareness by investigating the intimate interplay between your anal muscles and universal human emotions.

Your challenge will be to observe how your anus responds in a variety of situations throughout the day. Not only will you discover that your anus reflects whatever you're feeling, but also that your level of anal relaxation has a strong effect on how you feel; it works both ways. People often ask if anal tension and discomfort is a physical problem or all in their minds. The answer, of course, is always the same: *both*. Body and mind, anus and emotions, are in constant interrelationship. The more you learn about this fundamental truth the greater will be your capacity for anal pleasure and health.

Stress and Anal Tension

In order to understand the connection between the anus and emo-

tions you need a clear picture of how you, as a total organism, prepare to meet threats to your survival and well-being. Suppose you're confronted by a very real external danger, such as a violent person or dangerous animal. Instantly, without any conscious planning whatsoever—there's no time for that!—your entire being prepares to confront or escape from the danger. Blood rushes to your vital organs, particularly the heart and lungs, which begin working feverishly.

Blood rushes away from the surface of your skin, which is why you tend to feel cold and clammy when threatened. Tactile sensitivity drops, reducing the possibility of being distracted by pain if a confrontation occurs. Muscles tighten to provide a rigid armor against attack. Breathing, restricted by the tense muscles, becomes shallow and quick. Adrenaline flows. Your entire being is in the highest state of alert. These reactions are part of a comprehensive stress response linking mind and body in absolute unity.

In such extreme situations your innate tendency is to defecate, thereby unloading unnecessary weight to aid in escape or battle. Animals and human infants exhibit this spontaneous defecation reaction to severe threat, but we soon learn that this response is inappropriate. Therefore, when adults are under high stress our natural response is to rigidify our anuses in an effort to counteract the urge to defecate. This is why most of us associate a tense anus with fear.

Although extreme situations like this are relatively rare, our lives are full of less serious threats, all of which produce similar stress responses to a greater or lesser degree. In civilized society many of our stress reactions are to internal threats. These are specific fears ("I'm going to lose my job, get laughed at, or rejected.") or general anxieties ("I'm not the person I should be; I'm inadequate.") Most of these worries are about what might happen in the future. How often do you imagine potentially frightening or distressing situations that never actually materialize?

It is crucial to realize that imagined threats—no matter how irrational or unlikely—can produce the same stress responses as an attack by a wild animal. To dismiss these internal threats as all-in-the-head is to misunderstand the fact that your body takes *all* threats seriously, whether

internal or external, imagined or real, and responds accordingly. See-
ing the problem as in-the-head ignores another important process.
Just as fear makes your body tense up, the opposite is equally true:
When your body is tense you feel afraid. The anxieties of living are in-
your-body just as much as in-your-head. When you feel less stirred up
your body will relax—unless it's forgotten how. Conversely, if your
body relaxes you'll feel less anxious.

Most of us are under at least moderate stress much of the time.
We're worried about problems, insecure about the future, afraid of
losses, humiliations, and rejections. In addition, our bodies retain
accumulated tension from painful, frightening, and anger-produc-
ing events from long ago. On top of that, each time we can't or won't
express negative emotions, a small residue of tension is held in cer-
tain muscles until we find some way to release it—which we can't
always do. And all of us must cope with new stresses even in the
course of relatively uneventful days. No matter how much we may
hate it, this is how it is to be human.

When severely threatened we're tense all over. Yet all of us have
preferred places in our bodies where the fears, hurts, and worries of
life are most readily expressed in muscular tension. In our hypersen-
sitive *tension zones* old fears and hurts linger and fester. Usually these
pesky pockets of tension don't command our attention unless we're
unusually anxious or angry. Then we notice a pain in the neck, back,
shoulders, head, eyes, jaw, or anus—depending on where we habitu-
ally store and express psychic distress.

Particular tension zones tend to run in families. Parents commu-
nicate their tension habits to their children through subtle verbal
communication and body language. If mom or dad focuses stress in a
certain area the kids are likely to do the same.

The anus is an extremely popular tension zone, though the inten-
sity and consistency of anal tension varies tremendously from person
to person. There are two basic possibilities. First, maybe your anus is
fairly relaxed most of the time except when you're threatened by
specific worries or dangers. In other words, your anus may tense up
sometimes but it's *not* one of your chronic tension centers. The sec-

ond possibility is that your anus *is* one of your tension zones; it clenches tightly in reaction to even minor anxieties and insecurities of today and also holds onto the ones from the past. If this is true for you then your anus is a chronic tension zone.

Among my clients well over half discover that their anuses are habitual tension centers. Others may chronically store tension elsewhere, but not especially in their anuses. These people become anally tense only when they're stressed all over or when they feel unusually threatened anally—as when someone tries to initiate anal intercourse with them when they're not ready.

Chronic anal tension makes the anus vulnerable not only to unpleasant sensations but to a variety of health problems as well. Among my clients virtually all those with anal medical problems (except sexually transmitted diseases) are among those whose anuses are chronic tension zones. Rarely have I seen a case of hemorrhoids which wasn't at least strongly aggravated by chronic anal tension. The same can be said for constipation, fissures (small tears or scrapes in the anus or rectum), or even "Irritable Bowel Syndrome."

Since chronic anal tension greatly limits your potential for pleasure and makes you more susceptible to medical problems, you've got a lot to gain by learning more about your anal tension patterns. The best method is non-judgmental self-observation. The practice is deceptively simple: Whenever you notice tension just become as aware of it as possible. Don't bother trying to relax; this rarely works and often makes it much worse. However, if you allow yourself to become completely aware of tension it will begin to dissolve without any struggle or effort. You can see for yourself how this works in your own body.

Experience

Sit or recline quietly and comfortably. Close your eyes and let your attention drift down toward your anus. Can you tell how tense or relaxed it is? If you don't feel much of anything do a few pelvic muscle contrac-

tions until your conscious mind begins to register some sensations.

Now notice your breathing. Are you holding it? Is it shallow or deep and slow? Let your breathing become deep, so that your stomach and chest expand as you inhale. Then exhale completely. Notice your anus again. It will probably feel more relaxed than before.

Inhale deeply, hold your breath for a few seconds, and make your anus as tense as you possibly can—then let it relax as you exhale. Develop a clear image of your anal muscles and picture them as you exhale. As the muscles relax, picture blood flowing into the area, bringing warmth. Try a few of these tense-relax cycles and observe the results.

For at least a week or two, take a few moments many times each day to notice your anus. You may want to do this in conjunction with pelvic exercises. Make a point of noticing your anus before, during, and after you exercise.

The next time you're in an anxious or irritating situation—such as waiting in line, driving, having an argument, or feeling frustrated—observe your anus. Take a few moments to breathe deeply and notice what happens. Don't struggle at all to change anything. It will help you to make the most of your observations if you carry a notebook with you, although this is optional. Each time you notice your anus note the day and time and whether your anus is tense, relaxed, in-between, or numb.

At first you may not be sure whether your anus is tense or relaxed. But as you focus on it regularly at different times and in different situations you'll be increasingly able to identify subtle variations in your anal muscles.

Response

These self-observation experiments may sound so undramatic, maybe even silly, that you may be tempted to neglect them. But make no mistake about it, these may well be the most important experiments you will conduct. If you expect to enjoy your anus during sensual or

sexual activities and ignore it the rest of the time, you probably won't get very far—especially if your anus is a chronic tension zone.

If you do take time to observe your anus in a variety of different moods and situations you can learn a tremendous amount. First, you'll notice that your anus does get tense—probably *very* tense—when you're upset, angry, or afraid. It is important to realize that this will happen no matter how familiar you become with your anus, or how relaxed your anus typically is. To expect your anus not to get tense under stressful circumstances is to expect your body to abandon part of its basic mechanism for meeting danger.

What if you don't feel particularly upset or afraid and your anus is still tense? One possibility is that you are really having strong feelings but denying them. Your body doesn't lie or rationalize. Maybe your anus is expressing something of which you need to be aware. This is what Jane discovered:

> My boyfriend and I were having one of our 'discussions' the other night. He doesn't like to fight and neither do I. So we discuss. For some reason, I couldn't deny that my anus was tight, real tight—so tight it was hurting. And I realized I was furious. I wanted to strangle him! He was making me so mad but we were just *discussing*. Well, I decided I was going to let him have it—to hell with discussing. We were both really scared but we survived. And my anus felt much more relaxed afterwards.

People like Jane, who hate to get angry, often have an angry body. Your anus can tell you things about your emotions—kind of an early warning system—especially when you're trying to avoid them.

Maybe you're not holding back emotions yet you're *still* tense. Then there's a good chance that your anus is one of your chronic tension zones. Perhaps you've collected old hurts or anger from the past and stored them in your anus. Or maybe you've learned to keep your anus tight to prevent yourself from feeling too much pleasure. You don't have to uncover all the reasons in order to start changing. The key is simply to observe your anus. As you pay more attention you'll gradually release that festering bundle of tension and become more relaxed and open.

This release doesn't usually happen all at once, although it is quite possible to feel the good feelings associated with relaxed muscles after just a few moments of paying attention and deep breathing. This will motivate you to go on. For a while, perhaps a long while, your anus will revert to its familiar tense state. If your anus has been a chronic tension zone you've developed a predilection that will require considerable time and attention to modify. And keep in mind that pressure or coercion of any kind only multiplies the tension.

If you're a person who struggles with things, who sees a problem and wants immediately to tackle it, you may find this a frustrating situation. In fact, your tendency to struggle and push yourself may be a central reason why your anus is so tight to begin with. For strugglers everything has the flavor of battle and their anuses are always prepared for a confrontation. Maybe you don't see yourself as a struggler, but rather a perfectionist. It may sound a little better but the dynamics are the same. I don't mean to sound pessimistic, but if you demand a perfectly relaxed anus tomorrow morning, then you'll probably never have one. If your anus feels just a little more relaxed now than it did yesterday, you're doing just fine. Even if your anus isn't any more relaxed, but you're a little more aware that it's not, you're still on the right track.

If your anus is relatively relaxed except in certain stressful situations, consider yourself lucky. At least you don't need to grapple with an entrenched muscular pattern. Nonetheless, you can still benefit from considering what, exactly, your relaxed anus feels like. Feeling *nothing* in your anus doesn't mean you're relaxed—quite the contrary. When relaxed your anus will feel pleasantly alive and healthy. If you're not enjoying these sensations, or if you're not as in tune with your anus as with other parts of your body, then you have much to gain from continuing the self-observation.

Depending on the extent to which your anus has become a repository for excess tension, several factors may make changing the situation difficult. The first is the prohibition against anal awareness and pleasure, which is rampant in our society. Then there's the widespread belief, especially among men, that anal exploration is a sign of homosexuality

and thus to be carefully avoided (more on this in Chapter 10).

Yet another factor can cause you to avoid anal awareness: If your anus has been ultra tense for a very long time, the first thing you may notice is how much it hurts. If this happens to you, it's important to pay attention to your anal pain in spite of an inclination to tune it out. Take warm baths. Breathe deeply. Stroke your anus gently. And soon your pain will subside. If it doesn't, or if you suspect a medical problem, find a good physician and get a checkup.

If you encounter pain you may feel angry at your anus for causing you distress. Don't deny that anger; it's a natural response to pain. If you can express the anger—at least to yourself—you'll be better able to let it go. This exchange from one of my group sessions illustrates this point:

Dan: Last night I realized I always hated my anus. It was dirty and smelly. When I called someone an "asshole" that was the lowest of the low in my book. Yesterday I was feeling all the pain in my ass and hating the damn thing even more.

Leader: What did you do?

Dan: What could I do? I don't know how long it went on but a friend walked by my desk and said, "What's wrong with you?"

Leader: You and your anus were having a closer relationship at that moment than you probably ever had.

Dan: How do you mean?

Leader: You were feeling your anus, reacting to it instead of ignoring it.

Dan: I sure was feeling it!

Leader: What happened next?

Dan: Well, when I got home from work, I took a long bath and looked at it. I didn't like what I saw but, believe it or not, I felt sorry for my butthole. It was hurting me because I had neglected it. I could see how raw and red it was. I felt like apologizing to it. Pretty crazy, huh?

Group Member: You made up after a big fight. (Group laughs.)

Leader: Things may never be the same between you again.

Dan: I sure as hell hope not!

Dan's discovery came after several weeks of avoiding and, it turned out, resenting his anus. He couldn't feel genuine compassion for himself and his hurting anus until he actually felt the pain. The moral of the story: If you try to make your anus relax without first feeling it, very little is going to happen.

Increased awareness of your anal muscles and their response to emotions may be a catalyst for a global evaluation of the effects of stress on your body and what you might do to promote relaxation. A stress reduction program should include at least a half-hour of vigorous physical exercise such as jogging, brisk walking, swimming, bicycling or dancing several times a week. Weightlifting and other body-building activities are good but they don't result in the sustained heart rate required for optimum stress reduction. The benefits of exercise will be even more noticeable if you add at least one fifteen-minute period daily for practicing the relaxation technique of your choice.*

As you pay more attention to your anus throughout the day, see how it reflects and influences your emotions, and learn to release some of the tension collected there, you can turn your attention to what happens to your anal muscles when you're in a sexual situation. One enlightening approach is to recall certain experiences from the past. In the context of your present awareness, the past can be re-experienced from a fresh perspective. Don't worry if you haven't had any anal experiences to remember. You can easily use your imagination to guide you through the exercise.

Experience

Find a private, quiet place to sit comfortably, wearing loose-fitting

* Almost any technique can work if you use it consistently. Consider meditation, self-hypnosis, or a progressive muscle relaxation sequence. You might field test several techniques and focus on those with the greatest appeal and effectiveness. *The Relaxation and Stress Reduction Workbook* (Davis, et al., 4th Ed.) offers concise guidance for virtually all popular methods.

clothes or none at all. Close your eyes and breathe deeply and slowly as you become increasingly attuned to your anus. The pace of your awareness doesn't matter. Simply notice how your anus feels at this moment in time. You might want to place your finger on your anus to help you focus. Gently stroking your anus also helps.

Now recall at least one sexual encounter where a partner made any kind of tactile contact with your anus. Remember the specific behaviors and feelings in as much detail as possible. If a sexual partner has never touched your anus, imagine what it might be like if he or she did.

See if you can recall or imagine this experience from the standpoint of how your anus responded to being touched by a partner. Were you afraid, apprehensive, open, excited? Return your attention to the present and see how your anus is feeling right now. Has it tensed up a little, or is it still relaxed? If you notice any increase in tension, take a few deep breaths until it is relaxed again.

Next, recall or imagine a sexual experience where your partner inserted a finger into your anus. What did you feel as your partner's finger entered your anus? Did your anal sphincters tighten up or let go? Did you feel safe or insecure? Were the sensations pleasant or uncomfortable? When you are ready, return to the present and notice your anus. If you notice tension, breathe until you're relaxed once more.

Now recall or imagine a time a partner wanted to have, or actually had, anal intercourse with you. Go over every detail in your mind. If you don't ever want to receive anal intercourse or find the idea distasteful, then there's no need to picture it unless you're curious. Fantasizing about something doesn't necessarily mean you want to do it. On the other hand, if you've had more than one experience with anal intercourse, recall those you enjoyed as well as those you didn't. Remember them as your anus remembers them. Return to your anus in the present and see how it feels. Write your reactions in your journal while they're still fresh.

Response

The key to this exercise is to re-experience past or imagined events while remaining aware of your anus now. One thing you'll discover is that your body remembers; memories, both pleasant and painful, are retained in your body as well as in your mind. This is why suppressing memories of painful anal experiences will not relieve the tension. Only new, more positive experiences can do that.

With this in mind, ask yourself what factors contributed to any uncomfortable anal experiences you've had or imagined. Obviously, these are the things you will want to prevent from occurring in the future. Here are some common responses. Do any have a bearing on your experiences?

- I didn't know what was going on. My partner just tried it without telling me what he or she was doing.
- I didn't know anything about anal sex and felt that it was dangerous, dirty or perverted.
- My partner was insensitive and rough.
- I was afraid to say "no."
- I put my partner's pleasure ahead of my own comfort.
- I felt vulnerable, like I was being violated or used.
- I was angry but afraid to let it show.
- I felt I should be able to do it and didn't want to say that I was afraid.

As you consider the effects of these and other factors on your anal muscles, you'll realize that during every negative experience you were essentially out of communication with, or not taking care of, your anus. To be in communication with your anus is to listen and respond to the neuromuscular messages it gives you.

Often awareness is the missing link in unpleasant anal experiences. Maybe you didn't realize how tense your anus was—until you felt the discomfort. It is common for people to be aware that their anuses are tense but to decide (or let their partner decide) to go ahead anyway. Here the missing link is action; not taking concrete steps to protect yourself.

I always ask people how they would have liked their painful anal experiences to have been different. Usually the response is something like, "I wish I could have just relaxed and enjoyed it!" This is understandable enough but let's take a closer look. Here's a loose but probably accurate translation: "I wish my anus had felt differently than it actually did so that I wouldn't have had to deal with it." Fantasizing ideal, automatic solutions to anal discomfort is often part of the problem. Whenever you expect your anus to accept stimulation whether it feels good or not, you generate enormous inner conflict. If you leave your anus to fend for itself it will struggle valiantly by clenching more and more fiercely—until you get the message.

This is an appropriate point to challenge one of the most widely held and destructive myths about the insertion of a finger, object, or penis into the anus: that a certain amount of pain is an inevitable part of anal sex, particularly at first, and that if a person is willing to endure this pain it will soon subside, making the experience more pleasurable. When you approach anal sex with this expectation, here's what happens: Your anus is tense from habit or current anxiety but you decide to go ahead anyway. Your anal muscles resist with all the force they can muster to repel the unwanted invasion. Eventually the muscles collapse; they can fight no more. Then, if no physical damage has been done (there sometimes is damage) the pain goes away. The result is usually not pleasure so much as neutral toleration.

Once you set up this drama, it usually has to be repeated again and again. Your anus will never feel totally at ease in sexual situations. You will remain alienated from your anus until communication (awareness and protective action) is restored. The unmistakable difference between genuine anal pleasure and neutral toleration is reported universally by men and women once they give up the use of force and commit themselves anew to a no-pain-ever policy.

Obviously, you can also learn a great deal from positive anal experiences you've had or imagined. What made these experiences so good? Here are some typical responses:

• I was in a good mood and feeling relaxed.

• My partner was sensitive and spent a lot of time touching my anus.

- I trusted that my partner would never deliberately hurt me.
- Our encounter was slow and sensual.
- We would have had a good time with or without anal sex.

Your list may contain other items. If you look closely at your positive anal experiences you'll no doubt find that you were playing with your anus rather than working against it.

It's not unusual for enjoyable anal experiences to happen unexpectedly. When this is the case, people come to feel that good anal experiences depend mostly on their partner, luck, or other factors beyond their control. If, however, you look closely at what made an experience pleasurable, you'll discover that each experience was affected by *your* behavior, whether active or passive. To a significant degree, this is also true of the negative experiences.

Later we'll focus on how to bring this understanding into future anal experiences with a partner by actively fostering the conditions necessary for maximum pleasure. For now it's enough to embrace the realization that your anus is never simply a passive receptacle for sex, but rather a full participant in a richly emotional and dynamic event.

7

Inside the Anus
Learning Voluntary Muscle Control

A s YOU HAVE SEEN, awareness of what you're *actually* experienc-
ing—not an idealized notion of perfection—is the essence of
all bodily enjoyment. If you remain attuned to yourself you can be-
gin to develop voluntary control over your anal muscles. This is not
an authoritarian "Do what I tell you!" type of control, but rather a
natural and easy flow between what you intend and how your anus
responds. In order to acquire this type of control you first need in-
formation about how your anal muscles work. Then you'll learn how
to use your finger as a sensitive probe to explore the interior land-
scape of your anus.

Anatomy and Physiology of the Anal Canal

The anal canal is a tube-shaped entryway, less than an inch long,
which leads into your rectum. The outer two-thirds of the anal canal
is made of the same soft, sensitive tissue that is visible around the
opening. The inner third of the anal canal is lined with mucous mem-
brane. This part of the canal is less sensitive to touch than the outer
two-thirds, but is very sensitive to pressure. Depending on whether
it is wanted, pressure can produce either relaxation or tightening of

the surrounding muscles.

The folds of anal tissue give the anal canal a striking capacity for expansion, which varies tremendously according to personal preference, degree of relaxation, amount of practice, and other circumstances. For example, during rectal surgery, under anesthesia, a person's anal muscles can easily be dilated so that the surgeon's entire hand can pass through the anal canal.

In the erotic realm a similar expansiveness is called upon in the activity known as "fisting" or "handballing," which involves inserting several fingers or an entire hand into the anus and rectum. Although hardly a mainstream form of sex play, anal fisting is more popular than most people realize (more on fisting in Chapter 9). These extremes of anal expansion are not experienced by most people, but they do illustrate that anal tissue can easily and safely accommodate a finger, object, or penis.

Below the surface of the anal mucosa, veins and arteries pass blood through cavernous (filled with spaces) columns of tissue called *anal cushions*. There are three of these cushions running the short length of the anal canal. The cushions are anchored by connective tissue and muscle fibers to the internal sphincter muscle. Within the anal cushions, blood passes from arteries to veins without any capillaries—the tiniest of blood vessels that usually connect arteries and veins. As a result, blood flows with extreme ease through the anal cushions.

During a healthy bowel movement or during the insertion of something into the anal canal, the anal sphincters relax, allowing some blood to leave the cushions. However, if the sphincters are not relaxed, the anal cushions remain congested with blood. This is what happens when a person strains to force a bowel movement or uses force to insert something into the anal canal. The result is an uncomfortable stinging sensation or other pain. If such straining or forcing happens on a regular basis, a variety of medical problems such as hemorrhoids (protrusions from the anal cushions) or fissures (tears or cracks in the anal lining) can result. To prevent or eliminate this discomfort and the possibility of damage, it's necessary to understand how the two anal sphincter muscles work.

The anal canal maintains its tubular shape because of two ring-like sphincter muscles (see Figure 3). The sphincters are very close together, overlapping somewhat, and are quite capable of functioning independently, which they often do. The *external sphincter* is closest to the anal opening and is controlled by the central nervous system, the same system that activates muscles in the hands, arms, or legs. With a little concentration, we can make the external sphincter tense or relax at will—just as we move our fingers whenever we want.

The *internal sphincter* is quite different. It is neurologically controlled by the autonomic nervous system, the same system that makes adjustments in blood pressure, respiration rate and other "involuntary" body functions. Because the internal sphincter normally functions reflexively, most people can't tense or relax it at will.

When feces pass from the colon into the rectum, the pressure of fullness triggers the *rectal reflex*. This involves the automatic relaxation of the internal sphincter and a partial draining of blood from the anal cushions. Then the voluntary relaxation of the external sphincter allows for a quick and easy bowel movement.

Three factors can and often do disrupt this course of events. First, many people have been taught to ignore the urge for defecation caused by the rectal reflex. Instead they hold back, not wanting to be bothered going to the toilet. Perhaps they believe that bowel movements ought to occur only at certain predetermined times—a notion fostered by over-strict toilet training practices. When it's consistently ignored or overridden, the rectal reflex fades and the internal sphincter stops relaxing. Once this has occurred, almost every bowel movement requires pushing and straining. Any person who wants a healthy and relaxed anus must learn to pay attention to the rectal reflex. Gradually, the natural urges it produces will again become strong.

Another factor that can inhibit the rectal reflex is the common habit of resisting the passage of intestinal gases (flatus) through the anal opening. Gases are naturally formed during food digestion. And obsessive attempts to avoid farting inevitably result in unnecessary and potentially destructive muscle tension. Certainly most of us pre-

fer to exercise some control over the timing of our farts. However, it is a mistake to adopt an always-hold-it policy.

The third, and perhaps most important, factor that disrupts relaxation of the internal sphincter during bowel movements is the absence of adequate fiber in our diet, and thus in our stools. Feces should be soft yet well-formed and bulky. Small, hard feces don't provide the fullness necessary to trigger the rectal reflex. Once again, the person must resort to straining whenever bowel movements are attempted.

If your stools are not large, well-formed and slightly moist, your goal of anal awareness, pleasure and health will be very difficult to reach unless you add significant quantities of fiber to your diet every day. With adequate fiber your rectal reflex can be triggered more easily. This will help you immensely in learning how to relax your internal sphincter muscle. The best sources of fiber are whole grains, legumes (beans and peas), nuts, some fresh fruits, and vegetables. Fiber preparations such as Metamucil can also be taken as a supplement.

The ease with which you have bowel movements and the pleasure you receive from anal stimuli will be greatly enhanced if you learn how to voluntarily relax the internal sphincter. How can a person learn voluntary control over an "involuntary" body process? That such control is possible at all still isn't widely recognized in the West. In the East, practitioners of healing methods such as yoga and acupuncture have focused on this possibility for centuries. In the West, the turning point was the development of biofeedback, which involves the use of mechanical or electronic devices to provide a person with visual or auditory information about what the body is doing. Put simply, it has been found that if a person can get clear, immediate feedback (such as a changing tone or flashing light) about some "involuntary" body function (such as blood pressure, brain waves, or skin temperature), before long he or she will be able noticeably to influence that function just by paying attention to it.

The key to voluntary control of the sphincter muscles, particularly the internal one, is a steady, accurate stream of information about what the muscle is doing. Happily, no electronic instruments are needed to provide this information. Your body is already equipped

Figure 3. Internal and External Anal Sphincter Muscles

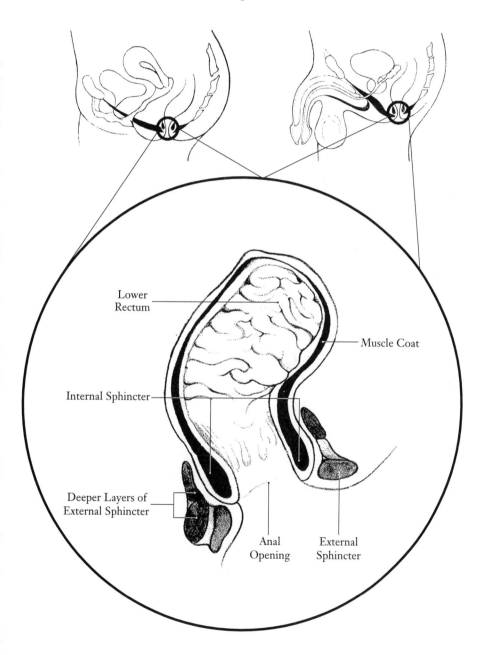

Lower
Rectum

Muscle Coat

Internal Sphincter

Deeper Layers of
External Sphincter

Anal
Opening

External
Sphincter

with a supersensitive biofeedback device that you can use at any moment—your finger. By inserting a finger into your anal canal, locating the two sphincters, and paying attention to the information your finger provides, you can learn to relax the muscles at will.

Before you begin to explore inside your anus, you should know that your anal canal and rectum normally contain little if any feces. Your rectum and anal canal are merely passageways for feces which, during a bowel movement, are moved by muscular waves called *peristalsis* out of the colon and into the rectum and out through the anal canal. Feces are not normally stored in the rectum for long periods of time. However, those who have learned to ignore the rectal reflex or whose feces are not well-formed are much more likely to encounter feces in the lower rectum, a situation that can be remedied by changes in diet and toilet habits.

Bathing is usually adequate for cleaning this area, especially when you learn to feel comfortable putting your finger in your anus as part of bathing or showering. If, however, you are concerned about cleanliness, you might want to give yourself an anal douche.

Anal Douching (Enemas)

Giving yourself an enema involves introducing liquid into the anal canal and lower rectum, holding that liquid inside for a few minutes, and then releasing it. Most people use enemas for initiating bowel movements, which isn't very helpful most of the time. Unfortunately, some children are forced to submit to enemas as "treatment"—more like punishment—for constipation. The regular use of enemas for initiating bowel movements is not a good idea because this can ruin a person's ability to have bowel movements naturally. And enemas containing harsh chemicals can be irritants, creating even more discomfort.

While it's smart to stay away from chemical enemas, using plain water enemas solely for the purpose of cleaning the anus and lower rectum is harmless. Many people find that the feeling of cleanliness that results helps them relax because they're no longer concerned

about encountering feces during anal play. The term anal douching is more accurate because it avoids the connotation of enemas as a treatment for constipation. The sole purpose of douching is to promote cleanliness and comfort.

There are four basic means of anal douching. First, you can buy a disposable "Fleet" enema at the drugstore. It comes in a plastic bottle with a lubricated tip for insertion into the anus. Just empty out the unnecessary chemical solution and fill the container with warm water. It can be used over and over again as long as the tip is thoroughly cleaned after each use. Second, you can get a rubber bulb-shaped "ear syringe" sold in drugstores for gently cleaning the inner ear. Both of these methods will introduce a relatively small amount of water into the lower rectum. For many people, though, it's just the right amount. (Some people use a plastic turkey baster with a rubber bulb, but this is too hard and often has rough edges and seams, so I don't recommend it.)

For those who wish to introduce water farther into the rectum, a third alternative is a rubber bag with a hose, a clip to regulate water flow, and a rounded tip designed for vaginal douching. The bag is suspended above the user so that the water flows easily via gravity. Finally, several products specifically designed for anal douching can be permanently installed between the water supply and the shower head. These can be quite convenient for regular users, but they must be used with very low water pressure. Water temperature must also be carefully monitored—not too hot!

Some people enjoy the process of anal douching whereas others merely tolerate it as a practical means to an end. Others have a visceral negative reaction to douching. In some instances the douche is a reminder of invasive and traumatic childhood enemas. Sometimes the sensations simply aren't pleasant, no matter what the reason. The bottom line: If anal douching makes you uncomfortable, don't do it. A high-fiber diet, combined with inserting your finger in your anus while showering, can provide perfectly adequate cleanliness.

Lubrication

The inner portion of the anal canal produces mucus to keep the tissues moist and protected, but anal mucus is not the same as the plentiful lubrication secreted by the vagina. For this reason, extra lubrication should always be applied when you insert your finger or anything else into the anus.

Talking to anal enthusiasts about lubricants is like talking to wine connoisseurs about wine—everybody has a different opinion about which is best. You have to decide this for yourself. A few guiding principles, however, are helpful. First, use a lubricant with as few chemical additives as possible. Your anus and rectum are not accustomed to a steady assault of harsh chemicals as is the rest of your body. Scents, colors and emollients are all chemicals that can irritate anal tissues. Second, lotions and creams don't lubricate well because they're quickly absorbed. Water-soluble lubricants are good because they clean up easily. For this reason they are the most convenient for anal exploring with your finger. And they're essential if you'll be using a latex condom, because oils or oil-based lubes destroy latex.

If you decide to try more prolonged anal stimulation, then greasy or oily lubricants have an advantage because they last longer. Vegetable shortening, safflower or peanut oil, petroleum jelly, or virtually any of the newer commercial erotic lubricants are all fine. It's a matter of personal preference. Water-soluble lubricants should probably be the only ones used in the vagina (if extra lubrication is desired or needed) because the vagina is a cul-de-sac from which heavy lubricants like petroleum jelly are difficult to wash out.

Experience

Begin with bathing and anal looking and touching, which I hope you have tried many times by now. In preparation, make sure your fingernails are trimmed and filed smooth. Apply a small amount of lubricant to your anal opening and to whichever finger seems most comfortable.

Inhale deeply, contract your anal muscles, and gently press your finger against your anus. As you exhale, let your anal muscles relax until your finger slides easily into your anal canal. Use no more than a gentle pressure. Go in only as far as feels completely comfortable—a quarter of an inch at first is fine. If you feel discomfort or pain it means that you are pushing too hard and should back off on the pressure.

When your finger is as far into your anus as it will comfortably go, stop there and let your anal muscles get used to the presence of your finger. Your anus will relax even more as it discovers this is not an invasion, but a friendly expedition. Be sure to keep breathing deeply and slowly. Feel the relaxation but don't push your finger in any further. Stay at this comfort point for as long as you want and then slide your finger out slowly and sensuously.

Each time you repeat this exercise you'll discover that your finger comfortably goes in a little further. At each step spend a few minutes moving your finger at a leisurely pace in a circular motion. Stop *before* you feel uncomfortable or bored.

Experiment with moving your finger in and out, back and forth, and around in a circle. Never push beyond your personal comfort zone. Do only what your anus will accept without protest. If you realize you've gone too far or too fast, back off a little. But don't pull out completely—and definitely avoid pulling out rapidly. Jerky movements tend to make your anus even more tense.

When you can move your finger around freely, slowly pull it out so that only the tip is inside your anal canal (about one half to three quarters of an inch). Gently press against the walls of the anal canal. You'll be able to distinguish your external and internal sphincter muscles as two separate rings with a small space between them (less than a quarter of an inch). The external one will probably feel more relaxed than the internal one. Notice how you can tense and relax the external sphincter at will, while the internal one seems to have a mind of its own.

Also notice that the internal sphincter frequently changes spontaneously, tensing up a little and then relaxing a little. The most beneficial thing you can do is simply pay attention. When your internal

sphincter relaxes, say to yourself, "Relax, relax." When it starts to tense up again, say, "Tense, tense." Just describe what's happening without trying to control it.

Spend a few minutes as regularly as possible doing this simple exercise. Why not make it a part of daily bathing or showering? Gradually—there's no hurry—you'll find that saying or thinking "Relax, relax" affects your internal sphincter. But whenever your sphincter ignores relaxed thoughts and tenses up anyway, don't fight it; just repeat, "Tense, tense." You are building a vital link between your thoughts and your anal muscles. The stronger this linkage becomes, the greater will be your capacity for anal pleasure.

As a sense of influence over your anal muscles increases, you'll quite easily be able to insert two fingers at a time, or even three if you'd like. The key is to continue using the same unhurried, pressure-free approach. If you push beyond your comfort zone, your anus will let you know with an obvious contraction—or even a jolting spasm.

Try a variation of this exercise the next time you feel the urge for a bowel movement. Remember, if you have learned to ignore these natural urges, your first challenge is to detect the signals that your body is ready to defecate. As soon as you feel the urge, go to the bathroom. Once on the toilet, breathe deeply and picture your anal muscles relaxing. Allow the muscles of your colon and rectum to expel the feces reflexively and effortlessly—no straining whatsoever. If nothing happens, don't push. Simply leave the bathroom and return again when your body signals its readiness.

Response

Exploring inside your anus can be a turning point in your desire for anal enjoyment. But keep in mind that if your anus has been abused in the past, whether through painful sexual experiences or straining during bowel movements, it may take your anus a while to trust the presence of your finger. Patience invites ease, whereas forcing generates tension.

Once inside even a little you'll probably encounter new sensations. Some will be pleasurable while others may feel rather strange. When you experience a new sensation you may automatically assume that it's uncomfortable and pull your finger out right away. This, of course, is exactly what to do if you really do feel discomfort. But take a moment to ask yourself, "Is this new sensation actually uncomfortable, or just *different?*" If it's merely unfamiliar, but not especially uncomfortable, then you can leave your finger inside for a while as you relax and familiarize yourself with the new feeling.

Exploring your anal canal sometimes triggers memories and pent-up emotions. Of course you may recall positive moments of anal pleasure, such as a particularly relieving bowel movement or memorable experiences of touch. But if you've had negative anal experiences in the past—anal medical problems or unwanted anal intercourse, for example—then leisurely finger insertions may remind you of what you'd probably rather forget. Ultimately you'll do yourself an important service by paying close attention to any and all feelings or memories, whether positive or negative. An open examination of your personal truth can, as they say, make you free. It helps if you write your responses in your journal after each session, or at least sit back quietly and think about them.

Also pay attention to any signs of resistance, such as forgetting to do the exercises, never finding the time, or doing something else when you had intended to touch your anus. There are always legitimate and understandable fears behind strong avoidance, fears which need to be brought to light and honored.

Beth made this important discovery:

I've been having a heck of a time getting anywhere near my anus until the other day when I was just sitting there and it struck me like an 'aha' kind of thing. I suddenly realized I feel exactly the same way about my anus that I used to feel about my vagina during my period, like I have a disgusting and shameful wound, or that it's sick or diseased, or God knows what; it's certainly not rational. It's just not right to put my finger into an open wound—way too yucky. I guess all these years I've been waiting for my anus to heal or something. After I

thought about this connection for a while, I actually tried my finger and it went in pretty easily. I can't say I'm exactly thrilled about it but—this is embarrassing—I was relieved to find no blood.

Pete's recollection was quite different:

I've always hated fingers in my ass. Every time a guy has tried to put his finger anywhere near there I've braced myself to get fucked any minute. My asshole reacts the same way to my own finger. It's like I'm getting ready to be raped. I now can see I've been more or less raped several times but I just silently went along with it. No wonder my ass is so clenched; it's an angry fist. And, you know, I don't blame it one bit.

As you saw in the last chapter, your anus has a memory (it shares yours). However, most people find that the anus does not hold a grudge. Instead, it will respond to a new situation if you patiently and compassionately give it a chance. Once your anal muscles start to respond to your own caring touch, progress is usually rapid. You can then begin to "train" your internal sphincter, not with intimidation, but with understanding. Under coercion of any kind, your anus will automatically assume its instinctive protective posture.

Learning a more natural approach to bowel movements can also increase your capacity for anal pleasure and dramatically reduce the negative effects of chronic straining. To the extent that you usually push your way through a bowel movement, undoing this habit will require special attention. A well-functioning rectal reflex, a diet rich in fiber, and reduced sphincter tension should result in bowel movements being completed within a few minutes. The need for a lot more time strongly suggests that your natural responses are still inhibited.

Modifying the ways in which you have bowel movements can be more complex than you might expect. For instance, rigid toilet training can be a source of great embarrassment, fear and anger. This is especially true when parents believe that anal muscular control can only be fostered by threats of ridicule and coercion. Actually, there's no reason why anal control shouldn't occur as automatically as walking and talking. Depending on your experiences as a child, you may find that the reduction of anal over-control, and a return to a more natural elimination pattern, brings with it a rush of unexpected feel-

ings. Many people find themselves spontaneously crying when they first experience the cleansing release of an unforced bowel movement. There's often anger too: "Goddamn her," said Meg referring to her mother, "It's so easy! Why did she have to make it such a humiliating ordeal?"

It's not unusual to remember distant parental warnings of "accidents" if anal control is not maintained. If this is true for you, it may take a while to relinquish completely the conviction that chronic anal tension is the price that one must pay for controlling feces. It may require repeated reminding that excess tension serves no useful purpose. The innate tone of healthy muscles is all that is needed.

Although it often sounds silly to people at first, almost all my clients report that a quiet sense of joy accompanies relaxed bowel movements—those in which the body's finely-tuned system of elimination is allowed to function properly. This discovery, of course, is not silly at all. Similar experiences of joy usually accompany optimal functioning of any body system. Put simply, bodily health is inherently pleasurable and it normally produces an overall sense of well-being.

8

Anal Eroticism

Including the Anus in Masturbation

V IRTUALLY ANY FORM of anal stimulation has the potential of
becoming a turn-on. Thus far I haven't emphasized the erotic
aspects of anal exploration, partly because the subject carries such a
negative charge for so many people, and partly because a premature
focus on sex can easily divert us from more fundamental acts of self-
discovery—like those you've been pursuing in the previous chapters.

Now that you've absorbed a significant amount of information
about the anal area and conducted some first-hand experiments, I
hope that your comfort level is rising noticeably. If so, this is prob-
ably an appropriate time to consider the erotic potentials of your
anus and how—or whether—you want to develop them.

Sexual Response and the Anus

Sexual responses are highly individual. The details of what excites
you, the private and shared meaning of your turn-ons, and a host of
other conditions determine whether a particular sexual experience is
fulfilling. Yet in spite of the ultra-personal nature of eros, many of
your physiological responses are also experienced by most other
people. After all, our capacities for arousal and orgasm are part of

our most basic human heritage.

After observing about 600 men and women (ages 18–89) being sexual in the laboratory, sex research pioneers Masters and Johnson (1966) conceptualized sexual response as having four phases: excitement, plateau, orgasm and resolution. During each phase observable or measurable changes occur throughout the body, including the anus. These bodily changes are similar regardless of the kind of stimulation you're receiving or from whom—as long as it's working for you. Whether you're masturbating alone, making love with your spouse, or having casual sex with a stranger, your body responds pretty much the same way.

There is, however, tremendous variety in how arousal and orgasm are subjectively perceived by the person experiencing them. In addition, today's sex therapists are keenly aware that yet another phase—*desire*—is usually a prerequisite for all the others. With rare exceptions, a person must be interested, or at least willing, to participate in a sexual activity in order to have much of a response. This fact is especially important for those who expect their partners to be turned on by anal sex whether they want it or not; this simply isn't going to happen.

Becoming attuned to how your body changes during sex not only helps increase your enjoyment, it also expands the range of choices available to you during sex—such as adjusting the timing, rhythm, or intensity. I'm including what is known about what happens to the anus, rectum, and surrounding areas as excitement builds. Masters and Johnson made relatively superficial observations of the anus, as it was not of primary concern to them, and no other laboratory research has yet been done to fill the gap. Therefore, I'm also relying on information I've gathered over many years from extensive subjective reports from my clients. Keep in mind, though, that we're all notoriously—and appropriately—non-objective when sexually aroused.

Excitement

Sexual arousal is the body's natural response to effective erotic stimulation. This stimulation may be received via any of the five senses or

solely from our thoughts or fantasies. Whatever form the stimulation, it must be interpreted by the individual as erotic to trigger a sexual response.* The human mind can assign sexual significance to virtually any sensation or image. Conversely, stimulation that's highly erotic to one person may be downright boring to someone else. In general, humans appear to receive most erotic stimulation through the senses of touch and vision. But there's tremendous variation here with some people responding strongly to sounds, smells, or tastes.

Effective sexual stimulation affects the entire body. As excitement builds, respiration, heart rate and blood pressure increase. Through a process called *vasocongestion*, blood rushes to certain areas so that more blood is flowing into that area than out, resulting in engorgement. Vasocongestion is caused by the dilation (opening up) of arteries and tiny capillaries. Sexual response involves widespread vasocongestion, not just in the genitals. Extra blood also flows to the surface of the body, resulting in sensations of increased warmth, perspiration, or visible flushing on the face, neck, or chest.

During early excitement a wide variety of muscle groups—especially arms, legs, face, and the entire pelvic region—increase their tone noticeably as they collect erotic charge. This is process is called *myotonia*. Contracting muscles are responsible for the nipple erections experienced by virtually all women and at least one-third of men.

During sexual excitement there is usually a perceived increase in sensitivity to pleasurable touch and sometimes also a blunting of sensitivity to pain. In short, a wider range of stimulation feels good when we're aroused.

The most noticeable sign of excitement for men is erection—the result of vasocongestion—which may occur within a few seconds of any effective stimulation or more gradually, depending on each individual's response pattern as well as his age, level of arousal, and

* It is often assumed that people are conscious of the erotic significance various stimuli have for them. This is not always the case. Sometimes we don't think we're aroused when, in fact, our bodies are responding. Research suggests that such disparities between subjective and actual bodily arousal are much more common among women (Singer, 1984).

sense of comfort and safety. Erection occurs when the arteries that feed blood into the penis *relax*, allowing the cavernous bodies of absorbent tissue within the penis to fill with blood. At the same time the veins that are usually open close off, trapping blood and sustaining the erection. Contrary to still-popular myths, the capacity for erection is inborn and operates even before birth. No skill, learning, power or virility is required, and attempts to force an erection typically assure failure. Overemphasis on the meaning and importance of erections or insecurities about one's desirability or adequacy—in fact any worries about sexual performance—can easily inhibit erections.

In the early stages of excitement, erections are rather unstable and react even to small fluctuations in excitement, as well as to distractions. As excitement rises, erections become more stable. At the same time the scrotum thickens and contracts, becoming less "baggy," although this response is variable. Inside the scrotum, the testicles, suspended in part by the vas deferens (the tubes that carry sperm from the testes), begin to elevate.

The first genital response to sexual excitement in women is lubrication of the vagina through the vaginal walls—also caused by vasocongestion. Vaginal lubrication, sometimes seen as analogous to male ejaculation, actually corresponds to erection both with regard to physiology and timing. As arousal builds, the vaginal walls thicken and grow darker. The inner two-thirds of the vagina expand and lengthen. The outer and especially the inner lips darken and swell.

The clitoris becomes engorged with blood and grows somewhat larger. But the clitoral hood doesn't permit it to stand up like the penis. The uterus also grows larger and begins to lift up from its resting position.

In both men and women the anus is actively involved in the excitement phase. The anal tissues, rich with blood vessels and blood-absorbing spaces, become congested, resulting in a noticeable deepening in color. Usually moist from its mucus membranes, the inner anal canal may secrete even more. Perspiration around the anal canal also contributes to increased moisture. A few people become so moist that no extra lubrication is required even for anal inter-

course, although this is rarely the case. It is not known if the amount of anal secretion is related to how sexually excited the person is.

The anal sphincters start to twitch and contract in response to direct stimulation or in sympathy with other pelvic muscles. Just as men and women may contract their pelvic muscles voluntarily to enhance their arousal, voluntary contractions of the anal sphincters can also heighten pleasure. Many people enjoy the unique sensation of the anus contracting *against* something such as a finger, dildo, or penis.

Anal contractions during excitement should not be confused with chronic anal tension or with situational anal spasms caused by fear of anal penetration. These patterns of anal tension actually inhibit the spontaneous contractions of the anus during excitement. It has been almost universally reported to me that the range of anal muscular activity—contraction *and* relaxation—increases as arousal builds, especially for those whose anuses have become more relaxed generally. This observation needs further investigation because, as we have seen, anal relaxation goes along with anal awareness. It could be that people who report more muscular activity have simply become more self-aware. It also seems reasonable that anal awareness might motivate a person deliberately to relax and contract the anus for the sheer enjoyment of it.

Sensitivity to anal touch appears to increase during excitation, at least for those who like it. Within the anal muscles and nearby perineal muscles (between the genitals and anus) are a great many nerve endings that can be stimulated not only by contractions but also by external touch.

For a man, two additional sources of pleasure may become involved when a finger (his own or his partner's) is inserted into his anus. First, because the bulb of the penis is very close to the anus, internal stimulation can feel like masturbating from the inside. In addition, a finger, penis, vibrator or dildo can provide stimulation or massage of the prostate gland. The prostate can be stimulated by inserting a finger about three inches into the anus and lower rectum and moving the finger in the direction of the navel. Generally, the prostate can't easily be felt as a separate organ during early excite-

ment because it's soft like other organs in the vicinity. Some men find prostate stimulation to be extremely pleasurable. Others find it irritating. Poking the prostate rather than stroking it, however, is almost universally unpleasant.

Women have an area known as the G-spot—also called the "urethral sponge"—which is made of tissue similar to that of the prostate. Although the G-spot isn't a discrete organ, it surrounds the urethra and can be stimulated by massaging it through the top of the vaginal wall about two inches in. For some women G-spot stimulation results in a noticeable expulsion of fluid—anywhere from a little to a lot—out of the urethral opening during orgasm, similar to a man's ejaculation. Unlike the prostate, the G-spot cannot be effectively stimulated through the rectal wall because it's too far away. However, some women thoroughly enjoy rectal massage combined with G-spot stimulation via the vagina, usually with the help of a vibrator, dildo, or lover's finger. The only precaution necessary is to avoid using the same finger or object for rectal and vaginal insertion.

For some men, focused anal stimulation, especially internally, leads to a partial or total loss of erection. Some are concerned about this, others aren't. Sometimes erection loss is clearly a reflection of discomfort or fear, but not always. In fact, the man may be thoroughly enjoying himself. The mechanisms involved in this loss of erection are not understood, though it may simply mean that one's erotic attention has shifted from the penis to the anus. It is not known if, or how often, a similar phenomenon occurs among women.

Plateau

The plateau phase is a sustained high level of excitement that usually leads into orgasm within a few seconds or many minutes. Many people learn to extend plateau as long as possible with the help of deep breathing, partial relaxation of the pelvic muscles, and subtle adjustments to the rhythm and intensity of stimulation. Sometimes plateau is absent as a discrete phase, with building excitement leading directly to an orgasm. This pattern is typical of premature ejaculation in men and is less common in women.

During plateau, vasocongestion and myotonia are at a high level all over the body, although different body zones may be affected in different people. Rapid breathing is usually obvious. Some people naturally hold their breath for a few moments and then release it almost explosively.

In men the penis may become even more rigid as the glans, or head, enlarges and takes on a purplish hue. The testicles also enlarge and pull up closely against the body. The scrotum may be drawn up tightly, or may hang loosely with the testicles fully elevated inside. The tiny Cowper's glands secrete a small amount of clear fluid that may appear at the urethral opening, sometimes in sufficient enough quantities to dribble noticeably. Popularly called "pre-come," this fluid is not semen though it may contain sperm. Its function appears to be to prepare the penile urethra for the passage of sperm during ejaculation.

In women the outer third of the vagina congests with blood and forms the "orgasmic platform." Later, orgasmic contractions will be obvious here. The inner portion of the vagina expands still further. The uterus becomes fully elevated, contributing to a "tenting effect" of the inner vagina.

The clitoris retracts under its hood during plateau, particularly if stimulated directly. Full congestion of the inner lips results in a deeper color and signals an approaching orgasm. Vaginal lubrication may slow down or cease during plateau. But the Bartholin glands, like the male's Cowper's glands, secrete scantily, presumably to make the vagina more chemically hospitable for sperm.

The anus continues its irregular contractions during the plateau phase. If direct anal stimulation has been a part of the sexual play, many men and women report that the anus feels particularly receptive and open just prior to orgasm. Pelvic movements during intercourse or at other times appear to increase anal sensations for some people while others prefer to lie still and focus quietly on their intensifying responses.

Among men, erection loss while receiving anal stimulation seems to be less common during the plateau phase, although it still can

occur. Sometimes physical or emotional discomfort is a factor. For others, the anus is simply their primary erotic focus at the moment.

During plateau many men find their prostates to be particularly sensitive to stimulation through the wall of the lower rectum with a finger, object, or penis. In preparation for orgasm the prostate enlarges and becomes firm and lumpy rather than soft. At this point a man can use his finger to massage his own prostate and to feel its shape and movement.

Orgasm

Orgasm is the discharge of sexual tension through rhythmic, involuntary muscle contractions. It's a reflex and not subject to direct voluntary control. Orgasm can, however, be influenced by deliberate adjustments in stimulation, position, muscle tension or relaxation, and fantasies. Orgasms can be inhibited by trying too hard. In this way, orgasm is very similar to crying. One *allows* it to happen, usually with a subjective sense of surrendering or letting go. The entire body is involved in orgasm: arms and legs may become rigid and extended; hands may grasp; facial muscles become contorted; the person seems to be gasping for breath and may moan or scream, perhaps even laugh or cry.

In men, orgasm begins with contractions of the internal sex organs: vas deferens, seminal vesicles, and prostate. These organs pour some of their contents into the dilated (open) ejaculatory duct. This movement of fluid is experienced subjectively as "I'm about to come." Indeed, once these fluids are in the ejaculatory duct, ejaculation is inevitable. Any attempts to postpone ejaculation must be made prior to this point of no return. Next, orgasmic contractions spread to more powerful pelvic muscles. Muscular contractions against the bulb of the penis, as well as contractions of the urethra, propel the semen out of the penis.

For most men most of the time, the contractions of orgasm occur in conjunction with ejaculation, but either of these two responses can happen independently of the other. For instance, a man may ejaculate with few, if any, orgasmic contractions; his semen simply dribbles out. More men report having strong orgasmic contractions without

necessarily ejaculating. Some deliberately learn to enjoy non-ejaculatory orgasms as a means to prolong their pleasure without the drop in arousal that typically follows ejaculation.

In women the most noticeable focus of orgasmic contractions is the outer third of the vagina. The intensity and frequency of these contractions are tied to the subjective experience of orgasm. The inner portion of the vagina doesn't contract, but continues "tenting." Rhythmic contractions do take place in the uterus. In some women the urethral sphincter also has contractions, occasionally resulting in the release of a little urine during orgasm, especially if the bladder is full at the time. This is a separate response from the G-spot ejaculations mentioned earlier. Also during orgasm the clitoris remains hidden under its hood.

All phases of sexual response happen physiologically in exactly the same way regardless of the source or type of stimulation. This is no less true for orgasm. Distinctions that have often been proposed between different kinds of orgasms are subjective and not reflected in physiology.

Following orgasm, most men require a "refractory period" during which no further orgasms are possible. This involves a rapid partial loss of pelvic vasocongestion and, therefore, erection. Many women experience no refractory period. If effective stimulation continues after orgasm, continuing arousal can quickly lead to another orgasm. Far fewer men experience multiple orgasms, although some do, especially when they're highly aroused or when they learn to distinguish orgasm (muscular release) from ejaculation (expulsion of semen).

Whether we're aware of it or not, the anus is thoroughly involved in the contractions of orgasm, though these subside more quickly than other pelvic contractions such as those of the outer vagina or penis. Reports I've received suggest that with increased anal awareness, orgasmic contractions are more pronounced and longer lasting. Anal contractions are most noticeable when the anus is squeezing against something. The same is true of vaginal contractions. These contractions which begin involuntarily can be continued deliberately, thereby increasing pleasure.

Resolution

Resolution is the body's return to a non-aroused state often, but by no means always, following orgasm. Blood drains from congested tissue while respiration and heart rate return gradually to normal. Myotonia will already have been discharged as orgasm occurred. Without orgasm the resolution phase may be more prolonged.

Most people feel profoundly peaceful and relaxed during the resolution phase. If the person was tired before sex, he or she may drift off to sleep. Others may feel elated, playful, and energized. For some, resolution is a time of guilt or remorse over what they've just done, or fear of possible consequences. The pleasure of resolution is clouded by a desire to forget or escape.

When resolution is comfortable the anus is likely to be relaxed. In fact, people commonly report that their anuses are more at ease after orgasm than at any other time. For this reason resolution is sometimes a preferred time for anal exploration. Some people even find anal intercourse to be easier and more enjoyable *after* they have experienced orgasm. For those bothered by anal or pelvic pain, orgasm often relieves tension, and thus the pain, better than any pill—yet another indicator of the profound relaxation that can follow orgasm.

Experience

When you're in the mood find a comfortable private place for self-pleasuring and masturbation. You might begin in the bathtub and then move to another room once you're thoroughly relaxed. Choose lighting, positioning, and perhaps music that suits your tastes. Also gather any paraphernalia you wish to include in your self-pleasuring, including a lubricant, towel or baby wipes (available at drug stores) for cleanup, maybe a vibrator or butt plug, or erotica—whatever it takes to make this encounter with yourself special.

Begin by touching your entire body, not just your genitals. At various points along the way, stroke your anus, the sensitive area be-

tween your genitals and anus, as well as your inner thighs and but-
tocks. You might want to stimulate other favorite body areas at the
same time using your other hand. Don't hesitate to include the type
of genital touching that typically turns you on. If you're not used to
masturbating very much, you'll want to give yourself plenty of time
to get used to it.

Apply a lubricant to your finger and slowly insert it into your anus.
Experiment with different movements, rhythms and positions. Con-
sider any discomfort a sign that you're not sufficiently relaxed. You
probably need some extra time for deep breathing and gentle stroking
of the anal opening. As tension drains away you'll feel your anus relax.

A reminder to women: don't insert the same finger in your vagina
that you insert in your anus without washing it first. If you want to
touch both areas, it's easier to designate one hand for anal stimula-
tion and the other for your genitals.

Notice how your anus feels as you become aroused. Use the tip of
your finger as a sensitive probe. It will give you invaluable informa-
tion about how your external and internal sphincters respond as ex-
citement builds. Move your finger in whatever ways feel good. But
also see what it's like to leave your finger inside with little or no
movement. This can help you become completely attuned to your
anal muscles.

A suggestion for men: If you reach a high level of arousal (plateau)
you may wish to locate and stimulate your prostate. Simply insert
your finger all the way and then move it toward the front of your
body. With some gentle probing you should be able to feel the shape
of your prostate through the wall of your rectum. What does it feel
like to massage it with your fingertip?

Allow your fantasies to come and go as they please. Try not to
suppress them. If you want to, explore fantasies of anal sensuality or
intercourse. But don't force your fantasies in any particular direc-
tion. If one fantasy isn't going anywhere, let it go and see if another
image arises naturally. Enjoying purely physical sensations without
fantasy is, of course, fine too.

Stop when you feel finished—according to your feelings. This ex-

perience need not lead to orgasm. You can stop and start your activities as you please. But when you do feel like having an orgasm now or on another occasion, pay attention to how your anus responds. Notice especially how your anus participates in the contractions of orgasm. Clients frequently tell me that tuning into anal contractions during orgasm is not only fascinating, but also expands their enjoyment.

Don't ignore your anus after orgasm. If you still notice good feelings in the anal area, allow yourself to prolong the experience even if you've had one or more orgasms. When it's time to stop, withdraw your finger slowly and bask in the afterglow. Even if you don't feel like basking, take a few moments to observe what you *do* feel.

Response

When it follows earlier, non-erotic forms of anal exploration, most people find that including their anuses in auto-erotic activity is natural and welcome. Quite a few people do this spontaneously from the very beginning. Others are surprised and delighted at how erotic the anus can be, like Frank: "I've been doing all this stuff with my ass lately but I never knew it could *feel* so good. What an amazing turn-on!" Or Angela: "It was great, just fantastic. I never had a better orgasm." Such responses are typical.

But it's not all sweetness and light. Many things can and do get in the way of anal eroticism. To begin with, some people don't masturbate at all or, if they do, it's very matter-of-fact and genitally-focused. Some see it as a substitute for "the real thing," associate it with loneliness, or feel guilty about it. Most people I work with do masturbate and enjoy it at least sometimes, men more commonly than women— but the gap is rapidly narrowing.

If any of these feelings remind you of your own, you have two options: You can either consider a new attitude toward masturbation, or you can skip this section and move on. Think carefully about the first option before choosing the second. The stronger the urge to move along, the more likely you'll benefit from staying. After all,

masturbation is one of the very best ways to learn about and expand your eroticism. Undistracted by a partner, you can concentrate completely on what gives you pleasure. At its most exhilarating, masturbation can be a way of making love to yourself.*

Occasionally, those who genuinely enjoy masturbation still find it difficult to touch their anuses in a deliberate, conscious way. This usually results from lingering guilt or embarrassment, emotions that should be acknowledged and felt. This is the only way to move beyond them. Suppression of feelings is the surest way to lock them in place.

Men—straight, gay, or bisexual—may find that anal eroticism accentuates their homophobia, an intense yet irrational fear and hatred of homosexuality. This reaction is particularly intense when a straight or bi man realizes that he wants his anus caressed by a female lover, but holds back because of his fear that this desire is inherently less than manly. After all, the "ultimate" gay male sex act has typically been seen as anal intercourse, partly because it most closely approximates the heterosexual ideal of lovemaking.

Many men and women fear that if they enjoy anal eroticism with themselves, they'll be obligated to receive anal intercourse from others—whether they want it or not. Obviously, such a belief casts an anxious shadow over even the best masturbation experience. Be very clear with yourself that what you do alone can be completely unrelated to what you choose to do with a partner.

Some practical complications surrounding anal eroticism deserve our attention. Rodney expressed some of these with humor: "I like to play with my anus, but it can be such a hassle. The other night I was in the mood to get it on with myself but I had to find the lubricant. My roommate was home so I had to calm down a bit before I started searching. Then when I was getting into it, I started worrying about getting oil on the sheets. Eventually I just gave up and beat off!"

Rodney didn't mention another common concern: cleaning up

* Women especially should see Betty Dodson's updated classic, *Sex for One*. Joani Blank's *First Person Sexual* contains masturbation stories from a variety of men and women writers.

afterwards. A little planning is essential. Keep a lubricant and mirror handy. Use a water soluble lubricant because it is easier to clean up. Baby wipes are an easy way to clean your anus and fingers and the aloe vera in most of these products can be soothing to the anus. Or how about masturbating before you plan to take a bath or doing it in the tub? Some people are more relaxed with anal self-stimulation when they slip on a latex glove beforehand and simply throw it away when they're done. With a little experimentation and practice, everything will progress smoothly. Just be careful that you don't use these everyday concerns to sidestep uncomfortable feelings about anal sexuality.

As I mentioned earlier, men sometimes lose their erections when they stimulate their anuses. If this happens to you, the best thing to do is *not* make a big deal out of it. Erections return, and you don't need an erection to have a good time sexually. Frequently, erection loss is simply a reflection of a little uneasiness that will soon go away when you're more accustomed to anal stimulation. If, however, anal stimulation is actually turning you *off* (a loss of erection doesn't necessarily mean you're turned off) then you need to take it more slowly, perhaps exploring your anus again in a more sensuous, less erotic way. At first you may want to wait until you're really excited before touching your anus, especially before putting your finger inside. The important thing is to have fun and not take it too seriously.

One sign of taking it too seriously is the feeling that masturbation must result in orgasm. Some people get so focused on coming that they hardly enjoy the journey. Masturbation is simply self-pleasuring, it doesn't have to lead anywhere; stop any time you want. And it's certainly better if you don't rush. Try taking breaks from self-stimulation and maybe coming back to it later. This is a good way of becoming less goal-oriented and more pleasure-focused.

Erotic fantasies, typically a part of masturbation, can be a source of either joy or concern. This is especially true of fantasies involving anal intercourse. "Why is it," asks James, "that I like fantasizing about getting [anally] fucked, but I can't actually do it?" Ruth echoes the same concern: "When I think about it [anal intercourse], it's always a

turn-on. I've even fantasized that Mel [her lover] was really inside my anus during vaginal intercourse, especially when he enters from the rear; but every time we try anal sex it's no fun at all." One reason for James' and Ruth's feelings might be that they don't want to receive anal intercourse in actuality, even though they very much like it in fantasy. After all, there's no direct relationship between fantasy and behavior; people frequently fantasize things they would never actually do. Another possibility is that James and Ruth would like to receive anal intercourse but are nonetheless anxious about it. Either way, it's best if you can enjoy your fantasies just for themselves right now. Later, I'll suggest comfortable ways of discovering what you'd like to try with a partner.

Other men and women discover that neither fantasy nor real-life anal stimulation is very erotic. Some even experience a *decrease* in excitement merely from thinking about it. If you're one of these people, the more at ease you become with anal fantasies and touch, the more your fears will subside. By deliberately introducing fantasies of anal stimulation at moments of high excitement you can gradually eroticize the anal area, gradually replacing negative associations with positive ones.

Discovering the Rectum
Mapping Its Shape and Sensations

Thus far you've explored the anal opening, short anal canal, and lower rectum—all of which can easily be reached with your fingers. We now turn our attention to the inner rectum where your fingers can't reach. The rectum is stimulated by feces going out during a bowel movement or by objects—such as a dildo, vibrator, or penis—going in. You're used to bowel movements but appreciating the sensations of rectal insertion requires the sensitive use of an object longer than your finger that you control. Exploring the rectum offers possibilities for new kinds of pleasure as well as discomfort, depending upon how your approach it.

Anatomy and Physiology of the Rectum

The rectum is a tube-like structure made of loose folds of soft, smooth tissue. Its total length is about eight or nine inches. Normally the rectum is more open and spacious than the anus. But like the anus it has a striking capacity to expand. The entire length of the rectum is supported by muscles which, during a bowel movement, contract and relax in wave-like motions—known as peristalsis—and move feces through the rectum and out the anal opening. The tension level

of these muscles varies from person to person and reflects, among other things, individual emotional states and habitual muscular patterns. Chronic, non-rhythmic contractions of the rectal muscles can contribute to constipation and other problems of the lower digestive tract. Rectal muscles are not nearly as powerful as the anal sphincter muscles (with the exception of one related muscle that I'll discuss shortly). Nonetheless, if the rectum is very tense, the insertion of an object or penis into it can easily become a pleasureless ordeal.

While the rectum is tube-like it's not a *straight* tube. Instead it takes two curves along its length (see Figure 4). Knowledge of these curves is essential for the would-be rectal explorer. The lower rectum tilts forward toward the navel. After a few inches it curves in the opposite direction toward the backbone. This first curve is created by a strong, supportive muscle known as the *pubo-rectal sling* (shown in a detail of Figure 4). After another few inches the rectum curves slightly toward the front once again.

It's the first curve—and the underlying pubo-rectal sling muscle— that are most likely to make it difficult to receive an object or penis into the rectum. Figure 5 shows how an object entering the rectum at an improper angle runs into the rectal wall at the first curve. If the object is inserted with force it can cause pain. If a lot of force is used, a tear (fissure) in the rectal wall can result. Figure 5 also shows how a slight adjustment in the angle of entry easily prevents this. Difficulty in moving beyond the first curve can be exacerbated if the pubo-rectal sling muscle is constricted and tension makes the curve more pronounced and less flexible. The pubo-rectal sling, like all anal and rectal muscles, clamps down in response to fear, stress, chronic straining, pain, or improper diet.

The pubo-rectal sling is responsible for about 80% of continence, the ability to avoid the unwanted passage of feces or gas. Thus, even people with damaged anal sphincters can still retain a high degree of control. When a person feels the internal pressure associated with the need to defecate, the pubo-rectal sling contracts to hold back feces and gas until the first appropriate opportunity.

Any pressure against the pubo-rectal sling—or at the upper end of

Figure 4. Anatomy of the Rectum

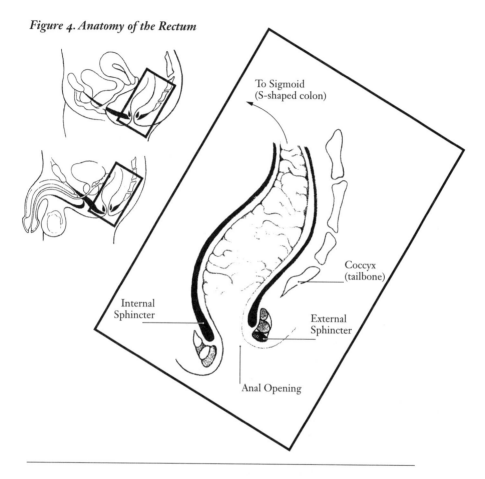

To Sigmoid
(S-shaped colon)

Coccyx
(tailbone)

Internal
Sphincter

External
Sphincter

Anal Opening

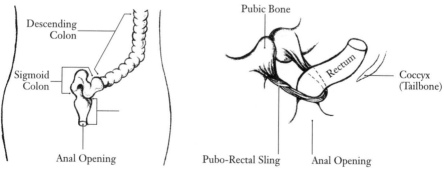

Descending
Colon

Sigmoid
Colon

Anal Opening

Front View of Body
showing relationship between
the rectum and the colon

Pubic Bone

Rectum

Coccyx
(Tailbone)

Pubo-Rectal Sling Anal Opening

The Pubo-Rectal Sling Muscle
supporting the rectum
and causing its first curve

the rectum where the colon starts—can trigger a similar holding-back response. Knowing this helps understand two phenomena commonly experienced when objects are inserted in the rectum: (1) the feeling of an imminent bowel movement even when this isn't going to happen, and (2) the tensing of the pubo-rectal sling, making insertion difficult and unpleasant. Clearly, these two experiences are related. Pressure from rectal insertion is perceived as an urge to defecate which, in turn, results in tensing of the pubo-rectal sling—a classic vicious cycle.

Comfortable rectal insertion requires a re-interpretation of this response. This is relatively easy to do for most people because the sling can readily be brought under voluntary control. The key is to learn gradually, in a visceral way, that the urge to defecate isn't necessarily linked with the need for a bowel movement. This awareness helps to relax the sling and gives your rectum maximum flexibility.

The second rectal curve is less pronounced and usually more adaptable. Consequently, it rarely is a source of difficulty or discomfort during rectal insertion. When it does cause discomfort, slight adjustments in the angle of entry will usually remedy the problem. It also helps to know that any position which places the legs at right angles to the upper body—such as sitting, squatting, lying on your back or side with knees pulled toward the chest, or on your knees in a "doggie" position—will straighten the rectum a bit. But no position completely eliminates the rectal curves.

Within this general description, rectal shape and size vary from person to person. Inserting objects into the rectum may be easier for one person in a particular position or at a certain angle of entry, while another position or angle is better for someone else. Differences are no doubt a combination of physiological variations and personal preference. Anyone who states that one position or angle is the best for rectal entry is over-generalizing from personal experience. There's no substitute for first-hand experimentation.

In contrast to the anus, the rectum contains relatively few nerve endings and is, therefore, less sensitive. The rectum has this in common with the vagina: the entryway is far more sensitive than the

Figure 5. Effects of Angle of Entry on Rectal Insertion.

At improper angle, an object
runs into the rectal wall
resulting in pain or, if force
is used, possible tissue damage.

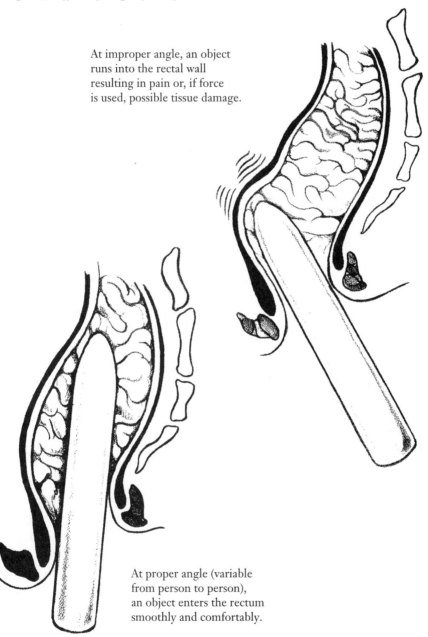

At proper angle (variable
from person to person),
an object enters the rectum
smoothly and comfortably.

inner portion. In general, rectal nerve endings transmit mostly sensations of pressure. Some people find these sensations pleasurable immediately while others need to get used to them. More than a few men and women, however, report a remarkable sensitivity in their rectums. To some extent this sensitivity appears to be a learned capacity developed through paying attention. In addition, the psychological enjoyment of rectal receptivity can greatly heighten all pleasurable sensations. And for men, stimulation of the prostate through the front of the rectal wall provides another set of potentially wonderful sensations.

When a penis or penis-sized object is inserted into the rectum only the anal canal and rectum are involved. Penises or objects longer than 9 or 10 inches may pass beyond the rectum into the sigmoid (S-shaped) colon (shown in Figure 5). Sometimes this occurs without difficulty, because the muscles of the lower colon tend to relax at the same time as the anal and rectal muscles. There may, however, be some initial muscular resistance at the entrance to the colon. In addition, the likelihood of encountering feces in the lower colon is greater than in the rectum. It is a natural function of the colon to collect feces until there is sufficient quantity to enter the rectum in preparation for a bowel movement. Those concerned about feces will want to consider how much time has passed since the last bowel movement whenever entry into the colon is desired.

Fisting (Handballing)

The colon is of particular interest to those experimenting with a form of anal-rectal stimulation popularly called fisting, fist-fucking, or handballing. This activity involves gradually relaxing the anal muscles until several fingers and eventually the whole hand, and occasionally even the forearm, can enter the rectum and colon. The term fisting is a misnomer because practitioners do not enter a partner's rectum with a closed fist, but rather with an open hand, allowing the fingers to be used gently as probes. The awareness, gentleness, and trust recom-

mended for all anal exploration are doubly important for safe experimentation with fisting. Those who wish to explore handballing—as givers or receivers—will find the exercises and information in this book useful, but additional knowledge and guidance is required to do it safely.*

Although significant numbers of people (especially, but by no means exclusively, gay men) are experimenting with fisting, relatively few people appear to be able to relax sufficiently to accommodate something as large as an entire hand. Those who do enjoy fisting sometimes become devoted enthusiasts. Receivers of fisting report deeply satisfying sensations of fullness and pressure and often describe it as the ultimate experience of receptivity. Fistees frequently mention the enjoyment of total surrender, trust, openness, and being the object of lavish and extended attention.

Those who do the fisting also speak about the extraordinary trust involved, along with a unique sense of control as their partners let go of all resistance. Some also say that having total responsibility for another's well-being can be a profound emotional experience. I've noticed that fisters usually don't seem quite as wildly enthusiastic about it as some of the receivers, although some are highly stimulated by exploring deep inside their partner's body.

Accommodating several fingers or a hand in the rectum and possibly the colon requires tremendous self-awareness, relaxation and trust. Some describe the experience as a form of meditation or spiritual odyssey. A handballing session takes time (several hours isn't unusual), gentleness and patience; it's definitely not a quickie.

Unfortunately, many fisting enthusiasts haven't developed the sensitivity and self-awareness necessary for doing it safely. Instead they rely on large doses of drugs and often use force, sometimes tolerating considerable pain. These problems are intensified when rough or rapid movements are employed. Like other forms of rectal stimulation, fisting can be quite dangerous when attempted with drugs or

* The only book devoted to anal fisting is Bert Herrman's *Trust, the Hand Book: A Guide to the Sensual and Spiritual Art of Handballing*. Those who are curious about fisting can also find many sites on the World Wide Web.

force, or without being thoroughly attuned with oneself.

Very little research has been done on either the positive or negative effects of fisting. One investigator (Lowry, 1981) collected questionnaires from 102 males involved in fisting. The average respondent had been active for nearly four years, with 40% participating at least once a week. Thirty-seven percent were inserters most often, while 18% were usually receivers. Forty-five percent experienced both roles equally. Twenty-four percent had even received two hands simultaneously.

Three of the men reported bowel perforations from fisting, requiring hospitalization. Extrapolating from his findings, the investigator speculated that there may be one serious injury per 2,000 fisting episodes. Eighty-five percent described their fisting experiences in extremely positive terms. A few of the men mentioned that fisting seemed to improve their anal health by promoting deep relaxation.

The arrival of AIDS on the scene has caused a re-evaluation of all sexual activities and how to make them as safe as possible. When it comes to preventing HIV transmission, the main concern with fisting is its potential for causing abrasions in rectal tissue which, even if too small to notice, may provide an entry point for HIV into the blood stream. Fisting recipients should take great care not to expose their rectal tissue to semen or blood, and similar care is necessary for fisters because of the likelihood of tiny scrapes on the hand. To this end, *all* fisting should be done with latex gloves (available at some pharmacies, most sex toy shops, or from a medical supply company). Generous amounts of a thick lube are also necessary; water-based ones should be used with latex. In addition, fisting and anal intercourse should *never* be practiced during the same session even with a condom. Condoms can unexpectedly break or fall off and rectal tissue, rich with blood vessels, is very likely to have tiny breaks in the skin due to the intense stimulation. Actually, it's a smart idea to let the rectum rest for at least several days following a fisting session.

Since most readers, while perhaps curious about fisting, are probably not planning to try it themselves, none of the experiential suggestions throughout this book specifically refers to fisting. However, anyone who might want to experiment with handballing should de-

vote plenty of time to self-exploration, using the same step-by-step approach to anal-rectal exploration proposed in this book.

Experience

Begin by bathing, relaxing, and touching your body in a self-loving and sensuous way. Explore your anus with your fingers as you allow your muscles to relax. When you're completely comfortable, apply lubricant to your finger and rub it on your anal opening and inside your anus.

Also lubricate a smooth object such as a soft dildo, a flexible vibrator, or a butt plug. These are all available in a variety of sizes; it's a good idea to start small and, if desired, to work your way up. You can minimize or eliminate cleanup of sex toys if you cover them with a condom before each use. Some people prefer a more natural object such as a cucumber or zucchini. These are fine as long as you wash them thoroughly (you don't want pesticide residue in your rectum); make certain that your chosen vegetable is smooth. Whatever the object, it should be about the diameter of two of your fingers or smaller. Figure 6 shows a selection of objects available for rectal insertion.*

Select a position in which you can easily reach your anal area without straining. Inhale deeply and push your anal muscles slightly outward. Then gently press the end of the object against your anus. As you exhale and release your muscles, the object will slide easily through the anal opening, anal canal, and into the rectum. No force should be necessary; if it doesn't glide in easily, return to deep breathing and external anal massage until your muscles relax.

Once past your anal sphincters the object will slide easily into your rectum. But after a few inches the object may stop as if it has run into something. This is your first rectal curve caused by the pubo-rectal sling muscle. If the object stops here, slowly pull it back *just a little*, move it to a slightly different angle, and then slowly push in again. By experimenting with different angles and positions you'll find one or more combinations in which the object will glide past your first rectal

Figure 6. Objects used for Rectal Stimulation.

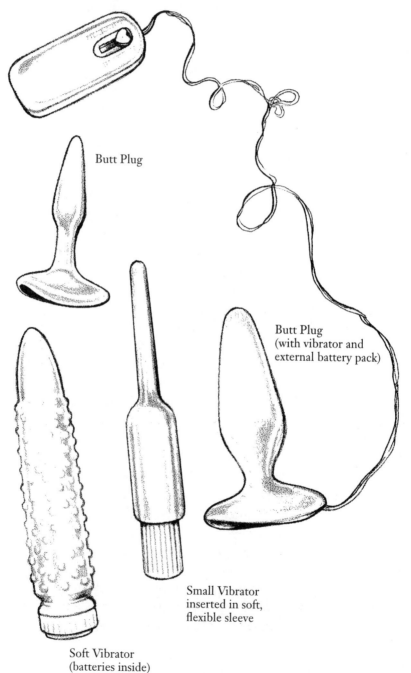

Butt Plug

Butt Plug
(with vibrator and
external battery pack)

Small Vibrator
inserted in soft,
flexible sleeve

Soft Vibrator
(batteries inside)

curve without resistance; notice exactly which ones work best for you.

You're likely to experience new sensations as the object enters your rectum. When this happens, ask yourself if the sensations are actually uncomfortable or just different. If uncomfortable, back off to a point that feels pleasant and remain there. And don't forget to breathe.

As I mentioned earlier, a common sensation is the urge to have a bowel movement. If this bothers you and prevents you from relaxing, try inserting the object when you are in a safe environment such as on a plastic sheet or in the bathtub. Tell yourself that it is all right even if you do have a bowel movement. Then allow yourself to relax completely. Visualize the relaxation of your pubo-rectal sling and other rectal muscles as you breathe deeply and slowly. You'll discover that even though you think you're about to have a bowel movement it won't actually happen. Since childhood you've associated slight rectal pressure with such an urge, and now you're reinterpreting these sensations in a new way. Give it a little time; soon you'll no longer be concerned.

Don't push an object so far into your rectum that you lose your grip on it. Contrary to some myths, your rectum will not pull the object out of your hand, although there may be a slight feeling of suction. Occasionally an object does end up inside a person's rectum out of reach when a person passionately shoves an object inside. If you should happen to "lose" an object inside your rectum, don't panic. Panicky feelings cause muscle spasms and are counterproductive. Just relax and the object will usually come out by itself. Squatting may also help. The best way to eliminate even the slight possibility of such an occurrence is to use a butt plug or dildo with a flared base which prevents it from entering all the way, no matter how passionately you push it. In fact, I recommend this type of object exclusively for passionate rectal play.

When you include your rectum in erotic self-pleasuring, allow yourself to enjoy any fantasies that come to mind. Afterwards, write them and your feelings in your journal.

At some point, explore your rectum before, during, and after orgasm; note the changing sensations. After you've finished, pay attention to how your anus and rectum feel throughout the day.

Response

Learning to enjoy inserting an object into your rectum is primarily dependent on three factors. First, the anal muscular awareness, control and relaxation that you developed earlier must be expanded to include your rectal muscles. This has happened already to a great extent because your rectal muscles tend to function in harmony with your anal muscles. For most people, a little patience, attention, deep breathing, and visualization of the rectal muscles relaxing is all that's needed. If this doesn't work, chances are you're going too fast and could benefit from further experimentation with your finger. While the vast majority of people find that inserting their finger is the best way to begin, a few people discover that inserting objects is easier and more pleasurable for them. If this is true for you, naturally you'll want to do whatever's easiest.

The second and perhaps more important factor is becoming intimately acquainted with the shape of your rectum and accommodating your movements to that shape. Uncomfortable or painful anal-rectal experiences are, as you have discovered, the result of muscular tension. And, in circular fashion, anal tension is often a response to pain that results from strong pressure against the rectal wall, usually in the area of the first curve. Medical problems caused by anal intercourse are often the result of lack of information about rectal shape. These problems can be avoided by learning about your own rectum and exploring the angles and positions in which objects can travel the length of your rectum unobstructed. While your rectum does not like to be jabbed or pushed, it's not nearly as delicate as you might think. With gentle guidance, objects can be moved in and out or around freely as you experiment.

The third factor involves becoming accustomed to new sensations, best accomplished with plenty of time to feel and get used to them. Some people, of course, react strongly to any new sensation, perhaps mistaking *new* for *dangerous*. Others react to new body sensations with curiosity rather than fear. If you're uneasy, ask yourself what you're afraid of. Then take concrete steps to protect yourself from

whatever you fear. See if you can adopt a positive, non-pressured curiosity.

It's important to apply the same positive curiosity to any sensations that occur after rectal stimulation. Sometimes these include a slight burning sensation in the anal-rectal tissues. This is probably due to increased blood flow into the area. The feeling can be tingly and pleasant or it may be irritating. If it's irritating, you probably did too much too fast, or else you were a bit tense and went ahead anyway. It's also possible that you're simply becoming more aware of sensations that have always been there, perhaps the result of chronic rectal tension. If irritation persists consult a physician to be certain that you don't have a medical problem. Another common sensation is mild bladder irritation that may be particularly noticeable when urinating. This is reported more often by women than by men. Usually with both men and women this is the result of indirect stimulation of the bladder and it can be greatly reduced or eliminated by proceeding slowly and gently.

Consider making a list, mentally or on paper, of what you like and don't like about rectal stimulation thus far. Instead of tuning out any bad feelings you may encounter, honor them. Negative responses contain important messages about how to take care of yourself; listen carefully. At the same time, give extra attention to the positive aspects of the experience, no matter how subtle. Even tiny hints of pleasure can point the way to greater potentials down the road.

10

Attitudes Toward Rectal Stimulation

Confronting Psychological and Cultural Blocks

RARELY IS THE ACT of inserting something into the rectum merely a bodily event. Though we may not fully realize it, each of us brings a highly personalized set of attitudes, beliefs, and emotions to the experience. Sometimes our response is as strong and positive as it was for Mavis: "Now that I'm enjoying this [rectal stimulation], I see myself as a more sensuous and sexually versatile woman." In a similar vein Drew proclaimed, "I'm becoming a more open and less uptight guy. What a relief it is to let go."

Not everyone, of course, is so unambiguously delighted with their newfound ability to receive objects into the rectum. Certain widely-held attitudes toward rectal stimulation are so negative and confusing that they can easily block anyone's ability to enjoy it. Indeed, some deep-seated ideas are so overpowering that no matter how relaxed the anus usually is, the moment an object enters the rectum the muscles are thrown into reflexive spasms. Other effects may be less obvious yet no less disruptive.

The best approach is to confront the troubling attitudes and beliefs head-on. Facing them by no means guarantees that they'll

immediately—or ever—go away completely. Usually, however, bringing deeply ingrained attitudes into the light greatly reduces their emotional charge and, in turn, their negative impact. Left unexamined, our beliefs operate automatically and truly control us, whereas conscious awareness increases our options for free choice.

The principal purpose of this chapter is to focus on complex, often hidden aspects of rectal stimulation you may not have considered before. This is also an appropriate time to discuss recreational drugs commonly used with anal exploration. Not only do some people hope to enrich their experiences with chemical assistance, but many also look to drugs to help them cope with inhibitions and conflicts they haven't yet resolved.

Feces

The most prevalent attitudes that block enjoyment of rectal stimulation are the ones we have toward feces—shit, if I may be blunt. You probably confronted concerns about feces when you first touched your anus. But rectal stimulation, reaching farther into the unseen interior of your lower digestive tract, is more likely to trigger intense reactions. Some people can't help but see rectal experimentation as a threatening descent into a mysterious nether world of the intestines, perhaps punctuated by taboo images of darkness, dread, and defilement. Peter got right to the point: "I just don't think I should be messing around in there. I get the eerie sense of being where I'm not supposed to be. It's creepy."

Clearly such reactions, to the extent that you have them, aren't going to make rectal exploration any easier. As with other strong emotions, vehement denial of their existence suggests that you're not dealing with them. If you continue to keep them outside of consciousness they're likely to haunt you in the form of persistent tension or tenacious avoidance.

Freud and many others have observed that infants show no particular disgust with feces; they readily play with them or even take

pride in them as "gifts." Before long, however, almost all of us change our opinion dramatically. Through a non-rational learning process we come to see feces as dirty, repulsive and foul-smelling. Freud theorized that adults, while expressing a conscious antipathy toward feces, often retain an unconscious attachment to them as well. Most people I've talked with will admit to at least an incidental interest in their own stools, such as gazing at them in the toilet after a bowel movement—not a bad idea, incidentally, for monitoring your digestive health.

But this is about as far as most of us care to go. One thing is clear, though: the overpowering revulsion typically focused on feces goes far beyond any legitimate concerns about hygiene and cleanliness. I believe this revulsion response reflects, in part, our culture's fundamental ambivalence toward the body's natural functions and our relentless efforts to cover up or eliminate all body odors and secretions.

With cultural values tending toward one extreme it's not surprising that some people are secretly drawn in the opposite direction, becoming obsessed by the very smells and excretions they were taught most vehemently to hate. A few even make excrement or urine the center of their erotic interest. In a sense, these seemingly opposite attitudes actually complement each other. What so often eludes us— and what most promotes optimal well-being—is a more accepting and less negatively charged attitude toward all of our secretions and excretions.

There's no escaping the fact that the anus and rectum are passageways for feces. Consequently there's always a chance of encountering the brown stuff during rectal play. I've heard many stories of men and women tentatively enjoying the sensations of rectal insertion, only to have their pleasure squelched by the sight or smell of feces on their dildo, butt plug, or finger. More than a few have felt so traumatized that they quit anal self-exploration for good. This is why it's so important to develop a two-part plan to: (1) reduce the chances of encountering feces and (2) calm the severity of our reactions if we do.

Worries about feces can be reduced by keeping in mind that they're not normally *stored* in the rectum, except when the body is preparing

for a bowel movement. The rectum is merely a temporary passage-way. The consistency of your stools determines, to a large extent, how much is left behind after a bowel movement. Soft stools leave more traces whereas better-formed ones exit more cleanly. The well-formed feces that result from a healthy diet rich in fiber are almost universally reported to be less messy and repugnant—even less smelly.

On days when you notice that your stools are especially soft, you may prefer not to insert anything into the rectum or make a point of douching or washing inside with your finger. If you're concerned about feces you might want to look over the discussion of douching in Chapter 7 again, and then experiment to see what works for you. For many people, cleaning out the rectum with warm water is the simplest way to avoid an unwanted rendezvous with poop.

Although these precautions are quite logical and effective, primi-tive attitudes toward feces may continue to haunt you. Visceral reac-tions aren't necessarily calmed by practical measures. If this is true for you, an important challenge is to deliberately initiate a shift in attitude. Paradoxically, one of the best ways to launch such a shift is to acknowledge and accept the depth and intensity of your current outlook. After all, you can only start from where you are.

I suggest that you look mindfully at your feces and notice, without judgement, exactly what you think and feel about them. It also helps if you raise the subject with an intimate friend, an admittedly diffi-cult yet highly beneficial thing to do. Gradually you can cultivate a greater acceptance of what you've probably long considered to be the least acceptable aspect of your body. In the final analysis, few of us are ever going to *like* feces. But it's realistic and healthful not to hate them either.

Homophobia

Among the most pervasive and intractable beliefs about rectal stimu-lation is that men who enjoy it are homosexually inclined, if not overtly gay. It's easy to see how this belief can have a huge chilling effect on

men who might otherwise be curious about anal exploration. Ralph, a straight client of mine who initially tried anal self-touch because his girlfriend thought they should do it together, soon discovered that he actually liked it. But when it came to rectal insertion his pleasure quickly switched to worry. "Putting things inside my ass," said Ralph, "makes me wonder if, underneath, I might be gay. Sure I have gay friends and I've even tried gay sex a couple of times in college, but that just proved how totally turned on by women I am. Yet suddenly I'm uptight about it and I don't get it."

Ralph's not alone. Hardly a week goes by that I don't receive a letter from a straight or mostly-straight man who's tremendously relieved to learn from this book that his secret desire for anal stimulation is far from unusual. Others write because they're having trouble finding a comfortable place in their lives for anal gratification. For example, one 39-year old man wrote:

> I've always had a great sex life with my wife until I recently told her I'd love it if she put her finger up my asshole sometimes when she gives me head, which she and I both like a whole lot. At first she laughed at me like I was joking and then she gave me a strange look like I was some kind of freak. Now she accuses me of wanting to get fucked by a guy. That doesn't appeal to me at all, but the truth is I'd like to get fucked by *her*! She's warmed up to me again but I guess I'm doomed to play with my ass alone.

What makes so many guys, and often their partners too, so edgy about anal play? Of course the anal taboo accounts for a lot of the problem. But men, regardless of their sexual orientation, must also contend with homophobia—a deep, irrational fear and loathing of homosexuality. While it's true that some segments of our society are becoming increasingly accepting of gays, the destructive effects of early anti-gay messages are difficult, sometimes impossible, to eradicate.

Straight men go to great lengths to avoid being labeled queer. So do most gays, bisexuals, and lesbians—until they come out of the closet. Even then it usually takes years to repair the massive damage to their self-esteem caused by their own internalized homophobia, which typically proves to be more tenacious than they had hoped.

Sadly, many are unable to stop hating themselves.

Although homophobia affects both men and women, rectal stimulation appears to trigger it almost exclusively for men. I've worked with dozens of women of all sexual orientations who struggled with the anal taboo, but virtually none of them believed that enjoying anal stimulation would make her any more or less gay. Men tend to be much more confused on this point, partly because men in general experience homophobia more intensely than women, and partly because being anally penetrated raises the specter of playing "the woman's role" in bed.

Many straight men are only able to enjoy anal self-exploration once they fully realize that doing so, by itself, says nothing at all about their sexual orientation; it's simply one more sensuous or erotic option. It helps even more if a man can sufficiently work through his homophobia so that fantasizing about gay sex doesn't send him into a tailspin.

The challenge may be even greater for gay and bisexual men. For instance, some of my male research participants were in the early stages of coming out. Their reactions to rectal exploration were often particularly strong. Obviously, reassuring such a person that a desire for anal stimulation bears no relationship to his sexual orientation is useless because he knows that he wants to explore gay sex, possibly including anal intercourse. For these men anal tension is a natural reaction against real desires they're having trouble accepting. Some have had to delay rectal exploration until they were better able to accept themselves. For most this takes time but the process can be accelerated with the help of a supportive psychotherapist. Unfortunately, far too many gays go through the early stages of coming out in painful isolation.*

It's also not uncommon for openly gay men who appear to have accepted their orientation to periodically encounter residual doubts about the acceptability of their erotic and affectional desires. Certain experiences can bring these doubts to the fore. Rectal stimulation, even

* For men beginning the coming out process, as well as those who are well under way, there's no better book than Don Clark's *Loving Someone Gay* (3rd Ed.).

with no partner present, is one such experience. This is what happened to Lee, a successful and normally self-confident gay man:

> I had just managed for the first time ever to get a dildo up my butt without any pain. I was getting really turned on when everything stopped cold. I thought, 'You know, if I were a real man (translation: straight) I wouldn't be sticking dildos up my ass!' And then my muscles pushed that thing right out and clamped shut. I could almost hear the door slam. And I haven't been able to do it again since.

Gay men such as Lee are often shocked by the intensity of their reactions, especially those who believed they had conquered the last vestiges of internalized homophobia. The development of gay pride furthers this goal immensely. But unfortunately, pride is sometimes merely a thin veneer pasted over festering shame. Facing lingering guilt and self-loathing is uncomfortable to be sure, but almost always results in a more relaxed and solid stance in the world. One man, after a long walk in the woods, felt the raw pain of his self-hatred and began sobbing uncontrollably. Afterwards he squatted down and took what he called a "cosmic shit." He later told me, "Never before have I felt so open and free. I'd been holding in all the crap my father had told me about queers."

Gender Roles

The more that homophobia is studied among people of all sexual orientations, the clearer it becomes that anti-gay attitudes aren't as much the product of traditional sexual morality as we might assume. Instead, fear of homosexuality is primarily the consequence of narrowly defined sex-role behaviors and rigid gender identity. While it's true that homosexuality has no direct relationship to masculinity or femininity, most people, including gays themselves, are convinced that it does.

When men get caught up in fears of homosexuality they may be ignoring an even more primal fear: the dread of being viewed by oneself and others as unmanly and effeminate. Most men try to sup-

press or restrain the softer, receptive aspects of themselves. They fear their masculinity will be compromised and thus their overall worth diminished. This is why men who are called sissies often adopt exaggerated masculine behavior as a compensation. Among men, homophobia could just as well be called "femiphobia"—an irrational fear and devaluation of femininity. Femiphobia is a manifestation of the sexism which still pervades our culture, in spite of the improving economic and political status of women.

In such an environment it is little wonder that receptivity to anal stimulation, with its physiologic similarity to vaginal receptivity, provides fertile ground for femiphobia. Although there is nothing inherently feminine about enjoying rectal stimulation, men who subconsciously or overtly believe such a connection exists are unlikely to give up this conviction easily. If a man wants to enjoy rectal insertion, gradually he must come to realize that embracing his femininity—if that's what receiving anal stimulation means to him—does not constitute a loss of masculinity. On the contrary, the ability to relax, to receive, to voluntarily surrender control is a psychological and interpersonal asset, not a loss.*

Many of my male clients, whatever their sexual orientation, have found that experimentation with rectal stimulation can be a symbolic way of becoming more at ease with receptive feelings. Sometimes this occurs without any conscious intention, as it did for Burt, who presented a super-masculine persona. Although he claimed to be a sexual adventurer who wanted to be adept at all forms of pleasure, at each new level of anal exploration he grew increasingly ambivalent. While he enjoyed the sensations of anal touch he also resisted it fiercely. He especially resisted rectal simulation because of its association with intercourse, which he definitely didn't want, fearing that he might be "contaminated" by femininity. This is what he discovered:

* The psychological theories of Carl Jung are particularly relevant in this regard. Jung recognized through his analysis of dreams and other symbolic material—such as art and myths—that a conscious integration of one's masculinity and femininity is a crucial aspect of psychological wholeness for both men and women (Jung, 1951).

I was trying to get my wife's vibrator in my rectum (it amazes me I would even try) and boy was I trying, pushing like I do with almost everything. The harder I tried, the tighter I got. Finally I just let go and it slid right in. Liz [his wife] says I became receptive. Anyhow, it worked. I now have some idea of what receptivity, submissiveness— whatever you want to call it—feels like. It's not half bad.

Others deliberately set out to develop a receptive frame of mind before even attempting rectal stimulation. Many men quickly discover that their subjective state determines both the ease with which they receive objects into the rectum and the extent of their enjoyment. Initially, however, the pleasure of receptivity is often overshadowed by femiphobia.

The fact that so many of us worry about gender roles and expectations isn't surprising. After all, at birth the first thing anyone ever wants to know is our gender. Then an extended training process ensues in which we learn how to walk, sit, gesture, talk, feel, and think in accordance with our assigned roles. Girls, and especially boys, who stray very far from the norm are ostracized and often teased ruthlessly.

It seems that in every culture where data is available, tremendous effort goes into exaggerating gender distinctions in every imaginable way. And yet generation after generation we keep this up, regardless of the havoc it causes. Sexologist C. A. Tripp (1987) argues convincingly that the central purpose of artificial gender distinctions is to maintain a certain distance between the sexes which he believes serves to intensify erotic attraction and excitement.*

Whether or not you buy Tripp's theory, you certainly know from your own experience the power of gender-based expectations. For most men, being sexually penetrated may seem like the ultimate repudiation of their masculinity. So don't be surprised if the seemingly

* Sex roles have other functions as well, of course. For example, pre-defined roles, when accepted by both partners, simplify decision-making and reduce the need for discussion. In addition, strict sex roles have traditionally fostered economic dependency, which tends to maintain relationships even when they have become dysfunctional. Sex roles are also effective tools for maintaining male economic and political superiority.

simple act of sliding an object through the anal opening and into the rectum sets off deep psychological reverberations.

For women, rectal play is more likely to reactivate commitments to the virtues of chastity and virginity, along with fears of being seen as amoral, depraved, lascivious, promiscuous whores. Jan explained, "Deep down I believe that anal sex is kinky and twisted, something a prostitute might do, definitely not for nice girls like me. Mom would never approve."

It's not unusual for today's liberated women to insist that they're open-minded about sex which, of course, many are. Yet within more than a few open minds a silent inner battle is being waged between opposing emotional extremes—it's the virgins against the sluts. It's better to let both sides have their say in a conscious dialogue. Centuries of gender stereotyping cannot easily be swept away.

Missing the Taboo

Throughout this book I've primarily addressed the negative aspects of the anal taboo, how it alienates us from ourselves and limits or destroys our capacity for pleasure. But in erotic life there's always another side to the story. In my book about the psychology of sexual desire and arousal, *The Erotic Mind*, I describe an in-depth analysis I conducted of peak erotic encounters and fantasies—the hottest and most memorable ones. In almost 40% of these peak turn-ons, the thrill of breaking the rules and flaunting taboos was a major aphrodisiac. I call the process through which prohibitions are transformed into erotic fuel the "Naughtiness Factor," and it tends to be an especially important aspect of eroticism for those who grew up steeped in anti-sexual messages and warnings.*

Now that you've come this far in your self-exploration, the anal

* I found that gays, lesbians, and those raised as Catholics were the most inclined to be turned on by themes of violating prohibitions, presumably because all three groups had to contend with particularly strong and consistent restrictions on their sexuality during the formative years when arousal patterns begin to take shape.

taboo is hopefully loosening some of its grip, which is very good news indeed. But as anal sexuality feels more acceptable and less forbidden you may begin to sense a reduction in certain kinds of raunchy excitation. For more than a few, this decreased arousal is so pronounced that they almost yearn for the "good old days" when anal sex was secret, sleazy, and sinful.

Some people feel the first hints of waning intensity when they get out the hand mirror and have a look with the lights on, or when using their finger to gather information about the anal sphincters. Usually the significance of breaking down the anal taboo becomes fully clear about now—when you've learned enough to focus on the erotic potentials of anal-rectal stimulation. Marc expressed his dilemma, "When it comes to pure lust, frankly the fantasy of anal sex was hotter when it was dirty. The down side was that I couldn't relax and enjoy it the way I do now. It pisses me off to think I might have to choose between excitement and comfort."

Similar dilemmas are commonplace in the paradoxical world of eros. The lustiest fantasies and encounters aren't necessarily the calmest. On the contrary, a certain amount of tension and conflict, including some anxiety and guilt, often serve as excitement intensifiers. If you feel torn about the anal taboo—both hating *and* missing it—the first thing to do is to realize that your situation is completely understandable considering the pervasiveness of the anal taboo. Then you have two fundamental ways to go.

One option is to cultivate alternative forms of arousal that can only be found beyond the limits imposed by a taboo. Sensuality reaches its zenith, for example, when all ambivalence has been transcended and you totally immerse yourself in the delights of the moment. Similarly, anal-rectal touch is most likely to lead to a profound communion with oneself or another when the last vestiges of prohibition fade into obscurity. These dimensions of arousal don't necessarily unleash the same raw, lusty kick as a scene of violational intrigue, but their rewards are deeply moving nonetheless.

Another option for those who crave the thrill of the forbidden is to imagine or pretend that you're being raunchy or wicked, even

though you're really not. Countless people use this technique all the time, sometimes without fully realizing it, to add an extra spark to sex. It can be quite effective to act as if you're still fighting against a taboo long after the battle has been won. The challenge here is to disconnect the titillation of naughtiness from genuine disgust, muscular tension, and other enemies of satisfaction. For instance, some people find excitement in the idea of shocking an imaginary prude or offended moralist. They appreciate their own comfort all the more in contrast to the image of disapproving others. And let's face it, no one who's aroused by the Naughtiness Factor needs to worry that anal eroticism will ever become mainstream or conventional; that's simply not going to happen.

Drugs and Anal Pleasure

People have always looked for substances that can alter their sexual experiences in some desired way. Sought-after effects include an increase in sexual desire, relaxation or suppression of inhibitions, and sensory intensification during sexual activities whether alone or with a partner. Today, recreational drug use prior to or during sex is still extensive, but far less so than during the freewheeling 1970s.

It isn't surprising that some anal enthusiasts have experimented with chemicals specifically to enhance their enjoyment of the anus and rectum. Similarly, those who want to enjoy anal stimulation but find it difficult to relax sometimes seek chemical help. Finally, men and women who are grappling with—or avoiding—one or more of the complex issues we've just been discussing may consider drugs an easy alternative for calming or forgetting about distressing inner struggles.

Anal relaxation or sensual enhancement claims are made for four types of popular drugs: (1) alcohol and other depressants, (2) marijuana, (3) cocaine and other stimulants, and (4) volatile nitrites. All except alcohol are illegal and all have a variety of negative side-effects, some potentially serious, when over-used. Anyone who aspires

to optimal anal pleasure and health and who might, or already does, use any of these drugs is wise to become informed about them, especially how each affects anal relaxation and enjoyment.

Alcohol and Other Depressants

Because alcohol depresses the central nervous system and because it's legal and readily available, it is by far the most popular drug for lowering anxieties and inhibitions prior to sex. Other drugs, such as barbiturates, are almost identical to alcohol in their effects. In fact, a person who develops a tolerance for alcohol will simultaneously develop tolerance for barbiturates.

Subjectively similar to alcohol are anti-anxiety drugs and minor tranquilizers, especially benzodiazepine compounds such as the well-known brands Xanax and Valium. These drugs are more popular for sex than barbiturates because doctors are more willing to prescribe them and because they can calm anxieties and inhibitions with less drowsiness than barbiturates. Benzodiazepines also have mild muscle-relaxing qualities which, in some instances, may reduce anal tension slightly.

One of the top reasons why alcohol and other depressants are used for anal sex is because of their calming effects—although some people are clearly energized by them, especially at lower doses. Central nervous system depressants are primarily used as a prelude to anal and other sexual activities because of their ability to reduce inhibitions. Luckily, the inhibition-reducing and anti-anxiety effects of all depressants reach their peak, for most people, at relatively low doses, such as one or two glasses of wine.

At higher doses these drugs have a sedating effect, reduce our sensitivity to touch, may disrupt sexual functioning, or significantly impair our judgement. Obviously, none of these side effects is conducive to sexual fulfillment, regardless of whether the anus is involved. Combining alcohol and other depressants is especially risky because each intensifies the effects of the other, often unpredictably.

Users of any depressants should also be aware that tolerance for these drugs develops fairly rapidly so that increasingly larger doses

are needed to obtain the same effect. This characteristic gives users of these drugs a relatively high potential for habituation and addiction. And because heavy use of any depressant with anal stimulation decreases awareness of pain, the user can be deprived of the messages necessary to guard against anal damage, especially when vigorous internal stimulation is practiced.

Marijuana

Although marijuana is still illegal and not nearly as available as alcohol, the smoking of marijuana to enhance sexual experiences is almost as common among some groups as drinking. For many, marijuana appears to have relaxing and inhibition-reducing qualities similar to those of alcohol and other depressants, but with less sedation. The effects of marijuana are quite variable. For example, some people regularly use marijuana specifically as an aid to sleep while others are stimulated by it.

Marijuana enthusiasts virtually always mention its sensation-intensifying properties as one of the main reasons why they use it with sex. Some people find that a couple of puffs of pot contribute to anal relaxation and appreciation of sensations or fantasies. However, others report that marijuana makes them anxious, jumpy, even "paranoid" (intensely self-conscious)—feelings hardly conducive to anal enjoyment.

One of the advantages of marijuana as a recreational drug is the fact that higher doses generally don't produce significantly greater negative side effects, as is clearly the case with alcohol and most other drugs. Another positive attribute of marijuana, from the standpoint of anal health, is the fact that it's less likely to deprive the user of the sensitivity needed for anal self-protection. But the belief that marijuana is benign is false. Regular users can experience powerful dependencies, reductions in motivation and energy, and negative effects on memory, thinking, and mood. In addition, smoking today's potent pot is puff-for-puff more damaging to the lungs than nicotine. Occasional and sensible use, however, appears to be no more or less dangerous than moderate drinking.

Cocaine and Other Stimulants

A white powder derived from coca leaves, cocaine is usually inhaled to produce a fairly brief, euphoric-stimulant effect. Its stimulant qualities can, in some instances, intensify sexual interest, fantasies, and sensations. On the other hand, because cocaine not only stimulates the central nervous system, but also the sympathetic nervous system that activates the body's reactions to danger and stress, the anal muscles may actually contract involuntarily as a result of cocaine use. This reaction occurs particularly when a person is feeling anxious to begin with.

Some people foolishly apply cocaine directly to the anus where it is absorbed into the bloodstream and also acts as a local anesthetic. Because this practice numbs the pain signals that would normally tell us that something is wrong, significant physical damage is sometimes the unwelcome result.

The fuzzy line between stimulation and stress also tends to make other stimulants such as methamphetamine (known on the street as speed, crystal, or crank) counterproductive for anal relaxation, even though they may intensify the subjective sense of anal eroticism. For some people, though, cocaine and other stimulants help divert their attention from worries about sexual performance. Consequently, the tension-producing tendencies of these drugs may be offset by higher levels of arousal.

This sort of trade-off probably accounts for the popularity of MDMA, popularly called ecstasy, which combines both stimulant and psychedelic effects. Some users report a heightened sense of intimacy, affection, and sensuality. Although some say they don't feel "speedy" on ecstasy, the typical increases in heart rate and blood pressure indicate otherwise.

Because so many people use and abuse it, alcohol causes far more problems than any other drug. But from everything I've observed over the last 25 years, I've concluded that the stimulant drugs, especially amphetamines, place users at the greatest risk for devastating effects on their sexuality. A distressingly high proportion of long-term users develop addictions that can be every bit as difficult to kick

as heroin. Stimulant highs are typically followed by demoralizing crashes which can last for days or even lead to chronic depression that can be relieved only by yet another drug-induced high. And if this isn't enough reason to beware, regular speed users often end up losing their sex drive or their ability to become aroused. My advice: If you wish to experiment with recreational drugs for sex, pick something besides speed.

Volatile Nitrites (Poppers)

For many decades volatile nitrites have been used medically for the relief of chest pain. Pharmaceutically produced amyl-nitrite (the prototype of this group of drugs) comes in capsules covered with a fabric webbing. To use, one crushes a capsule and inhales the fumes. The sound of the capsule breaking has resulted in the nickname "poppers" for all volatile nitrite liquids, whether or not they are packaged in breakable capsules.

In the 1970s poppers became quite popular as a recreational drug, first among gay men and later among young sexual adventurers of all orientations. They mostly fell out of favor in the eighties because of medical concerns that long-term use could be a co-factor for the development of Kaposi's Sarcoma, a skin cancer most commonly seen in gay men infected with HIV. As that concern turned out to be unwarranted, poppers have made something of a comeback in the nineties.

Inhaling the fumes of volatile nitrites causes blood vessels to dilate, which in turn triggers a rapid *drop* in blood pressure, followed by a dramatic increase in heart rate as the body attempts to stabilize blood pressure. Within a few seconds of inhalation the person experiences a "rush" which devotees say enhances the intensity of orgasm and causes a brief sense of abandon during dancing or sex. The entire experience lasts only a couple of minutes.

Some people claim that inhaling poppers helps the anal muscles to relax and therefore makes it easier to receive a finger, object, or penis into the anus and rectum. It has been known since the late 1920s that volatile nitrites have a mild antispasmodic effect on the gastrointestinal tract (Holmes & Dresser, 1928). Poppers can also

enhance relaxation by providing a feeling of flushed sensation all over the body, which may increase desire for anal stimulation or divert one's attention from worrying about it.

Many people feel anything but wild abandon when they inhale poppers. Instead they feel scared and even panicky as their bodies react to the disequilibrium caused by the drug. And because volatile nitrites are the shortest-acting of all recreational drugs, many users inhale them repeatedly in the course of a sexual encounter. Used this way, poppers not only become decreasingly effective but may also produce headaches and feelings of depression. These effects are undoubtedly exacerbated by impurities of poppers produced in unregulated, often makeshift labs; you never know exactly what you're getting. Many experienced users seek to minimize negative effects by limiting popper use to one or a few high points during sex—such as just before orgasm. As with all drugs, an inability to restrain usage is a sign of dependency.

Variability of Effects

It's inaccurate to say that any particular drug causes most of the effects ascribed to it. Responses to all drugs vary widely from person to person and from situation to situation. With experience most people learn to predict their own responses fairly well by taking into account the many important factors that affect them such as emotional state, setting, expectations, reactions of others, dosage, and interactions with other chemicals.

While all drugs trigger varied responses, some are more variable than others. For example, large quantities of alcohol invariably produce the symptoms universally recognized as intoxicated. But how much alcohol it takes to produce drunkenness and whether a drunk person staggers joyfully, tearfully, or looking for a fight depends on factors other than the alcohol itself. The effects of other drugs, most notably marijuana, vary so widely from person to person that no particular response can be expected consistently.

Nowhere is this variability of responses more obvious than it is with anal eroticism. A drug that appears to obliterate the last vestiges

of anal tension and inhibition for one person may make another person taut, frustrated, or totally uninterested. Any drug may conceivably help reduce anxiety about anal eroticism, increase it, or have no effect either way. Those who claim that a particular drug *makes* a person more open to anal eroticism are simply misinformed.

What to Do

Especially if you have trouble associating erotic feelings with the anal area or find it difficult to relax sufficiently to enjoy them, it can be tempting to search for a drug to—as one client put it—"open doors that I don't even know how to find." And it can't be denied that the use of a drug can, on occasion, trigger a breakthrough in the erotic enjoyment of the anus. Nonetheless, I believe that recreational drug use should be kept to a minimum or avoided altogether, particularly during the early stages of anal erotic exploration. Certainly, if an occasional glass of wine or puff of marijuana helps you to relax and focus on pleasurable sensations then there's no reason, other than moral or legal concerns, for not using it.

Keep in mind that healthy recreational drug use requires that the drug primarily be used to *enhance* experiences. This is possible only when the person can also enjoy that experience without the drug. If a person believes that a certain drug is *required* for the full enjoyment of anal eroticism (or anything else), then he or she has become dependent on the drug. Dependency of this type, reinforced over time, is highly likely to be detrimental to one's enjoyment of sex as well as to one's overall well-being.

If you find yourself using more than moderate amounts of a drug or using it more than occasionally when you explore anal eroticism, then you're probably looking for a chemical solution to inhibitions that can be more safely and effectively reduced through gentle, persistent self-exploration.

Once you become fully at ease with anal eroticism, you'll be in a much better position to decide which recreational drugs, if any, you'd feel comfortable using, in what quantity, how often, and under what circumstances. Take the time to gather much more information than

I have presented here about any drug you might consider using or are already using. Even though research on the effects and risks of most drugs is far from conclusive, it's still possible to weigh potential risks against likely benefits and structure one's drug use to keep the risks to a minimum.

Especially since the AIDS epidemic began, self-affirming men and women have been carefully evaluating—and often reducing or eliminating—their use of recreational drugs. Heavy drug use suppresses the immune system and undermines good judgment, possibly making a person more susceptible to HIV and other sexually transmitted diseases (see Appendix A).

Drug use that is primarily motivated by a desire to reduce anal pain is virtually always unwise. Anal pain that accompanies the insertion of an object into the rectum signals the need for relaxation or indicates a medical problem. It isn't helpful, and may be extremely damaging, to try to deaden anal pain chemically. Therefore, never apply over-the-counter local anesthetics, cocaine, or any other sensation-reducing agent to the anus. Pleasure and numbness are inherently incompatible.

Coping effectively with the complexities of recreational drugs, feces, homophobia, gender roles, and the paradoxical effects of the taboo takes considerable awareness, courage, and persistence—all built on a fundamental desire to act in the most self-affirming ways possible.

11

Mutual Exploration
Sharing Anal Pleasure with a Partner

N OW THAT YOU'VE BEEN paying more attention to your anus and rectum, you can begin making choices as to whether, and in what ways, you wish to include this area in sensual and erotic experiences with a partner. Of course, these decisions don't have to be made all at once. Remember your private anal explorations: Before you began you couldn't know for sure what they were going to be like. What you thought, felt, and did unfolded in tandem with new information and first-hand experience. The same will happen as you consider the interpersonal aspects of anal eroticism.

Receiving anal stimulation from another is very similar to giving it to yourself; either experience is best in the context of a positive, non-threatening relationship. So far you've cultivated a "relationship" with your own anus and rectum. But you may not yet be equally comfortable with a partner. This chapter is devoted to building such a relationship. Our goal will be to combine verbal and tactile communication into a seamless tapestry of respectful connection between you and your partner. Unfortunately, many people neglect verbal communication the moment they begin touching. They forget that both aspects of communication are essential for deeply satisfying interactions.

The key is to develop or refine crucial skills, including the ability to make and receive explicit requests, to experiment playfully without

pressure or demand, and to ask for and receive explicit verbal feedback. Obviously, these skills are useful not only for anal exploration, but for all forms of shared enjoyment.

Almost any form of anal-rectal stimulation with a partner can be part of your experimentation at this point, with one exception—intercourse, our focus in the next chapter. Believe me, putting intercourse aside for now will serve you well. Many couples make the error of jumping into intercourse without adequate anal touching first. Far too often the result is a negative or painful experience which can easily be avoided by taking it one step at a time.

Choosing a Partner

Who would you like to accompany you on this adventure? If you're in a monogamous relationship the choice is obvious. If you're in a primary but non-monogamous relationship, chances are you'll want your primary partner to participate with you. However, if you've received a clear message from your partner that he or she has no interest whatsoever in anal exploration, then you'll need to weigh the advantages and disadvantages of asking someone else. Maybe you've already been talking with another sex partner about your self-exploration and have found them to be more supportive. On the other hand, you may not know anyone like this, in which case you'll want to consider whether cultivating an outside involvement is a good idea.

Choosing a non-primary partner for anal experimentation may very well threaten your primary relationship, but not necessarily because of the sex. Actually, many non-monogamous couples learn to cope with outside sexual contacts with a minimum of turmoil. A far more serious threat arises if the secondary relationship becomes more communicative, and thus more intimate, than the primary one.

For those who are dating but not seriously involved, or for those not seeing anyone, focusing on several questions can help you identify a potential partner either now or in the future: In what kind of relationship would you expect to feel most open to experimentation,

even if some of it is awkward? Do you want to be "in love"? For some this is a must because they're gloriously uninhibited when caught up in the unbridled intensity of romantic passion. For others the vulnerability of high romance is an inhibiting factor because the emotional stakes are so high. In addition, during early romance the starry-eyed partners are often convinced that communication about sex is superfluous because they're so magically attuned.

I've also known people who've found it easier to be adventurous with an ongoing sexual friend—what some people call a "fuck buddy"—because they share an informal, relaxed rapport unencumbered by the intensity and expectations of a romantic attachment. Others don't want a sex buddy but derive a similar sense of freedom from dating two or more people at once.

Some people are understandably upset when they're ready for anal exploration with a partner but they don't yet have one, perhaps not even any prospects. Needless to say, those who long for a relationship experience sadness and frustration at times; feeling a new level of openness can make the sting of loneliness all the more poignant.

If you're in these circumstances, about all you can do is make yourself as emotionally available as possible, identify ways in which you might be holding yourself back, vigorously reject the common misperception that single people are somehow inferior, and by all means be patient. Remind yourself that the self-exploration you do now can enhance the joy of future intimate connections. Relationships are often at their sweetest following an extended dry spell.

Once you've selected a suitable partner the next step is to present a clear proposal for what you have in mind, and why you think it would be beneficial to try it. If you've kept this person up to date on your private activities and he or she has been encouraging, then your request will likely be greeted with enthusiasm. Planning time and defining a few basic ground rules may be about all you'll need to do.

Typically, however, the transition to shared anal exploration requires one more ingredient: opening or expanding a dialogue about each other's feelings, wants, and hopes. Be sure that both of you bring up any reticence, worries, or concerns you have, even if they're diffi-

cult to talk about. The main goal is to reach a mutual understanding of what each of you requires for the most comfortable experience possible. Use a consensus approach—don't try anything unless you both genuinely want to.

Reluctance, wherever you may find it, is usually a sign of fear, one of the most difficult emotions to articulate. Intimate self-disclosure and some gentle probing may be necessary to uncover what a person is truly concerned about. But once acknowledged, many concerns are easy to take care of. For instance, worries about encountering feces can be addressed by agreeing to take a shower or bath together beforehand. Anticipated awkwardness with the unfamiliar may result in thoughts such as, "I'm not sure I can do it right," or, "what if I freak out half way through?" A mutual understanding that you're both entering new territory, that there's no "right" or "wrong" way to respond, and that you'll stop the moment either of you asks, all go a long way toward building a sense of security.

Your partner will be more willing to participate if it's clear that *both* of you have something to gain. Your partner's reticence is likely to soften if you express willingness to discuss or experiment with something he or she has been wanting. For example, Laura convinced her lover to try non-intercourse-oriented sensual touching—with the possibility of anal touch—by suggesting that this might help her feel more at ease giving him the oral stimulation he'd been craving for a long time. Another couple agreed to try a total body massage one night in exchange for going out dancing the next.

If your partner hasn't done any anal exploration privately, he or she may fear that you'll want to touch his or her anus as well. Not surprisingly, this fear is especially common among men in heterosexual relationships. Depending on how you feel, you can offer assurances that one-way anal touching is acceptable. This is difficult for couples who feel that every sexual or sensual activity must always be reciprocal. It's also quite possible that you may be open to receiving anal touching from a partner, but not yet ready to touch your partner in the same way; make your limits clear.

It's never too late to suggest that you and your partner read all or

part of this book together or separately. If your partner is open to the idea, this can be an effective way of fully engaging him or her in the process, promoting mutual comfort and understanding, and leveling the playing field between you.

Experience

Start by making two explicit agreements with your chosen partner: (1) that you'll spend time together exchanging pleasurable touch all over your bodies including your anus (and, if desired, your partner's anus as well), and (2) that you will *not* have anal intercourse during this encounter no matter how tempting it may be.

After taking a bath or shower together, find a comfortable place—not necessarily the bedroom—in which to take turns pleasuring each other. When you're being touched don't *do* anything. Just lie back and enjoy it. See if you can focus all your attention on yourself. Likewise, when you're the toucher, focus all of your attention on what that experience is like. When touching, make no attempt to read your partner's mind. Assume that what you're doing is fine unless you hear otherwise or, if in doubt, ask directly.

Use a massage oil to eliminate friction and add a silky feel. Safflower or peanut oil works just fine, as do a variety of commercial preparations. The oil can be warmed by placing the container in hot water. If you haven't had this kind of experience before, it's a good idea to plan at least one massage exchange that doesn't include anal stimulation.*

If you've agreed that anal touch will be reciprocated, decide who will receive first. Make an explicit agreement that each will ask the other to stop *before* anything becomes annoying or uncomfortable. When you're thoroughly relaxed, find a comfortable position in which the receiver's anus can be explored visually and tactilely. It works

* Readers who would like to learn more about this kind of massage can find guidance in Ray Stubbs' *Erotic Massage*.

well for receivers to lie on their backs or fronts with touchers sitting or kneeling between their spread legs. At an appropriate moment, the toucher can apply extra lubricant to a finger and also to the receiver's anus. Note: if it will contribute to either partner's comfort, a latex glove can be used with a water-based lubricant.

As both of you breathe deeply the toucher can gently massage the anal opening and then, if there's a positive response, slowly slide a finger into the anal canal and lower rectum using only a slight pressure. Once inside, it's best to let the finger rest there for a few moments before beginning slow and sensuous movements. Use the other hand to stroke the inner thighs, buns—anywhere that can easily be reached. Male receivers may want their prostates massaged and, if so, should guide the toucher with groans and words. The prostate is a few inches in and can be stimulated through the front of the rectal wall (in the direction of the genitals). The toucher's longest finger is usually best for prostate stimulation.

If the receiver is having an enjoyable time, the toucher may want to prolong the experience with a medley of strokes and caresses. How does the receiver respond to a feather-light touch around the anal opening? Is there a change in response with a deeper or faster touch? Does sliding in a finger ever so slightly and then slowly removing it incite the recipient to beg for more? Might the receiver enjoy the gentle insertion of a dildo or butt plug?

Many receivers will find this sensuous attention quite arousing, in which case the toucher may supplement anal-rectal caresses with genital massage, using one hand for each area. Applying a bit more oil to the genitals may be a welcome addition. Sometimes this combination of manual genital and anal stimulation can be overwhelming; in other instances it's a recipe for ecstasy. Another combination that some receivers enjoy immensely is simultaneous oral-genital and anal stimulation. Keep in mind that some receivers will become aroused only intermittently or not at all, and may prefer not to have their genitals stimulated during anal play. But this doesn't mean they're not feeling good. When in doubt, just ask.

All of these suggestions are merely options to consider and to dis-

cuss beforehand and afterwards. Adopt a slow-paced, experimental approach with as few expectations as possible. And avoid the pitfall of frantically trying to do it all; there'll be plenty of other opportunities in the future. When something feels particularly good, savor it.

If being the receiver leads you into a state of high arousal and orgasm, allow the waves of pleasure to ripple through your entire body. Whatever you do, don't make having an orgasm into a necessity, a chore, or a symbol of success or failure.

When the time seems right, take a languid break before trading places, perhaps washing up with soap and water or baby wipes and then holding and kissing each other for a while. Be sure to check in on how you're both feeling thus far. If only one partner has chosen to receive anal stimulation, offering the toucher another kind of sensuous or erotic pampering is a fitting expression of gratitude.

Making Requests

Later, or perhaps on another occasion, take turns pleasuring each other in the same way, only this time agree that the person being touched will direct the action by making requests. The receiver begins by making a simple request such as, "I'd like you to massage my feet." Stick with what is requested until you get another message, such as, "A little harder and faster (or softer and slower) please," or "Include my legs now." Even though you'll probably feel a little silly at first, there's no better way to learn about each other's preferences.

A crucial aspect of effective sensual and sexual communication is the ability to speak up when something hurts, tickles, or is unpleasant in some other way. Isn't it ironic that during activities intended primarily for pleasure, so many of us grin-and-bear-it to protect our partner's feelings? Yet the vast majority of my clients say they'd like to know the truth—as long as it's delivered diplomatically.

You can expand the value of this exercise considerably if you mutually agree to practice giving and receiving "negative" feedback. Sometimes this begins with a direct statement such as, "Honey, that doesn't feel good." But don't stop there. Your comments will be much more easily accepted if you emphasize what would feel good or what

already has been feeling terrific. Saying, "I really like it when you..." is an excellent way to get your point across. Try it and you'll appreciate how much graceful skill is involved—and why repeated practice is a necessity.

Taking Breaks

Pause frequently during your activities. Maybe you'll just want to sit or lie together quietly or have an intimate chat. When someone requests a break, the session isn't necessarily over. Discovering this can help to replace a cookbook approach to sex with more spontaneous rhythms. When you stretch things out and make room for breaks, sexual arousal will almost certainly fluctuate. A man's erection may come and go, just as a woman's lubrication may ebb and flow. These changes are natural and don't reflect a lack of interest. Even if your erotic interest does wane, you can still enjoy yourselves; notice what it's like to give and to receive touch when you're not particularly aroused.

Coping with Anxiety

If at any point you feel anxious, uneasy, or self-conscious, these steps can help you relax: (1) tell your partner how you feel, (2) stop what you're doing, and (3) do something new that you can enjoy with complete comfort, or ask for whatever reassurances you need to continue what you're already doing. Lying quietly together and taking deep breaths in unison is an excellent way to relax. After restoring a sense of calm and security, decide whether you'd prefer to continue with anal touch or wait until another time.

Response

For most of my clients this kind of communicative, non-goal-oriented encounter is a landmark in the development of their capacity to share anal pleasure with another. Those who have never before included their anuses in erotic play are usually able to do so comfortably once they agree to take it slowly and let expectations dissolve. Those who've

unsuccessfully tried anal sex in the past may worry that anal stimulation might lead to intercourse and another "failure." The explicit agreement not to have intercourse sets the stage for a new kind of anal experience, completely free of pressures to perform.

Nancy, in therapy with her lover Tom, explained, "We've been together for three years now, and this is the first time we've agreed it's okay to touch each other's butts and talk about it without me feeling nagged and without Tom feeling guilty for raising the subject. What an exciting relief!" Then Tom added, "I realize I've never really explored Nancy's vagina that much either. I guess we've done a lot of groping in the dark. And usually I'm trying so hard to get her turned on or make her come. I didn't work so hard at it this time, but I think we got hotter than ever. I sure did. But we didn't *have* to—I guess that's the difference." And Nancy nodded.

Reports like this are common, but only part of the picture. Steve's experience was just as positive but in a different way:

> It seems like most of you guys [in the group] had a good time with this but I didn't. When my lover touched my ass I went up the wall. He said, 'What's the matter?' and I said, 'Nothing.' Of course, that was a bunch of crap and we both knew it. He said, 'Look, I thought we were going to be honest.' So I told him I hated it. It was really hard to say that but he calmly replied, 'So what else do you want to do?' That was three weeks ago and it was only last night that I let him touch my ass and it felt pretty good. I never knew I was so squeamish about it.

At first Steve thought that everything had to go like clockwork or else he had failed. Soon he came to understand that it's impossible to fail if you grant yourself permission to be completely yourself. Go ahead and be anxious, angry, bored—anything. If you communicate these feelings and go on from there, you've been true to yourself and real to your partner. I've talked with very few people for whom anal stimulation, or any sexual activity for that matter, is always pleasurable. If you expect this, you're setting yourself up for disappointment.

Many people report that what feels good is quite different from what they had imagined. For instance, people often assume that an in-and-out motion of a vibrator or finger will be the best because of

its similarity to intercourse. Actually, quite a number of people report that a gentle circular motion around the anal opening is much more pleasurable. This is understandable because the highest concentration of nerve endings are near the anal opening. But anal pleasure involves much more than nerve-endings and techniques; it's the total response of an individual to a unique set of circumstances.

The suggestions made here are for a particular kind of encounter that is slow, relaxed, and sometimes accompanied by discussion. Not every encounter will or should be like this. However, it's good to bring a little structure to an encounter—with your own creative variations. The basic principle is that by deliberately focusing on things that don't come naturally, you can integrate these skills into your repertoire of comfortable behaviors. For instance, usually you won't speak very much unless a specific request would enhance your pleasure—or you like to talk dirty. Sometimes you won't want to go slow. It's unlikely that you'll always want to take turns either. But it's good to be able to lie back once in a while without having to do anything.

Obviously, not all the potentials inherent in these communicative touching experiences can be realized in one session, or two, or even ten. Erotic communication is both a skill and an art; there's always room for refinement. Yet those who repeatedly try these experiences almost universally report a greater sense of freedom, a reduction of performance anxiety, and heightened feelings of intimacy.

As always, those who have the most difficulty doing these things, who find them threatening or silly, are usually the ones who most need to do them. Some feel that talking and planning takes all of the mystery out of sex. This concern is primarily based on a fear of sexual communication. An authentic sense of sexual mystery—which involves venturing beyond the predictable—is actually enhanced by full communication. People who rarely talk about nitty-gritty sexual details are often following a scripted approach to sex from which all genuine mystery has been carefully extracted.

The Nice Person Syndrome

Some of us are strongly influenced by a destructive pattern called the Nice Person Syndrome, which distorts or totally blocks effective communication. The Nice Person Syndrome is an exaggerated role adopted during childhood as a means of getting approval and affection. Nice People are carefully trained to be good boys and good girls at all costs. They're steeped too soon and heavily in the values of unselfishness, cooperation, and pleasing others. They grow up inclined to defer to the wishes of others and to put their own desires in second place, or ignore them altogether.

I use the word Nice (capital N) to describe adults who still act like good boys and girls. Such people are often highly intuitive but they use their sensitivity mostly for the purpose of discerning what's expected of them. They have a profound need to be liked and will violate, if necessary, their own integrity for even the possibility of love and affection. Ironically, they usually *are* accepted and well-liked, but they're not satisfied because they know they've withheld something of their true identity. As a result, Nice People often live in fear that nobody will ever really love them—including their imperfections and blemishes. They're convinced they must be perfect yet they're constantly and painfully aware that they're not. Not surprisingly, they often exhibit bodily signs—including anal tension—of an unrelenting inner conflict.

Nice People operate on the basis of one central conviction: The only way to get what I need is to avoid upsetting anyone. They're usually very good at getting what they want without asking for it, but there's always something missing. Spontaneity is difficult since each interpersonal exchange is, in a sense, a performance. Keeping up the image requires constant vigilance, since all "bad" qualities—such as anger, selfishness, or competitiveness—must either be squelched, denied, or re-channeled in such a way that they at least *appear* nice.

I've deliberately presented a somewhat exaggerated characterization. But in it you may be able to see aspects of yourself. If so, I suggest that you look more closely at the negative effects this pattern

is having on your relationships and sexuality. The impact of the Nice Person Syndrome is typically heightened in the presence of a significant other. This helps explain why some men and women can feel very relaxed and safe when they're alone, but tense up when they're with someone. In fact, people who have trouble sharing anal pleasure with a partner when they can easily give it to themselves often discover that playing Nice is getting in the way.

Nice People have trouble making straightforward requests. Instead, they tend to be manipulative, maybe dropping a few hints or else giving what they, in fact, want to get. One of my clients expressed his strategy for getting what he wanted from people as "nicing them into submission." Nice People believe that if they're just good enough, others will eventually discern what they want and give it to them. When this doesn't happen they're hurt. They would feel angry too— but that's not Nice.

Nice People are usually "rescuers" who gravitate toward taking care of others. We rescue somebody each time we withhold or distort our true feelings to avoid hurting or upsetting the other person. We do the same thing when we go along with something when we really don't want to. What we usually don't realize is that in rescuing others we treat them as helpless victims who can't take care of themselves. Rescuing, except in instances when someone genuinely needs help, is actually a subtle put-down.

Because Nice People have trouble expressing their desires, they tend to infuse potentially pleasurable situations with obligation and duty. After launching a sexual encounter they may feel compelled to go through with it to the bitter end. This is one reason why making requests and taking breaks is especially important, although at times exceedingly difficult.

All of the experiences suggested here can help you become more cooperatively selfish. Non-manipulative communication is the only way to remain simultaneously in full contact with yourself and your partner. Obviously, if you tune out your partner, touching can become an exercise in alienation. But what many fail to recognize is that if you ignore your own desires and feelings, then you have very little to share.

But if you maintain a rich connection with your partner *and* yourself, you'll become a more sensuous and enthusiastic lover.

Rimming (Analingus)

One form of anal stimulation that you and your partner may wish to discuss is oral-anal stimulation, technically called *analingus* but popularly called "rimming." Because the lips, tongue, and anal opening are all highly sensitive and potentially erogenous, it isn't surprising that many people enjoy bringing them into intimate contact. Rimming involves kissing or licking the anal area. Occasionally the tongue is partially inserted into the anal canal and moved in-and-out or in a circular motion. Some people have a strong, perhaps even exclusive preference for either rimming or being rimmed. Others enjoy both, either taking turns or else experimenting with positions that allow simultaneous rimming. But for many, such positions are too awkward to be enjoyable.

Of all forms of anal stimulation, rimming is most likely to trigger strong revulsion and disgust. Most of us learned early in life that when something is dirty we should definitely avoid putting it in or near our mouths. For this reason, partners would be wise to avoid pressing each other into rimming. If someone is uncomfortable with it, even the thought of rimming can be a complete turn-off.

Those who decide to explore rimming usually want to try it during or immediately after showering or bathing. This can lower discomfort with the odors commonly found in the anal area and also reduce the possibility of encountering feces. There are some people, however, who find anal odors highly arousing. For these people, washing actually reduces the excitement.

Frequently, those who are squeamish about rimming feel the same about being rimmed. Others enjoy being rimmed even though they would never consider rimming their partner. Sometimes rimming is a part of s/m role playing. Here the rimmer is seen as the submissive "bottom" and the one rimmed is the dominant "top." For some of

these men and women, the notion that rimming is degrading and humiliating heightens their turn-on. Those who don't want to feel degraded won't enjoy rimming unless and until they view it as pleasurable rather than subservient.

Unfortunately for those who enjoy rimming, there are significant health risks involved such as contracting or spreading diseases like hepatitis A and intestinal parasites. Those who want to experiment with rimming should read Appendix A, carefully consider the risks, and adopt a safe rimming policy. For example, thorough washing substantially reduces the risk of infection, as does limiting the number of partners with whom one practices rimming. An effective means of eliminating the risk of infection is to use a barrier such as a "dental dam" (a small latex sheet available at some sex toy shops) or a piece of plastic wrap. Some creative rimmers cut a non-lubricated condom or latex glove into workable shapes that facilitate protected tongue insertion.

The risk for healthy, monogamous couples is extremely low. However, a person can have an intestinal infection, even for a long time, without realizing it. And in casual sex settings, especially the kind readily available to gay men in urban areas, a partner's penis could easily have just had contact with someone else's anus. In this case the risks of oral-penile sex are similar to those of rimming. Also, engaging in oral-vaginal contact after unprotected rimming can cause vaginal infections.

Thinking about and discussing these issues may not be entertaining conversation. You might be tempted to ignore the entire subject of rimming. However, virtually all of my clients discover that discussing the risks and pleasures of rimming—along with other erotic alternatives—helps them to be less anxious about sex in general because they know what they're comfortable with and what they're not. This knowledge frees them to enjoy whatever they choose to do.

12

Anal Intercourse
Enjoying It Safely and Comfortably

P EOPLE WHO HOPE to enjoy anal intercourse usually view it as the culmination of their anal exploration activities, which is hardly surprising considering the prevailing belief that intercourse *is* sex. One advantage of following the step-by-step approach recommended in this book is that it provides first-hand opportunities to discover just how satisfying even the simplest forms of anal stimulation can be. As a result, many people report an unmistakable *decrease* in their preoccupation with intercourse. In turn, as they move beyond an intercourse-centered view of sex, they're much better able to enjoy whatever anal activities they choose, including intercourse. Conversely, whenever intercourse feels like a requirement rather than an option, the capacity for taking genuine delight in it drops substantially.

Even those with an expanding anal repertoire think of receiving intercourse as a bit of an ordeal, and for good reason too. Not only does it require even deeper levels of self-understanding and honest communication, there's also a whole new group of risks and opportunities to take into account. Only about a quarter of my research participants were able to progress quickly from other forms of anal stimulation to intercourse. I'm not saying that intercourse is necessarily difficult; in most cases it's not at all. But usually the transition works

best when it's approached gradually and totally free of pressures.

Not surprisingly, taking it slowly is especially important for those who've been hurt by or traumatized by intercourse in the past. Anybody who's coped with a painful anal medical problem, been coerced or abused, or been subjected to heavy demands from a partner, knows how difficult it is to replace negative associations with positive ones. With patience, though, most people who desire anal intercourse are eventually able to make it safe enough to enjoy, at least occasionally.

There is little likelihood that anal intercourse will become enjoyable unless self-pleasuring has first become comfortable. I've seen only a few exceptions to this rule. These few, mostly men, once given permission and basic information, go directly for intercourse. I recommend that you not attempt intercourse until you've tried most of the experiences suggested thus far. This is a caution to those of you who skipped or skimmed the previous chapters because they seemed too elementary.

Similarly, those who make a point of developing and practicing the verbal and tactile communication skills discussed in the last chapters usually find the transition to anal intercourse far less anxiety-provoking and thus more enjoyable than those who skip these exercises. Virtually all of the women and most of the men I've worked with feel that a partner with whom they have already shared other experiences is the natural choice for experimentation with anal intercourse. However, a few of the men prefer a partner whom they don't already know. Rather than consciously creating a comfortable atmosphere for experimentation with anal intercourse, these men wait until they're in the mood and then go ahead and do it. Of course, the AIDS epidemic requires that they give the matter at least enough forethought to have condoms handy and to know how to use them effectively.

In general, once anal self-pleasuring and non-intercourse mutual pleasuring have become enjoyable, a positive transition to anal intercourse is almost totally dependent on how it's attempted and the nature of the relationship in which it occurs. Some people abandon all they've learned about their anal muscles and expect them to yield to intercourse immediately without giving themselves a chance to

relax and feel secure. More than a few violate their no-pain-ever agreement and resort to coercion, and then are frustrated and disappointed when pain is the result. The goal of this chapter is to help you explore anal intercourse while remaining in contact with both your partner and yourself.

What is Anal Intercourse?

Anal intercourse involves inserting an erect penis through the anal canal and into the rectum, typically accompanied by varying types of rhythmic movement and body contact. This traditional definition precludes a number of intriguing possibilities, such as two women enjoying intercourse with each other, a straight man being on the receiving end with a woman lover, or a man who can't, for whatever reason, maintain a rigid erection as the inserter.

We can begin to see how anal intercourse could occur in any of these situations if we broaden our definition to include the option of using a phallus-shaped object instead of an actual penis. With this slight change, anal intercourse becomes available for practically anyone who wants it, whether there's an erect penis around or not.

Ever since the invention of the strap-on dildo, anyone can enjoy intercourse as the inserter, the receiver, or both. Strap-on harnesses are made of leather or fabric. The most common designs have an adjustable strap for the waist plus two others for the legs. In the front, a ring holds a dildo with a flared base securely against or slightly above the genitals. When a woman uses a strap-on for anal or vaginal intercourse, the base of the dildo may stimulate her clitoris, adding intense sensations to the psychological aspects of intercourse. Men can also use a strap-on when they don't have an erection, prefer a more prolonged experience, or don't want to use a condom. Needless to say, it takes practice to use these devices effectively and comfortably.

Another alternative is a flexible "double dildo." Longer than the usual variety, with a head on each end, and requiring no extra equipment, double dildos are ideal for couples who are curious about the

sensations of penetration.*

Any combination of mutual insertions is workable: anus and vagina, two vaginas, or two anuses. Be aware, however, that coordinating positions, angles and movements is tricky, to say the least. And remember to wash the dildo thoroughly before switching orifices.

The advantages of moving beyond a penis-required conception of intercourse seem obvious. Yet a surprising number of people find the idea ludicrous or even personally threatening. I've often heard it said by men and women alike that intercourse without a penis is just pretending, a pale imitation of the real thing. Hardly any, though, have actually tried it, which raises the question: Why not? What's the point of clinging to an unnecessarily restrictive idea of anal intercourse?

Expanding our ideas about intercourse requires that we free ourselves from the limitations imposed by strictly defined gender roles—an unwelcome proposition even for some who consider themselves liberated. If anyone can be an inserter or receiver, how do we know how to act? The answer, of course, is: any way you want. But even those who've been oppressed by gender stereotypes may still be reluctant to violate them. Some women fear that being more sexually aggressive is unfeminine. And men who place a high value on traditional masculinity often can't tolerate being penetrated because they fear being somehow depleted or demeaned by it. I can't help but wonder what such fears reveal about their attitudes toward those whom *they* wish to penetrate. Are these partners similarly demeaned?

Most of us realize, to some degree at least, that intercourse—anal or vaginal—is much more than body parts interacting. All deeply satisfying erotic activities are personally meaningful in more ways than one. Far richer than any technique or mechanical devices, intercourse is an act of the imagination, a dramatic role play, a state of mind, an avenue for self-expression. During your self-exploration you probably encountered some of the social, psychological, and interpersonal meanings attached to anal stimulation. How could it be any less so with intercourse?

I'm devoting the next chapter to some of the most common of these meanings—the ones linked to power. As we shall see, both vagi-

nal and anal penetration often derive their intensity not only from the sensations involved, but also from top-bottom dynamics in which one person dominates and the other submits. We know that many men and women of all sexual orientations are fascinated by these dynamics, often taking great delight in abandoning their culturally assigned roles; some men long to be dominated and some women are more than happy to oblige. Who does or doesn't happen to have a penis can be temporarily irrelevant.

For the sake of simplicity, when referring to anal intercourse in this chapter I'll often refer to "he" as the inserter and "penis" as the inserted object because this is the most common arrangement. But please keep in mind that except where I specifically describe what can happen for a man and his penis, everything else applies equally well to the use of a dildo.

Condom Sense: Which Type is Best for You?

One of the first things you have to think about when it comes to intercourse is how to protect yourself from sexually transmitted diseases (STDs)—including, but not limited to, HIV and AIDS. Partners who've been in a monogamous relationship for at least six months and have both recently tested negative for HIV, and are free of intestinal infections, don't have to be concerned about protection. Even so, many health-conscious monogamous couples continue using condoms to be extra safe or to streamline cleanup.

There are two fundamentally different kinds of condoms to choose from: the traditional latex male condom and the newer "female condom," a polyurethane pouch that fits inside the vagina or rectum rather than being worn by a man. The more you know about their advantages and disadvantages, the wiser will be your choices.

Latex Condoms
Few items have been cursed and derided as vociferously as the lowly "rubber." And yet I can't think of another simple device that has pro-

tected so many millions of people from such a variety of dangerous or even deadly infections. For this fact alone condoms deserve our gratitude.

Although very effective, condoms are far from ideal. Anyone who's tried one on has noticed a significant blunting of tactile sensations; there's no way around this. Besides the reduction in feeling, condoms take practice to put on gracefully, can easily interrupt the flow of an encounter, and more often than most guys admit, the whole process can create sufficient self-consciousness to disrupt their erections partially or completely. From a health perspective they're also prone to breaking or slipping off, which you may not even notice if you're caught up in passion.

In spite of their drawbacks a great many people learn to use condoms effectively with a minimum of disruption. Some creatively erotic users even learn to associate them with sexual arousal, even to the point where opening the package and sensuously slipping on the condom becomes part of the turn-on. Combine this inviting prospect with the fact that latex condoms *work* to prevent disease and pregnancy and you can see why they're so readily available and widely used.

To get the most out of latex condoms you need to memorize a few basic principles:

- Buy only lubricated latex condoms, with or without a spermacide such as nonoxynol-9.*
- Keep extra water-based lubricant on hand; oils deteriorate the latex.
- Put the condom on before your penis touches your partner's anus; many men secrete fluids ("pre-come") before they ejaculate and others may ejaculate quickly and unexpectedly.
- Use a fresh condom for each erection.
- Open the wrapper close to an edge to avoid tearing the condom, and keep it rolled up until you put it on.

Next, practice the following steps—first by yourself, perhaps dur-

* Although nonoxynol-9 kills sperm and HIV in the lab, its effectiveness in actual practice is in doubt. In addition, spermacides can cause irritation of vaginal and anal tissues, which may create an entry point for HIV.

ing masturbation, and then with a partner—until you can put one on smoothly and without struggling or fumbling. While experimenting with yourself, deliberately break and tear a few condoms so you have a clear idea of how much stress they can take.

- Place the rolled condom over the tip of your erect penis; put a few drops of water-based lubricant inside if it's not sufficiently lubricated.
- Leave a half-inch space at the tip to collect semen; most condoms have an obvious reservoir tip for this purpose.
- Before rolling it on, gently squeeze out any air trapped in the tip to reduce the chance of breakage.
- Unroll the condom to the bottom of the shaft, smoothing out air bubbles as you go.
- Apply extra water-based lubricant to the outside of the condom as well as to your partner's anus; consider doing this earlier during finger massage.
- During intercourse, check the base of the condom regularly with your fingers to make sure it's still in place.
- When you pull out (preferably before you ejaculate) hold the base of the condom.
- Be careful not to spill any semen before you dispose of the condom.
- If you've ejaculated, wash your penis and hands (plus any other areas where semen may have spilled) with soapy water before embracing again.

Trust me, it sounds much more complicated than it actually is. These guidelines are mostly a matter of common sense once you clearly grasp this simple imperative: A man needs to keep his urinary opening and semen away from his partner's anus or vagina. Doing this is what protects you both.

The Reality "Female Condom"

After years of development, testing, and languishing in limbo, during the summer of 1994 a new type of condom began appearing in American pharmacies and supermarkets. Known as the "female condom" or "pouch" and marketed under the brand name Reality, it

deserves far more attention and experimentation than it has received thus far. Although officially approved by the FDA for use only in the vagina, the Reality should also be seriously considered by men and women interested in anal intercourse.

The FDA has neither studied nor approved Reality for anal use because anal intercourse is a felony under antiquated anti-sodomy laws still on the books in 25 states. They consider it inappropriate to market a product to use for illegal activities. Following the same short-sighted logic the FDA has also failed to approve regular latex condoms for anal use, even though they save millions of lives. In spite of the FDA's blind spot on this topic, all kinds of people, especially gay men, are reporting that the pouch is a better alternative to latex condoms for anal intercourse. For example, in a survey of 100 gay men conducted by the San Francisco Stop AIDS Project, 86% of the participants liked the Reality condom for anal intercourse and 54% said they preferred it to conventional condoms.[*]

The Reality condom is a lubricated polyurethane sheath with flexible polyurethane rings at each end. Like latex condoms, it has been shown in the lab to be impenetrable by viruses including HIV (Drew, et al., 1990). But it has a number of advantages over latex condoms:

- Polyurethane is softer and stronger than latex; its breakage rate is reported to be less than 1% (Leeper & Conrardy, 1989) as compared to approximately 14% for latex condoms.
- Receivers of intercourse can use it to protect themselves without having to rely on the motivation or competence of inserters. Since receivers have more at stake with intercourse than inserters, this is very good news indeed.
- Once in place inside the vagina or rectum, Reality's polyurethane readily transfers heat, contributing to a more natural feel.
- There's no need to stop in the midst of sex to put it on; it can be inserted minutes or even hours before sexual contact begins, allowing for more spontaneity.

[*] For additional information about condom choices and safer sex, call the Stop AIDS Project at 415-621-7177 or visit their Web site at *www.stopAIDS.org*.

- Intercourse can be initiated at any time and easily alternated with other activities without having to remove it or apply a new one.
- Many people report feeling more natural sensations with intercourse because the pouch naturally moves around somewhat, providing sensuous friction for inserters and receivers alike.
- Oil-based lubricants may be used with polyurethane. But users must remember not to use a latex condom later on because latex-damaging oil residue will remain inside the anus or vagina.

Like all barrier methods the pouch is less than perfect. Accidental pregnancies following vaginal intercourse are more common with Reality. With "typical" use (including inconsistent and improper use) failure rates during the first twelve months are reported to be 21% versus 12% for latex condoms. However, with "perfect" use (meaning used properly *every* time) failure rates drop to 5% for the pouch compared to 3% for male condoms.

Whereas male condoms can slip off the penis, the female condom can slip out of the vagina or anus, or occasionally be pushed in. Although the female condom is more likely to stay in place, periodic checking with fingers is still necessary to make sure. The Reality condom also costs several times more than latex condoms (as much as $3 each), but some STD prevention centers give them away, and increased demand should lead to lower prices. Finally, some people are turned off by its relatively large size, ungainly shape, or the crinkling sound it can make during intercourse. Others can't be bothered learning how to use it properly, particularly if they're already comfortable with latex.

I suggest that you initially practice inserting the Reality condom into your anus and rectum when you're alone. Carefully follow the illustrated directions that come with the product. During partner sex you need to use a fresh condom for each encounter or if it slips out or in. But during solo experimentation you can use the same one repeatedly. When used in the vagina, the pouch can be readily inserted with fingers. Some people insert it rectally just as easily, while others find it easier to place it over a butt plug, dildo, or an erect penis and insert it just like a regular condom.

For vaginal intercourse, the inner ring is designed to hold the end in place against the cervix. Current health department guidelines generally suggest that the inner ring also be used for anal intercourse because it may help to prevent the pouch from slipping out past the anal sphincters. But some people report that the inner ring is uncomfortable and not helpful, and simply remove it prior to inserting the pouch. But remember that the outer ring should never be removed. With rare exceptions it prevents the pouch from slipping inside.

Experience

In this section I'll describe the approach to anal intercourse that has proven to be the easiest, least anxiety-provoking, and most pleasurable for the widest range of people. Keep in mind, however, that a different approach might work better for you. The key is to trust your intuition and personal experience.

Choose a person with whom you've previously shared other forms of anal stimulation. Be clear that you would like to receive anal intercourse but that you don't want to feel obligated or pressured. Reassure one another that you can still have a good time together even if you discover that anal intercourse is not going to be comfortable during that encounter.

Gather together any paraphernalia including condoms, lubricant, perhaps a dildo, and a couple of towels or baby wipes for cleanup. Begin by showering or bathing and then try some of the sensual and erotic touch that you've enjoyed together before. Consider exchanging a full body massage to set the mood and promote deep relaxation. As you give and receive touch, use your verbal communication skills to ask for what you want.

When you're ready, ask him to stroke your anal opening gently with his finger(s) or, if you both want it, with his mouth. As you feel your anus relaxing, ask him to lubricate his finger and slide it inside. This can be done in a side-by-side position or with him sitting or kneeling between your legs, with you lying on your back or front.

Be playful; if one or both of you is taking this too seriously, break the tension by talking and laughing about it. If you're anxious over anticipating intercourse, your anus will probably become tense and you won't have much fun. Breathe deeply and avoid feeling rushed. If you're unable to relax, postpone intercourse until another time and concentrate on alternative ways of sharing pleasure. Talk about your feelings now or later.

At some point, move together into several positions that would make anal intercourse possible (see Figure 7), but ask your partner not to insert his penis. For now you're just experimenting with the positions so that you can get a sense of which might be the most comfortable. Notice how your anus responds in each position. Tell your partner which position you feel the most relaxed with and also the reasons why, if you know. For instance, maybe a certain position allows you more freedom of movement, makes you feel more in control, less anxious, or less vulnerable.

Don't be concerned if your partner loses his erection during these explorations. He may be afraid of hurting you, self-conscious about maintaining an erection, or just feeling awkward and unsure. For everything you're doing thus far, an erection isn't necessary at all. If you sense he's nervous, offer reassurance that it's okay with you.

When he does have an erection and you feel comfortable, he can put on a latex condom. Maybe it will be more exciting if you help, but maybe not. If you've decided to use a Reality condom, you can either insert it yourself, or ask him to do it.

Select a comfortable position, apply a lubricant, and ask him to press the head of his penis gently against your anus while you breathe deeply. Stay in this position until you feel your anus relax. Gently push your anal muscles outward and ask him to move the head of his penis gently into your anus as you visualize your anal and rectal muscles and let them release completely. Or if you're sitting over him—the easiest initial position for many people—lower yourself slowly onto his penis. If you encounter any pain, back off to a more comfortable point and stay there until you become accustomed to it.

Once his penis is inside, ask him to hold relatively still until you

Figure 7. Positions for Anal Intercourse.

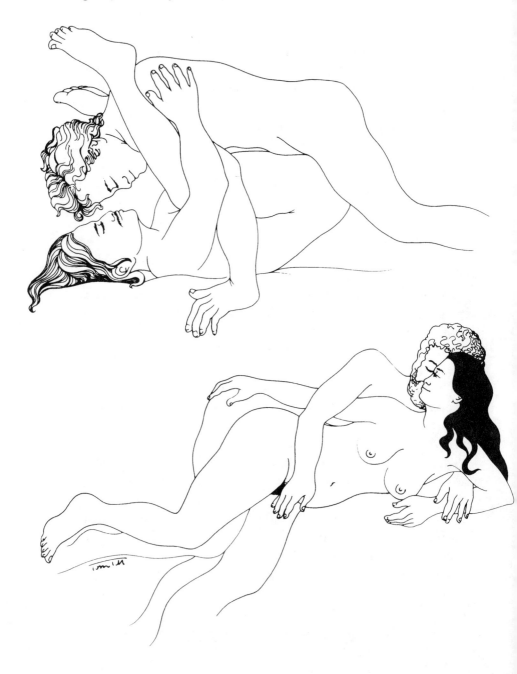

Figure 7 (cont.)

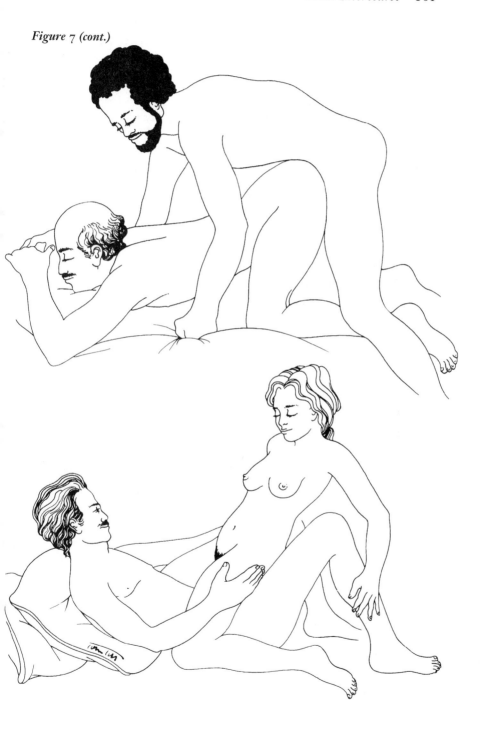

get used to the sensations. Take advantage of all you've learned about the shape of your rectum, make small adjustments in positions and angle of entry so that the penis enters without resistance. Then tell him which movements, if any, are most pleasurable. You'll probably want to start with slow ones. Especially at first, his erection may come and go somewhat, which is normal.

It's perfectly all right for you to stimulate your own genitals with fingers or a vibrator to help increase your arousal. In certain positions, especially side-by-side, your partner can easily reach around and stroke your genitals while he's inside of you—but only if you both want that.

Either of you may stop at any time according to your agreement. Enjoy other erotic activities together, perhaps returning to intercourse later. When your partner withdraws his penis he should hold the rim of the condom so it doesn't slip off. If you're using the Reality pouch, he can grasp the outer ring and remove the pouch with his penis, unless he might be re-entering later, in which case he can leave it in place. If you're a woman and you desire vaginal intercourse after anal intercourse, be sure to use another condom.

If this first attempt doesn't work as you'd hoped, express any feelings of disappointment or frustration. It's important, however, that you don't give up on pleasuring each other. Quitting prematurely may cause lingering bad feeling and thus intensify your misgivings about anal intercourse in the future. Acknowledge and appreciate the positive aspects of the experience such as: You enjoyed being in one or more positions for anal intercourse, liked it for a little while, or the anal touching felt good.

When anal intercourse becomes comfortable in one position, you'll probably be able to try other positions without difficulty. If, however, you find that some positions consistently don't work for you, don't be shy about stating your preferences.

Response

The success of this approach depends on your willingness to be clear and direct in asking for what you want. Those who have the most trouble often fear that nobody could possibly be interested in spending any more than limited time and energy with them. For instance, Jerry lamented, "I don't think it's fair to ask my partner to go through this whole rigmarole with me. Aren't I asking for an awful lot?" Jerry obviously felt that he wasn't worth any special time and consideration. Yet he'd tried a more rapid approach and found that it didn't give him sufficient time to relax and feel safe. He was convinced he had very few, if any, options.

Although Jerry initially denied it, he also felt a great deal of resentment toward his partner for not being more helpful. It took him several weeks to admit to his anger and how tense it was making him. Eventually he began taking more responsibility for his predicament, especially the fact that he was denying himself the attention he wanted because of his unwillingness to ask for and receive it. Jerry's doubts about his self-worth were quite persistent and didn't go away overnight. But as he took halting steps toward asking his partner to spend more time with him, his partner—much to Jerry's surprise—was quite willing to do so.

Sensations

There are very few sensations involved in anal intercourse that you haven't experienced before. You've already stimulated your anal opening many times and also experienced the feel of your finger and soft objects inside your rectum. If a partner has inserted a dildo or vibrator into your rectum, you're familiar with what it's like for somebody else to control the movement, pressure and angle of entry—guided of course by your words and nonverbal cues. You're also acquainted with the sensations that occur during and after rectal stimulation.

One new sensation is the greater body contact with your partner that's usually an aspect of intercourse. Perhaps the body heat and weight turns you on. But it may also make you uneasy. If so you'll

initially want to select a position that minimizes body contact. Many people find that sitting over their partners gives them more control over motions, angles, and depth of penetration and thus reduces sensations of being pinned down. Others report that the weight of a partner's body is highly arousing and makes them feel more secure and free. Some prefer to lie on their backs with their legs lifted up so that they can gaze into the eyes of their partner. Others, in contrast, find this position to be awkward and uncomfortable.

Becoming aware of your position preferences and assertively asking for them is extremely important. Many men and women find out that the primary reason for uncomfortable anal intercourse is that they feel obligated to do it in a particular way. For example, once Rose accepted that she didn't have to receive intercourse on her back, which she found unaesthetic and humiliating, she was tremendously relieved. She enjoyed intercourse without any trouble in a side-by-side position. Incidentally, she also recognized that she disliked the "missionary position" for vaginal intercourse. She had gone along with this for years because she thought it was natural. After several weeks of assertively refusing to accept this position, she could enjoy it occasionally as long as she didn't feel obligated.

Other possible new sensations are those associated with the particular kind of pelvic thrusting used by your partner. Some men like to thrust very vigorously during intercourse and you may like this too, or it may be frightening or irritating. Tell your partner how it is for you and then negotiate a mutually satisfying solution.

Talking openly about such matters often reveals surprises. For instance, some say that their partners automatically start thrusting vigorously and deeply. But when they talk about it they're amazed to discover that neither of them derives any special pleasure from such intense movements. Instead, their partners believe it's expected of them; their actions are based on predetermined ideas about anal intercourse rather than their own desires.

Some people also get confused about the "proper" amount of time to engage in anal intercourse. Concerns about timing are very common manifestations of sexual performance anxiety. Men often enter

sex therapy feeling that they ejaculate "too fast" or "too slow" during vaginal or anal intercourse. When asked what makes them feel this way the answer is usually founded on expectations that the partners have never discussed. One man may consider fifteen minutes of stimulation prior to ejaculating to be "premature" while another feels that he's taking too long.

Likewise, those receiving anal intercourse show a wide variation in their desires and expectations—which often don't coincide—about timing. Some may enjoy receiving intercourse for only a few minutes but tolerate much more, believing that they must continue to please their partner. Others want it for as long as possible. Rarely is either partner as rigid about timing as the other thinks. Occasionally, of course, either one may have rigid preferences. But it's certainly not unusual for partners to participate together in activities that each feels are expected, but which neither one is particularly enjoying.

Men and women sometimes wonder what they ought to be doing while receiving anal intercourse. Should they move? If so, how much? Or should they lie perfectly still, acting as a passive receptacle? Here, too, preferences vary widely. Many people prefer to be still during intercourse and concentrate all of their attention on the sensations; too much movement is a distraction. Others like to thrust their pelvises wildly and are actually far more animated than their partners. These people, of course, are drawn to positions that allow maximum freedom of movement—usually side-by-side, on top, or doggie style.

Experiment with different ways of receiving intercourse, paying attention to what you *actually* like rather than what you're supposed to like. It also helps if you can transcend your ideas about passive and active roles, focusing instead on what brings pleasure to you both. Keep in mind that you will be genuinely receptive to your partner only to the extent that you're having a good time. The most pleasurable experiences with anal intercourse occur when neither partner feels compelled to do anything that he or she doesn't want to do. These are pleasure-oriented encounters; performance-oriented encounters, tied up as they are with expectations, tend to be more hard work than fun.

A good example of this principle involves the use of voluntary muscle contractions during anal intercourse. Some people have heard or read about using rhythmic contractions to "milk" their partner's penis (vaginal contractions can have a similar effect). Consequently, men and women sometimes feel that they must be proficient at this in order to be adequate receivers. Actually, those who don't worry about these fine points appear to enjoy themselves a lot more than those who struggle to be perfect. Remember, anal contractions occur naturally as part of arousal and orgasm. Once you're comfortable receiving you can then experiment with deliberately contracting your anal muscles in rhythm with your own or your partner's pelvic thrusts; this may enhance your own or his pleasure.

People often wonder if they should be able reach a climax while receiving intercourse. Masters and Johnson (1979) observed five gay male couples and seven straight ones having anal intercourse in the laboratory; each couple did it on two separate occasions. Women receivers reached orgasm on 11 of 14 occasions (including three instances of multiple orgasm). On the other hand, during 10 instances of male-male intercourse only two of the receivers reached orgasm, and they were masturbating themselves at the same time.

Although I haven't made laboratory observations, I have gathered several hundred self-reports from clients. Their experiences indicate a far smaller discrepancy between men's and women's orgasms than Masters and Johnson observed. Whereas women in general seem to be more flexible in their orgasmic responses (some are even able to climax simply by fantasizing), men enjoy the advantage of prostate and penile bulb stimulation during anal intercourse. But the majority of my clients who orgasm from anal penetration, regardless of their gender, say that they combine intercourse with direct clitoral or penile stimulation. I've also noticed that those who regularly include anal stimulation in their private masturbation are more likely to be orgasmic during anal intercourse with a partner.

Keep in mind that not everyone feels a need to reach an orgasm during anal intercourse, although some believe this is expected. Similarly, an inserting male partner may feel pressure to ejaculate inside

his partner's rectum. Some men, however, very much enjoy being inside their partner, but can only, or prefer to, ejaculate while receiving other forms of stimulation.

I've heard some receivers express disappointment when they couldn't feel ejaculation inside them—obviously in cases where no condom was used. Because the rectal nerves respond mostly to pressure, and because so many other sensations are being triggered simultaneously, it's unlikely that ejaculation will be felt. A few people do report incredible rectal sensitivity. However, in the vast majority of cases the perception of ejaculation is probably fantasized in conjunction with other more dramatic signs of orgasm. Of course, if you're using a condom you definitely won't feel your partner ejaculate, although you may be highly aroused by the excitement of your partner as he comes.

Inserters in anal intercourse, especially men, have their own special concerns. Sometimes these concerns are ignored as attention is focused on the needs and feelings of the receiver. Even men who have actively pushed for anal intercourse may be considerably less than comfortable when the opportunity presents itself. Many inserters feel on the spot, not only pressured to produce and maintain an erection, but also saddled with total responsibility for the success of the experiment. Sometimes the inserter feels so pressured that he'll try to avoid intercourse at the very moment when the receiver is eager to try. Some lose interest in sex altogether or try to shift the attention to other activities besides anal sex.

It helps a lot if the fears of the inserter can be sensitively discussed. But this may be easier said than done, since most men hate to acknowledge even the possibility of erection problems. In addition, if anal intercourse has previously been a point of contention, some inserters will feel a lingering resentment—a major enemy of cooperative communication. Non-defensive listening, compassionate understanding, and simple reassurances are the best anyone can offer to an anxious or resentful inserter.

It's also possible that one or both partners may secretly feel guilty about their past difficulties with anal intercourse. Tim, who consis-

tently lost his erection whenever he attempted intercourse finally realized, "I've nagged Bill about letting me fuck him for so long I just can't believe he really wants it now, even though he says he does. I can see how I made things really miserable for him." Not everyone is as honest as Tim. Frequently one partner doggedly clings to a blaming attitude toward the other. More often than not, this is a defensive cover-up for guilt. The need for honest discussion is obvious here, but starting a productive one requires sensitivity and tact.

Most difficulties encountered with anal intercourse can be alleviated by proceeding slowly and patiently, focusing on the sensuous and practical aspects, overcoming unrealistic expectations, and assertively communicating personal preferences. But what if you're doing all these things and anal intercourse is *still* uncomfortable? Ask yourself once again if you really want to receive anal intercourse. People have a remarkable capacity to fool themselves. Particularly those caught in the Nice Person Syndrome, or those who have been traumatized in the past, may find it challenging to distinguish external pressures from their own desires. Perhaps a talk with a close, supportive friend—someone with no personal investment in your decision—can help clarify where you stand.

If you reaffirm your desire to be able to enjoy anal intercourse, the next step is to re-evaluate the approach you've followed thus far. Have you spent sufficient time exploring on your own? Many people don't take the self-exploration process seriously because their attention is totally focused on the goal of receiving intercourse. They simply go through the motions in an obligatory way, thinking to themselves, "Okay, I'll do this half-heartedly if it's the only way to get what I really want." Sometimes unsuccessful attempts at anal intercourse are actually beneficial because they compel a person to reconsider what they've been doing in the self-discovery department. Only then may they be ready to release their urgency about intercourse and re-experience other forms of anal pleasure in a more authentic way.

If, however, you're truly in touch with your anus and rectum and able to enjoy anal touch with both yourself and a partner, but you just can't seem to relax for penetration, then it's almost certain that

intercourse has negative symbolic significance for you. For a great many people, intercourse—vaginal or anal, given or received—is infused with the imagery of dominance and submission. Could it be that you're uncomfortable or confused about the dynamics of power as expressed in your sexual relationships or your fantasies? Understanding the messy complexities of eroticized power is our focus in the next chapter.

13

Realms of Power
Probing Interpersonal Dynamics

ALTHOUGH MANY OF US are reluctant to acknowledge it, power is an unavoidable aspect of every significant relationship. Whenever two people interact there are decisions to be made and differences to be negotiated. And the more intimate we become the more apparent are our idiosyncrasies and disagreements, both in and out of bed. Those who avoid or deny inevitable conflicts eventually pay the price of emotional distance, smoldering resentment, and often a tense, armored body.

The only relationships in which the intricacies of power can be easily ignored are those in which clear roles are rigidly adhered to by both partners. One person dominates and the other submits; it's automatic. Although many relationships are structured this way, very few couples are truly satisfied with their inflexibility. Even those who consistently gravitate toward one role or another eventually want the freedom to step outside of their assigned position once in a while.

Many people are reluctant to look at power in their erotic relationships because they think of it as primarily destructive, manipulative, or coercive. Yet it's crucial to recognize that honestly grappling with power is also beneficial. In order to take a creative, self-affirming stand in the world we must feel that our desires, decisions, and actions will have some effect. People who view power solely in a negative light

often adopt a role that psychologist Rollo May calls "pseudo-inno-cence"—an unwillingness to leave behind the naiveté of childhood and confront a world of conflicting wills (May, 1972). Functioning effectively in adult relationships requires a realization that we're all capable of using power both creatively *and* destructively. Those who pretend to be aloof from the untidy complexities of power typically end up hurting other people or being hurt themselves because they refuse to take responsibility for their actions and reactions.

Others refuse to examine how power is expressed in their ro-mantic love relationships because they view love and power as fundamentally incompatible. But Rollo May warns, "When love and power are seen as opposites, 'love' tends to be the abject sur-render of one partner and the subtle (or not so subtle) domina-tion by the other. Missing are the firmness of assertion, the structure and the sense of dignity that guard the rights of each of the partners" (May, 1972).

Another manifestation of pseudo-innocence is an unwillingness to examine the role of power exchanges in our sex lives. Delving into the interplay of power and eroticism is particularly important for anal explorers because, in the public imagination at least, anal inter-course is intricately linked with images of dominance and submis-sion. The purpose of this chapter is to stimulate thinking and discussion about the multitude of ways in which anal eroticism can be positively or negatively intertwined with power dynamics in our relationships, fantasies, and erotic styles.

Symbols of Power

Virtually any physical characteristic or personality trait can be a sym-bol through which one person invests power in or withdraws power from another. Although it's not a very romantic idea, we all use one or more of these symbols as a kind of currency to position ourselves relative to our partners, whether casual or committed. Most of us try to compensate for our perceived weaknesses by playing up our

strengths, sometimes with such subtlety that we don't even know we're doing it. But others deliberately emphasize their vulnerabilities; they prefer to see their partners as stronger. Complicating things all the more is the fact that partners' perceptions of each other's assets and liabilities can be radically at odds.

There are both risks and benefits involved in making this process more conscious. It can be disturbing to see that genuine caring may coexist with less lofty motives. Yet opening our eyes to the inner workings of interpersonal power dynamics can clear the way for more honest relationships with fewer covert manipulations. In addition, becoming conversant in the symbolic language of power can make it possible to use this language deliberately for erotic enrichment. Consider first some of the more common symbols and sources of power.

Appearance

Though beauty is indeed in the eye of the beholder, every social group has its paragons of attractiveness. In modern times the mass media have spawned an unparalleled homogeneity of ideal physical types. Many people, maybe most, consciously or unconsciously place themselves and others on a hierarchy of desirability. One's place on a hierarchy (as perceived by oneself and others whose opinions are valued) contributes to one's confidence, or lack of it, in the sexual marketplace. Of course, everyone has appearance preferences, some more narrowly defined than others. This selectivity helps to intensify our erotic response to favored characteristics. However, when we use physical appearance as the primary means of assigning overall worth to ourselves and others ("looksism") we set the stage for considerable conflict and suffering.

At its worst looksism terrorizes a person and literally determines the power dynamics of a relationship. Some people attempt to move up the appearance ladder by attracting someone whom they see as more desirable than themselves. They think, "If I can only get someone this beautiful to want me I'll feel better about myself." If, however, their self-worth depends on winning affection from or possessing the prized object, they'll gradually give up their own

power. Appreciating another's appearance, rather than being enjoyable, then becomes an act of self-deprecation. Ambivalence toward the partner, self-protective muscular tension, and seething resentment are the likely results—hardly a recipe for a positive relationship or good sex.

Some people who demean themselves in this way find it difficult to be the recipients of sexual pleasure, anal or otherwise, because they're locked into the role of servicing the "more desirable" other. Quite a few clients have consulted me precisely because they wanted to receive anal intercourse *on demand*—not for any enjoyment of their own, but solely as a bid to hold a partner's interest. Some succeeded, but most became more constricted and wary than ever, often with their anal muscles expressing the unspoken rage that springs from denigrating their own worth.

Keep in mind that it's natural to feel that the object of our desire is more beautiful than ourselves. After all, our most powerful attractions are typically reserved for those who appear to have something special that we lack and therefore want to import. This is why attraction often goes hand in hand with a certain amount of envy. But hopefully we also believe that we have something of value to export. One-sided attractions may generate intense longing and wistful fascination, but they're ultimately unfulfilling. It's the give-and-take, the uncertainty, the juxtaposition of possibility and risk that makes our attractions prime motivators in the erotic adventure.

Age

Obvious and subtle differences in appearance, experience, values and perceptions resulting from a significant age discrepancy can provide some of the contrast conducive to passionate desire. However, because of our culture's tendency to assign overall worth based on age—"ageism"—youth can easily become a source of power and status. Men of all sexual orientations are more likely than women to place youthfulness on their lists of sought-after qualities. It's commonly believed that a person's sexual desirability increases throughout his or her twenties and thirties and begins to deteriorate sometime dur-

ing the forties or fifties. But many people start worrying about aging much earlier.

It's very difficult *not* to be affected by what our society teaches us to expect as we age: more responsibilities, less fun, less sex, less attention from others, and therefore less power. To some extent the life process runs counter to these negative expectations. With age can come greater knowledge of and comfort with oneself, hopefully a degree of financial security, and a heightened capacity for genuine intimacy. For the perceptive man or woman, passing years also bring a clarity of values, an ability to distinguish the truly important from the trivial. But for many, these rewards never quite make up for the losses.

A large age discrepancy between two partners sometimes—but by no means always—leads to a parent-child type of interaction. The "child" feels dependent on the stability and security provided by the "parent," but also resents the loss of freedom and may express displeasure indirectly via underhanded maneuvers such as not following through on commitments, disappearing unexpectedly, or withholding sex or affection.

The "parent" admires the "child's" unjaded, free-spirited vitality but ends up resenting his or her ambivalence and lack of constancy. Secretly the "parent" hopes that by giving the "child" sufficient love and guidance he or she will grow up and return some of that love out of gratitude. Occasionally this happens, but more often one or both of them gets sick of their roles and terminates the relationship, with considerable psychic pain all around. A string of similar relationships indicates, with little doubt, that this dynamic is at work.

The symbolism of age extends far beyond chronological time. Many partners who are close in age nonetheless gravitate toward parent-child, older sibling-younger sibling, or teacher-student roles, which wouldn't be nearly so prevalent if they didn't offer some clear advantages. Because each role exists only in interaction with the other, there's a built-in complementarity and often a psychological division of labor wherein one player handles practical details, for instance, while the other concentrates on intuitive possibilities and adventure; each partner has a sphere of influence.

If the chasm grows uncomfortably wide, we would logically expect the players to ease up a bit in order to restore a modicum of balance. Quite commonly, though, both partners act out increasingly extreme renditions of their roles, often to the point of parody. As the more practical partner edges toward possessiveness and condescension, the free spirit reacts, becoming increasingly irresponsible, flighty, and self-absorbed—and vice versa.

Regardless of the chronological ages of the participants, people who overdo parental roles need to allow their own childlike qualities to surface, especially the ability to play and to release themselves from the crushing burden of constant obligations. Those who compulsively play the child role can free themselves by developing opposite characteristics, such as the ability to make and keep commitments, to exercise self-discipline, and delay gratification.

In positive relationships with a significant age discrepancy—and many work out very well indeed—each partner evolves toward wholeness by observing underdeveloped aspects of the self reflected in the other and then gradually developing them internally. Over time the psychological significance of the age gap is greatly reduced, but it rarely disappears completely.

Race

Whereas we typically look for qualities and interests similar to our own when selecting non-sexual friends, contrasts are likely to be of greater sexual interest. For this reason, racial differences can act as inexhaustible fuel for high arousal. Body and facial characteristics, language, and a wide array of cultural traditions all accentuate the intriguing dissimilarities between self and other. Erotic preferences based on race are as legitimate and potentially gratifying as any others.

I see nothing inherently problematic about being attracted, even exclusively, to members of a particular race. However, racism—the assignment of overall worth based on race—can complicate or ruin a sexual relationship. One problem is that racial stereotypes can readily be projected onto some or all members of a group, a tendency that increases with mistrust and lack of familiarity. Members of disparate

racial groups often perform "mass projection" on each other, thereby creating a degree of commonality in what an individual of one race will see in or expect of an individual of another.

For example, black men have told me that sexual partners customarily expect them to be super masculine, with huge penises, and always dominant in sexual interactions. Understandably, many of these men feel inadequate when they can't or don't want to live up to the stereotype, and angry about being pigeonholed. Some black men deliberately play on racial typecasting to gain a power advantage, especially over white partners whom they may simultaneously envy and resent. Needless to say, white men and women just as frequently make use of their privilege as members of the dominant group.

I'm certainly not suggesting that interracial pairings are doomed—far from it. Differing backgrounds and perceptions actually work against some of the merging, loss of individuality, and boredom that befalls so many couples. The key is to discover each other as distinct individuals, to differentiate genuine differences from projections. This process, though rich with potential conflicts and misunderstandings, can bring a singular vitality to the exchange.

Money

One of the most common symbols of power is money; it's also one of the most difficult to discuss. When there's a large discrepancy between the assets of two individuals, it's almost certain to create a power imbalance. And when this discrepancy is combined with other factors such as race or age, the potential complications skyrocket.

When affluence tilts the power scale toward one partner, some other aspect of the relationship—like sex or affection—usually functions as a counterbalance. For instance, a less affluent partner may withhold sex or a particular activity or, at the other extreme, may demand more sex than the wealthier partner is able to give, with the implied message, "Look at the abundance that I possess. You can't begin to satisfy me." Berating the wealthier partner, or thoughtlessly consuming his or her resources, are also common strategies for indirectly expressing envy and anger and shifting the power balance.

It's not unusual for the more moneyed partner to feel used or to worry that he or she is buying affection that wouldn't be freely given. Some men and women in this situation vacillate between lavish spending and penny pinching, sometimes out of confusion, other times as a blatant strategy of control. Escalating conflict, withdrawal, and muscular tension are likely consequences for both—until unvarnished emotions are aired and mutually agreeable solutions negotiated.

Social Skills

The ability to socialize and form friendships relatively easily is yet another symbol of power and worth. Most likely, partners who tend to be shy or socially inept may feel simultaneously dependent, invisible, envious, jealous, and resentful—especially those with few social connections of their own. On the other hand, comfortable socializers often don't know whether to restrain themselves, coax their partners into being more outgoing, or simply be who they are and let the chips fall where they may.

There's no getting around the fact that our society places a higher value on extroverted, gregarious behavior. Introverts are rarely encouraged to develop their natural personality traits and instead are pitied or devalued. Some introverts believe that social ease is a sign of overall worth and are likely to think less of themselves. This idea is magnified when the socially confident person has a wider variety of stimulating contacts and allies which the introverted partner may both admire and fear.

Partnerships with a wide introvert-extrovert discrepancy have their work cut out for them because their desires and interests will frequently be at odds. Their greatest threat is in criticizing themselves or one another, leading to a vicious and destructive cycle. Creative pairs of this type de-emphasize the paradigm of togetherness and make a point of allowing for plenty of separateness. Milder discrepancies on the introvert-extrovert axis, although still a potential source of conflict, can also be a significant impetus for growth as each partner stretches beyond his or her comfort zone.

Sexual Confidence

It's not unusual for one partner to be more comfortable than the other with sex in general or more versatile and experimental with particular sexual acts and situations. Some folks who appear to be sexually adept actually are, whereas others put on an exaggerated persona of confidence. Or else they may simply be perceived this way by a less assured partner. Whether real or contrived, sexual confidence can be a significant source of power, especially for those who define sexual competence as the ability to perform certain sexual "tasks"—such as anal intercourse—on demand and with few, if any, concerns or personal requirements.

When sexual confidence becomes a symbol of power, the less confident partner feels enormous pressure to perform better sexually or else risk the loss of the more confident partner. I often see this dynamic played out in sex therapy when one partner is targeted for fixing while the other adopts the role of cheerleader, complainer, or both. Progress only begins when they both acknowledge their contributions to their problems as well as the solutions. Interestingly, in some cases where the less assured one unilaterally develops greater confidence, perhaps by becoming more assertive and less deferential, the supposedly confident partner is visibly shaken. It's not unusual for such people to resort to pouting or put-downs, anything to restore the illusion of greater confidence. As a consequence of gender training, men are particularly prone to measuring their worth on a scale of sexual prowess.

Many more couples who once took delight in bolstering each other's sexual confidence, unwittingly slip into anti-erotic comparisons and accusations. Unfortunately, anal experimentation is sometimes the catalyst when one partner is ready to go while the other is afraid. Too often the hesitant one—typically the designated receiver—is labeled uptight or prudish, feels ashamed or angry, and retreats even further. Scenarios like this can quickly undermine sexual confidence, not to mention desire. Once undermined, sexual confidence will flourish again only insofar as performance pressures are replaced by a reciprocal commitment to pleasure and mutual validation.

Self-Esteem

Enduring respect and compassion for oneself is, by far, the most substantial and versatile source of psychological and interpersonal power. A concurrent enlargement of self-esteem in both partners almost always defuses destructive power struggles—not by eliminating power dynamics from the relationship, but by making each person more comfortable with power and, therefore, more willing to deal with it openly. When both partners are moving toward greater self-esteem they'll naturally be drawn to honest conversation and, whenever necessary, good faith negotiations. Self-loving people have greater internal resources to draw upon and are less apt to cling doggedly to unproductive power contests that spring from insecurity.

Serious problems ensue when one partner's self-esteem is consistently on the rise while the other's is stagnant or in decline. Falling self-esteem breeds defensiveness, disengagement, self-criticism, depression, and aversion to risk—qualities hardly conducive to any kind of enjoyment. And the interpersonal consequences are just as bad. Low self-esteem partners feel guilty and inferior, whereas high-esteem ones feel helpless, annoyed, and may even constrain or hide their own growth in order to maintain a semblance of equality. Those inclined toward abusiveness may even use their own or their partner's weakness as opportunities to inflict psychic harm.

Chasers and Chasees

When potential lovers first meet and begin dating they must grapple with crucial questions about who's more attracted, emotionally invested, hesitant, or needy. The right mixture of hopefulness and doubt raises romantic interest to a fever pitch. But if one consistently wants more than the other, their involvement will either unravel or the participants will slip into the roles of chaser or chasee. The more the chaser clings and pursues, the more the chasee distances. If the chaser lets go or gives up, sometimes the chasee will switch course and start pursuing.

While chaser-chasee dynamics are frequently feverish in early romance, they often remain a part of established relationships as well.

Even committed partners fluctuate in their levels of attachment, availability, and expressiveness. Besides these inevitable fluctuations, a partner who chronically feels one-down is more inclined to pursue due to a lower sense of personal value. All by itself the act of pursuing transfers power from the chaser to chasee.

Chaser-chasee dynamics can take a different form when one partner is pressing for anal intercourse and the other is hesitant. If the desirous one nags or pesters, thus becoming a chaser, the other will inevitably withdraw even more. More than a few couples have ruined their chances for mutual enjoyment by turning anal sexuality into a repetitive game of pursuit and escape.

Although it certainly doesn't help to deny what one does or doesn't want, I've seen many couples step away from fixed positions and embark upon a straightforward, game-free discussion. Either person can initiate these talks but the typically avoidant partner is in an especially good position to reach out and signal a break from the old pattern. Of course, chasers can demonstrate a similar shift by inquiring about the fears and hopes of their partners rather than harping on their own desires.

Eroticizing Power

Those who can enjoyably insert penis-size objects into their rectums in private but are unable to receive intercourse with a partner—even though they want it—typically discover that power inequities like those I've just described are breeding resentment, causing muscular tension, and are downright anti-erotic. Similarly, unpleasant and unwanted feelings of being dominated, controlled, or demeaned are almost always incompatible with anal pleasure.

But the role of power in erotic life is paradoxical. Just as destructive skirmishes for control can wreak havoc on a couple's sex life, many men and women of all sexual orientations discover that deliberately fantasizing or consensually acting out scenarios of dominance and submission can have unmistakable aphrodisiac effects. There's no doubt

about it: The messy complexities of power can either be turn-offs or turn-ons. Anal explorers need to be aware of these contradictory possibilities and discover which expressions of power, if any, might enhance their pleasure and which are likely to get in the way.

The degree of interplay between eros and power stretches out over a wide continuum, ranging from subtle to extreme. At one end of the spectrum are nearly universal images of male-female intercourse in which at least some degree of dominance is expected on the part of men with a corresponding submissiveness for women. I would venture to say that most people's ideas about sexual interactions, particularly intercourse, involve a top who initiates, choreographs, and directs, and a bottom who responds, yields, and surrenders.

Simple top-bottom exchanges are aspects of everyday sexuality. Contrasting yet complementary roles can positively energize an encounter or fantasy for everyone involved. And it's a mistake to assume that tops are winners of the game and bottoms the losers. Actually, when both partners are enthusiastically involved each feels validated and empowered, no matter which role they play. Tops experience the passionate surrender of their partners as compelling evidence of their own irresistible erotic allure. Similarly, bottoms interpret the focused desire of tops as signs of their own desirability.

Another big advantage for bottoms is appearing not to be responsible for what happens—"I couldn't help myself; he or she *made* me do it." Relinquishing responsibility to a more powerful other can be a useful method for getting around the lingering effects of guilt and anti-sexual training.

Although many men and women automatically re-enact gender-based power roles in most or all of their sexual encounters, this predictability can become routine and boring. Consequently, adventurous lovers often get a charge out of reversing their usual roles. Many men long to surrender to a dominant other, just as some women wish to cast aside their feminine restraint and feel the rush of someone yielding to them without reservation.

When I analyzed over 1,000 anonymously written stories of peak erotic encounters and fantasies in preparation for my book, *The Erotic*

Mind, enthusiastic descriptions of various power scenarios were the third most common type after *longing and anticipation* and *violating prohibitions*. But I also discovered that top-bottom roles are usually more complex than they appear on the surface, often to the point where it's difficult or impossible to pinpoint who's really in control.

Peter, a construction worker in his mid-thirties, told a tale that captures this ambiguity perfectly:

> I had just stepped out of the shower when she rang the bell. I wrapped a towel around my waist, invited her in and followed her to the couch. I felt excited and vulnerable to be nearly naked while she was fully clothed. Tension was rising.
>
> She said, "If you're not careful I'm going to rip off that towel." I liked her taking control, but I played it cool (I knew I was driving her wild). Soon she *did* rip off my towel. I was totally naked and she was still fully dressed. There was something completely unnatural about this but also very satisfying.
>
> She took *total* control and did something completely out of character. She turned me on my belly, draped me over the couch, stuck her finger up my asshole and masturbated me with her hand. It was as if my whole body became a giant penis and she was massaging the whole thing, inside and out. After orgasm, I shivered for ten or fifteen minutes while we held each other. I can't remember *ever* feeling more alive than I did that night!

On the surface she's in control, no doubt about it. But notice how he's anything but passive. He actively stokes her excitement, first by seductively presenting himself half-naked, and then by acting nonchalant, goading her into aggressive action. There's a graceful dance in which erotic power flows both ways, escalating as their interaction evolves. It's the fluidity of their exchange that allows Peter to experience the surrender through which he is unforgettably vitalized and enriched.

S/M (Sadomasochism)

At some point along the sex-power continuum—no one can say exactly where—we enter into the kinkier realm of sadomasochism, popularly called s/m. Traditionally, sadomasochism has referred to obtaining sexual gratification from inflicting or submitting to pain.

The problem with this definition is that pain isn't necessarily a part of s/m at all, and even when it is, the pain is of a qualitatively different sort than most of us are used to.

In popular parlance s/m is now an umbrella term for a wide variety of behaviors and fantasies in which dominance and submission is deliberately played out in stylized psychodramas called "scenes." Participants, known as "players," often use props, equipment, or costumes for dramatic effect—which underscores S/M's inherent theatricality. So important are the props and costumes—such as the dominatrix's spiked heels, black stockings, garter belts, and whips—that the props themselves can become fetish objects embodying tremendous erotic power. The look, smell, and texture of leather is so ubiquitous in s/m gear that lots of people refer to s/m as the "leather scene."

The overriding purpose of s/m imagery and roles is the creation of high erotic intensity and connection between the participants, or within oneself during fantasy. In some extended scenes, players actually achieve altered states of consciousness, sometimes with mystical or spiritual overtones.

One popular form of s/m is *bondage and discipline* (B&D), where consensual restraint with soft ropes or scarves—or with paraphernalia such as straps, handcuffs, collars, leashes, or cages—spotlights the utter helplessness of the bottom and the total control of the top. Once restrained, the bottom either passively submits or struggles and squirms while the top "inflicts" overwhelming pleasures. Sometimes a blindfold, mask, or hood is used for visual deprivation and to focus awareness on the other senses.

Discipline rituals, with or without bondage, involve the strategic use of punishments in the context of power-infused roles such as parent-child, teacher-student, or prisoner-guard. The basic story line is that the bottom is caught or confesses to being bad or disobedient and must be taught a lesson with verbal reprimands and possibly a good spanking or whipping. Some clever tops drive their bottoms completely wild by depriving them of the punishment they crave. Disciplinary actions tend to be rather mild, done more for show than anything else. But some discipline enthusiasts like it rough.

Pain inflicted during an s/m scene may be physical, psychological, or both. Physical pain is induced by slapping, scratching, biting, pinching, tickling, spanking, body piercing, dripping hot wax and, in the most extreme instances, flagellation and beating. Skillful players aren't going for pure pain; for most that would be anti-erotic. The challenge is to find the point where pleasure blurs into pain, so that the two become synergistic and exquisitely intense. Concentrated stimulation near the pleasure-pain boundary releases a flood of endorphins and other internal chemicals which are undoubtedly part of the high. For those who enjoy this sort of thing, body stress and ecstasy become one. As they coax their bottoms toward the pleasure-pain nexus, experienced tops gradually apply greater stimulation in fluctuating steps, escalating in tandem with the bottom's tolerance and desire.

Psychological pain typically takes the form of stylized humiliation, embarrassment or degradation. Depending on specific arrangements made by the players or preferred by a fantasizer, the bottom eagerly obeys orders to grovel at the top's feet, relishes the opportunity to be a sex slave, or even begs for insults. But curiously, what looks like torment and cruelty to an outside observer is, to the satisfied sexual masochist, an uplifting gift of affirmation and love. Another common reaction to a successful humiliation scene is a feeling of pride at being able to endure and derive pleasure from indignities that would be an anathema to most.

The allure of s/m is rooted in its many paradoxes: Pain is transformed into pleasure; tops are granted power and status by their bottoms, and vice versa; the right kind of punishment can be the greatest reward; total submission becomes a path to liberation; celebrating dark, uncivilized impulses can even be a springboard to transcendence.* None of this makes logical sense, which is probably one reason for the predominant view in psychology that s/m is a symptom of psychopathology. Popular ideas that s/m enthusiasts are inher-

* See Thomas Moore's *Dark Eros* for a remarkable examination of the infamous Marquis de Sade and the healing power of the shadow.

ently angrier, crueler, more self-hating, or in deeper psychic conflict than others, don't stand up to scientific scrutiny—of which there has been far too little. People who respond to s/m are as different from one another as they are from those who prefer more conventional lovemaking. Strong inclinations toward s/m can be readily found among severely disturbed *and* exceptionally high-functioning individuals—and everywhere in between.

Of course, one's level of psychological health influences whether s/m role-playing promotes pleasure or causes harm. Certain s/m players are prone to taking unnecessary and unwise risks. For example, some act out scenes without setting up clear agreements about the limits and parameters of the encounter, including a "safe word" for the bottom to signal an actual desire to stop, since in s/m scenes "no" and "don't" so often mean "yes" and "don't you dare stop." Unfortunately some bottoms have trouble setting boundaries and some tops have trouble respecting them. A few even allow themselves to be tied up by total strangers and may be badly mistreated by sociopaths who couldn't care less about consent and respect. And too often heavy drug use undermines the awareness necessary for healthful erotic play.

It must also be said that some s/m enthusiasts are decidedly *not* uplifted by their scenes and fantasies. I've worked with quite a number of men and women whose chronic feelings of worthlessness were only reinforced and perpetuated by their sexual behavior. I believe that it's human nature to weave longstanding psychic wounds and unfinished emotional business symbolically into our erotic adventures in search of healing and mastery over our pain. Fulfilling sexual experiences and fantasies, with or without s/m, often transform distress into passion and surely do promote healing and growth. But our turn-ons can also turn against us if we find ourselves compulsively re-enacting old wounds and traumas, merely confirming our helplessness and self-loathing, and receiving little or nothing of value in return. All complex and potentially rewarding human endeavors are like this: they can either enrich or undermine our well-being. It all depends what we do with them.

Scenes of dominance and submission of any type or intensity can be freely explored in fantasy. Quite appropriately most of us grant ourselves a wider range of sexual possibilities in fantasy than in actual behavior. Consenting partners can experiment with milder forms of s/m in real life with little more than a brief preparatory discussion and perhaps a few props. Those who wish to explore heavier scenes require much more guidance in learning the ropes, so to speak. One sign of the popularity of s/m is the unprecedented proliferation of popular books on the subject.* The Internet is also packed with sites about every imaginable form of s/m. For the serious experimenter, however, there's no substitute for an experienced mentor.

Power and Anal Intercourse

Since receiving anal penetration is commonly viewed as a quintessential expression of sexual submission, it comes as no surprise that many people want to surrender to a dominant other, at least to a certain extent, when they receive anal intercourse; they're very clear about it. In fact, some can be remarkably aggressive in arranging encounters that fulfill this need. For these people, playing a bottom role doesn't result in anal tension. On the contrary, the excitement of feeling sexually overpowered may even be a prerequisite for maximum anal relaxation and sensitivity.

Most of the people I've worked with either don't want to feel dominated during anal sex or else have mixed feelings about it. For them submissiveness isn't necessarily conducive to anal enjoyment and may even be completely antithetical to it. Men in particular may be concerned about their own feelings and fantasies of dominance when

* I recommend Pat Califia's *Sensuous Magic* which offers wise insights and practical suggestions for couples who wish to experiment with s/m. *Different Loving* (Brame, et al.) explores the gamut of unconventional sex related to dominance and submission. Mark Thompson's *Leatherfolk* brings together essays from a variety of authors about an amazing range of issues—slanted somewhat, but by no means exclusively, toward gay readers.

they're on top during anal or vaginal intercourse. For them, the thought of having the tables turned causes an instant protective spasm of the anal muscles.

For many it's not the submissiveness or receptivity per se that are troubling, but rather the belief that allowing oneself to be anally penetrated is, by its very nature, demeaning and humiliating. Some women, and even more men, associate anal penetration with rape. Denying such unappealing associations isn't a helpful strategy because it simply drives the troubling ideas further underground where their inhibiting influence is at its worst. Again and again I've noticed that those who muster the courage to voice their most secret and embarrassing concerns are usually the ones who find workable resolutions.

For some the answer is to disconnect anal intercourse from themes of dominance and submission altogether and enjoy it instead as an expression of sensuality, playfulness, adventure, intimacy, trust or passionate exchange. For others resolution comes in the form of accepting the troubling images, embracing rather than rejecting them, or possibly even transforming them into aphrodisiacs. The key here is to learn to see oneself not as the victim of dominance, but rather its master.

Some of those who become very tense whenever anal intercourse is attempted express a fear of being dominated precisely *because* the idea excites them tremendously in fantasy—including, perhaps, the humiliation aspect. Usually they're relieved to discover that people regularly have fantasies they have no intention of acting out. Obviously, making a clear distinction between fantasy and action makes it easier to define what one does and doesn't want to do with a partner. In some instances, though, fantasies of anal submission will eventually be acted out, not because they have to be, but because this is what the person genuinely desires.

Even those who might normally enjoy a sense of submission during anal sex are likely to avoid it like the plague if they feel controlled or manipulated in the rest of their lives. This is another reason why assessing the power dynamics in a relationship is so important. While there are a few people who long to be dominated in all spheres of

life, most of us accumulate resentment when the balance of power is consistently and unfairly skewed toward our partners. For couples with large power discrepancies, anal enjoyment—and possibly sex in general—may need to be set aside until a more equitable arrangement is found. In most cases the search for a new alignment begins when the less powerful partner rises up and asserts that the status quo simply cannot continue.

For those who'd like to include anal intercourse in dominance-submission styles of interaction, especially in heavier s/m scenes, special precautions are required to optimize the pleasure and minimize the risk. The first priority is to recommit to your no-pain-ever-pledge, which may be difficult for those who enjoy super intense sensations at the pleasure-pain boundary. It's true that a relaxed and healthy anus and rectum can handle fairly vigorous and deep stimulation—but not the kind that *actually* hurts. Those who are aroused by being pushed beyond their comfort zone should confine body stress experiments to surface areas that can be readily monitored for tissue damage, and where recovery occurs much more easily if irritations or bruises do result. Keep in mind that anal-rectal tears (fissures) are extremely painful, slow to heal, and prone to infection.

Gay men often face extra complications in working out the power dynamics of anal intercourse, beginning with the fact that both are potentially able to give as well as receive it. We know from surveys that most gays enjoy it both ways. Many gays fluctuate in their desire to be tops, bottoms, or neither—depending on the situation or the partner. Sadly, some male couples are drawn into ongoing battles over who should be the inserter and who the receiver.

These conflicts can spring from preferential incompatibilities, as when both partners prefer the same role. But contests over anal intercourse can be highly symbolic, as when either believes that the top holds the upper hand or that the bottom is, by definition, less manly. In one study, most gay men said that the inserter was more masculine. Interestingly, in couples where *both* partners were forceful, outgoing, and aggressive, there was more anal sex (Blumstein and Schwartz, 1983).

One partner may be comfortable receiving anal intercourse while the other isn't. Sometimes this is perfectly acceptable for both, sometimes not. Or neither may be comfortable with anal sex, but one wants to experiment while the other is reluctant. The greatest pitfall for discordant couples is resorting to demands, threats, or put downs. Partners who genuinely wish to expand their sexual repertoire can only do so in a spirit of collaboration combined with a respect for inevitable differences. When intercourse is a symbol of power, one or both may insist on "equality"—inserting half the time, receiving half the time—as a matter of principle rather than preference. But all too often the enjoyment of anal play becomes secondary or nonexistent until the underlying power struggle is addressed.

Although some lesbian partners thoroughly enjoy anal intercourse with a strap-on dildo, most don't or have never tried it. However, this doesn't mean that lesbians are spared from the untidy intricacies of sex and power. Erotic enjoyment of top-bottom roles is by no means confined to insertive sexual acts, but can be played out whenever one partner is aroused by taking the lead and the other finds excitement through surrender. Top-bottom scenarios are first and foremost a state of mind; particular behaviors are secondary. That said, the fact that lesbian sex tends to be less intercourse oriented, and thus less dictated by predetermined gender stereotypes, seems to make it a bit easier for lesbian couples to experiment with various forms of anal play, if they're so inclined.

An ongoing controversy among lesbians is over the legitimacy of butch and femme roles, both in and out of bed. Some lesbians want nothing to do with the butch-femme dichotomy—actually a continuum—because they see it as reenacting heterosexist stereotypes. Others find the contrasting energies to be a huge turn-on, including many who intellectually disapprove of such things.*

Nowadays increasing numbers of lesbians are openly celebrating

* JoAnn Loulan's *The Lesbian Erotic Dance* offers a thorough exploration of the subject. She argues that butch/femme is *not* about mimicking straights, but rather a creative way of adding dynamism to lesbian sex and intimacy.

voluntary dominance and submission, with or without s/M, as an erotic intensifier. Claiming the right to be an enthusiastic top is a useful antidote to early gender socialization that can easily confine a woman's sexual options to waiting, responding, or resisting.

I've heard quite a few straight people say that they envy the ability of gays and lesbians to free themselves from rigid sex roles and to experiment with unconventional erotic styles. But this freedom usually doesn't come easily. Whereas straights have the option of taking their assigned gender roles for granted and having sex "by the book," gays and lesbians must grapple with an array of choices that can be as confusing as they are liberating. Yet it's clear to me that any man or woman, regardless of sexual orientation, can expand his or her choices considerably by becoming more conscious of the infinite interactions between eros and power.

14

A Lifetime of Anal Pleasure

Integrating and Sustaining Your Discoveries

ONCE YOU'VE EXPLORED the many forms of anal stimulation, discovered those you do and don't like, and identified which factors make the difference, you may think that your journey of anal awareness is over. In actuality, becoming intimately aquainted with your anus and rectum raises two crucial questions about the future: What role will anal pleasure play in your life from now on? And how will you go about maintaining anal and rectal wellness as the years pass? To some extent the answers to these questions will come clearly into focus only as you live them. Yet consciously thinking about a few key areas can start you off in the right direction.

Staying In Touch

Much of this book has been devoted to the development of self-awareness and relaxation. Unfortunately, once some people learn how to share anal pleasure with others they stop looking at and touching their anuses privately. If you make this mistake you'll miss out on a variety of simple pleasures that can enhance the quality of your life. But even more is at stake. Ignoring the private aspects of anal enjoyment can lead to a gradual reduction of anal awareness and a recurrence of

muscular constriction. This is especially true for those with a history of chronic anal tension.

Conversely, if you carry on regular self-pleasuring and exploration you're far more likely to become increasingly comfortable with anal sexuality as time passes. For this reason, I strongly suggest that you make a point of continuing self-exploration in addition to any anal activities you might be sharing with a partner.

Do yourself a big favor by regularly exercising your pelvic muscles in order to preserve their tone, elasticity and sensitivity (see Chapter 5). You can also promote optimal anal and intestinal health by regularly consuming foods rich in fiber, especially whole grains and plenty of fresh fruits and vegetables. It's equally important to avoid straining during bowel movements, relying instead on your body's natural rhythms and signals. These are health-conscious habits that will serve you well for the rest of your life.

Every now and then use a hand mirror to give yourself an anal self-examination, especially if you're feeling any discomfort. Minor irritations as well as more serious medical problems can often be detected visually more readily than by any other means. Looking at your anus periodically can also alert you if everyday stress is accumulating in your anal muscles. If you notice the tight, reddish, or puffy look of excess tension, make a special effort to spend more time relaxing, perhaps with the help of warm baths and deep breathing. During particularly stressful times, it may be best to avoid anal intercourse and focus instead on gentle stroking of your anal opening.

One of my favorite recommendations deserves repeating here: Nothing can promote long-term awareness and relaxation more effectively than developing the habit of sensitively inserting a finger into you anus for a minute or two every time you shower or bathe. Once your fingertip is inside, use it to feel both of your anal sphincter muscles. Briefly contract these muscles against your finger as you inhale and then release them as you exhale. Complete the routine by briefly massaging inside your anus with a gentle, circular motion. Incorporating this habit into your daily routine has the ef-

fect of "resetting" your anal muscles to a reasonably relaxed state, and thus avoiding the gradual accumulation of tension.

Who, When, and How

Once you're comfortable sharing anal pleasure with a partner you have many new choices to contemplate. With whom do you feel comfortable including your anus in erotic activities? What sorts of stimulation do you wish to include or exclude from your repertoire? And how will you express your desires within the specific circumstances of each encounter?

Most people who follow the approach to mutual exploration described in Chapters 11 and 12 are open to including at least some forms of anal stimulation with intimate partners, particularly when they've successfully cultivated trust, rapport and the ability to communicate honestly. Those who aren't currently involved in such a partnership usually feel that they, too, will want to experience anal stimulation with intimates in the future.

Of course, some people don't want to restrict their sexual activities to intimate partners, or aren't exactly sure what they want. During my original research, a large majority of gay and bisexual men, close to half of the straight men, and about a quarter of the straight and lesbian women engaged in casual sex at least occasionally. One impact of the AIDS epidemic has been to reduce the frequency and modify the types of casual sex practiced by most groups, especially gay and bisexual men. Yet casual sex is still quite common and readily available, particularly in urban areas. A key challenge for those who enjoy recreational sex is to decide what forms of anal stimulation, if any, will be a part of these encounters.

For those considering anal stimulation with casual partners, a good place to start is with very low risk activities such as external anal touching or insertion of a finger or object. It's important, however, to make sure the partner's fingernails are smooth before allowing finger insertion. Generally, people are more apt to enjoy finger or

object insertion if they're prepared to say "enough" at any time. The partner's response to such a request is a good indication of whether he or she can be trusted. If your requests aren't immediately honored, or if the partner applies pressure to proceed anyway, I suggest that you discontinue anal experimentation with this person.

Those who enjoy anal penetration express a wide range of attitudes about the conditions under which they're willing to try it. Among my research participants, well over half—including those who enjoyed other forms of casual sex—considered it unlikely that they would ever feel sufficiently secure with a casual partner to receive anal intercourse. The feelings expressed by Don, a gay man in his thirties, are representative of those who feel this way:

> I like sex for pure fun and I don't always need to know the person to get into it. Even if I have no intention of seeing the person again I can still enjoy momentary pleasure with them. When it's over, it's over. But with other people I want whatever we do to lead somewhere. For me sex can either be intimate or not. It all depends on the situation and how we feel about each other. Frankly, I can enjoy oral sex or mutual masturbation with just about anybody I'm attracted to. And I always like lots of touching, affection, and body contact, even with a complete stranger.
>
> But to me there's something much more intimate and personal about anal sex. I hardly ever feel comfortable with that when I first meet somebody. I have to trust the person and feel close to him and want to know him and have him know me. At first I thought this was a little weird 'cause I know lots of guys who get fucked and it's no big deal. But that's not me—something I've finally come to accept. I just tell the guy I don't fuck until I get to know him better. If somebody can't accept that, too bad. I no longer think it's my duty to satisfy everyone.

Other men and women feel quite differently than Don. They view anal intercourse as no more or less intimate than any other sexual activity. Naturally, they're more inclined to include it in casual encounters. Even so, many avoid it anyway in the interest of safety. Some are willing to consider it as long as strict condom use is explicitly agreed upon ahead of time. Receivers are wise to reach down periodically and check with their fingers that the condom is still in

place. As an added precaution, some seek an agreement that their partners won't ejaculate inside of them even though they're wearing a condom.

More than a few are torn by mixed feelings. On one hand they like the fantasy of casual anal intercourse but in actual practice they don't enjoy it. Follow-up interviews indicate that some research participants continued to feel conflicted about this for months, or even longer. Eventually, though, most became more accepting of their need for safety and comfort, and recognized the fact that enjoying something in fantasy can be very different than trying it in real life. Paradoxically, those who became most comfortable saying "no" discovered that their willingness to say "yes" simultaneously increased.

When it comes to anal play in a dating situation, the most common questions are how and when to initiate it. Of course, some people are ready to jump in right away and don't hesitate to ask for it directly or to broach the subject non-verbally, perhaps by touching the partner's anus and observing the response, positioning or moving their bodies to invite anal attention, or placing condoms and lubricant conspicuously next to the bed. These approaches are particularly prevalent among gay men because of widespread acceptance of anal sex as an erotic option. Nonetheless these unspoken strategies can backfire when they trigger anxiety in an unprepared partner.

Many gay men, along with most opposite sex couples and lesbians, require a bit more comfort-building groundwork before initiating anal sex in a dating situation. Some discussion ahead of time can provide vital information about what you each require to assure a pleasurable experience. Such discussions aren't necessarily easy, though, which is why some partners choose to wait until something happens spontaneously. The trouble is that spontaneous anal experimentation may go poorly, making future attempts unnecessarily difficult. You might want to review the section "Choosing a Partner" in Chapter 11 for ideas on how to create optimal conditions for anal experimentation. If you're currently very comfortable with anal sexuality, some of the suggestions may seem unnecessarily detailed and cautious. If so, modify them to better suit where you are now.

As you can see, there is quite a range of possibilities. As you go about discovering which are best for you, you'll undoubtedly discover that the level of enjoyment you receive has relatively little to do with which choices you make. A far more important factor is your willingness to be assertive about whatever it is that works for you.

Aging and Anal Pleasure

One of the few certainties of life, besides the proverbial death and taxes, is that our bodies change as we age and that some of these changes inevitably affect our sexuality. Although hardly anyone is thrilled about getting older, most of us adapt reasonably well to a slowing of our sexual responses, an increasing susceptibility to health problems, and the realization that our bodies are drifting further away from the ideals of youthful perfection that permeate our culture.

As we lose beauty and stamina we hopefully gain self-knowledge born of experience and a deepening zest for sensuality. Many older lovers put far less emphasis on performance and prowess, concentrating instead on the simple joys of touch and affection. Concerns about technique tend to take a back seat to richer and more varied expressions of eros.

Although erotic experimentation is typically a preoccupation of the young, they by no means hold a corner on the market. I'm regularly struck by how true this is of anal exploration. I've worked with a much higher proportion of under-50 explorers and I must say they bring a special determination to the adventure. In more than a few cases, however, their motivation springs primarily from an urge to be sexually versatile rather than an enjoyment of the process. By contrast, the older men and women I've worked with, as well as the dozens who write me regularly, typically infuse their descriptions of each new discovery with genuine delight; the goal rarely overshadows the process.

Aging need not be an impediment to anal pleasure. But everything I've said about the importance of awareness and self-care goes

double for older explorers. Already sensitive tissues can become more delicate over time. Muscles that haven't been exercised regularly lose some or even most of their tone and elasticity. The prevalence of medical problems such as hemorrhoids and constipation increases with age. And a smorgasbord of aches and pains, even those far removed from the anal area, can make it difficult to find comfortable positions for anal viewing and touching.

The good news is that older men and women have the most to gain from maintaining anal awareness and relaxation because the health benefits tend to be obvious, sometimes dramatic, and relatively easy to obtain. Many older anal explorers initially follow my program to heal their symptoms and only later—as a positive side effect—stumble upon erotic and sensuous potentials they never expected to find.

More commonly than you might think, older lovers can be highly enthusiastic and adventurous about all forms of anal stimulation, including intercourse. For example, one couple in their seventies wrote to thank me for writing this book and then went on to say:

> You've shown us a new opportunity we've been missing out on all of our lives. But we're making up for lost time, I'll tell you that. The other day Betty licked me to a fairly full erection and before I knew it she greased me up, sat over me, and slid me inside of her. I was shocked at how relaxed she was. Then she used her ass muscles to stroke me to the best orgasm I've had in years. I swear I don't know how the old gal learns these things.

With a bright pink pen Betty added, "I'm not telling! But in case you didn't notice, Bob, you weren't the only one having orgasms."

Bob and Betty are by no means unusual. I have the impression, though, that the majority of older couples who enjoy anal play appreciate giving and/or receiving anal massage with a finger, perhaps in conjunction with manual or oral genital stimulation, and don't necessarily care about penetration. Whatever they may do, one lesson is clear: We're never too young to begin preparing for those golden years—or too old to learn a few new tricks.

Honoring Erotic Preferences

Just as it's helpful to consider the conditions under which anal pleasure is desired, the relative importance of anal sex among all erotic activities is a highly personal matter to be decided by each individual. Of course, the "people pleasers" believe that they shouldn't have any preferences of their own. Instead, they want to be available for whatever their partner desires. Yet as much as some may deny it, virtually everyone has unmistakable preferences which, while certainly subject to change, tend to become more clearly defined with experience.

As each form of anal pleasure is embraced as an option, it must be integrated into a pre-existing set of preferences. Typically this happens fairly naturally, but by no means always. New erotic possibilities sometimes turn out to feel very different than originally expected. For example, some people experience varying degrees of disappointment with anal stimulation even though they've enjoyed it on occasion. In spite of frequent discussions with my clients about their hopes, some don't become fully aware of how much their ideals and their actual desires differ until they've gathered a considerable body of experience.

Mary expressed her disappointment: "I guess I hoped anal sex would perk up my sex life with Frank. But it hasn't changed anything really. I *still* don't like the way he makes love to me." Jeremy voiced a different kind of expectation: "I was hoping anal sex would be the greatest sexual trip ever. It's okay sometimes, but I like oral sex much better—just like always. I'm so different from my friend Rob who thinks getting fucked is the ultimate turn-on."

Believe it or not, disappointments with anal stimulation often result from subtle vestiges of the anal taboo. Just as taboo pressures can give anal sexuality a highly negative emotional charge, they can also turn forbidden fantasies into larger-than-life expectations. Discovering that anal pleasure probably won't be the sole solution to a dull sex life or a source of cosmic ecstasy may understandably feel like a loss. A few people actually go through anger, depression, grief, and other feelings associated with grieving before they reach an accep-

tance of what anal sexuality is and is not for them. In the midst of this process Andy expressed an important insight: "I think this whole thing [disappointment with anal sex] is one reason why I had so much trouble learning to do it in the first place. Somewhere inside I must have known it couldn't possibly live up to everything I'd imagined. I may have lost my tense ass, but I also lost a couple of dreams."

At first glance, feelings like these may seem unfortunate and sad. However, with a little support most people are able to resolve them with minimal distress. Instead of clinging to larger-than-life expectations, they're able to allow desired forms of anal pleasure to find an enjoyable place within the larger context of their sexuality. It's uncommon for the ability to enjoy anal sex to change one's preferences dramatically. Of course, for some people anal erotic activities quickly become their favorites. Others decide that they don't like some or any forms of anal stimulation much after all. But most people end up somewhere between the two extremes—happy to have discovered one more way to please themselves, appreciate their partners, and celebrate the many facets of their evolving eroticism.

Health Problems Involving the Anus and Rectum

S MART, SAFE AND PLEASURABLE enjoyment of anal sexuality requires that we become aware of a variety of sexually transmitted diseases (STDs) and other common health problems that can affect the anal area. Armed with accurate information, we can establish sensible guidelines for preventing these problems altogether, or for dealing effectively with any that might arise. For example, tension-related anal problems such as hemorrhoids, fissures, constipation, and Irritable Bowel Syndrome (IBS) typically respond very well to active self-healing measures. Later in this appendix, I'll describe a practical and highly beneficial seven-step approach to anal-rectal healing.

Long ago I was concerned that discussing the nitty-gritty details of anal health problems might frighten people and make anal exploration even more threatening and difficult than it already is. However, I've repeatedly observed that matter-of-fact discussions about the medical aspects of anal pleasure help demystify the entire subject and actually *reduce* fear—especially the irrational anxieties born of ignorance.

This appendix includes information about:
- HIV and AIDS (including guidelines for safer sex)
- other STDs involving the anus and rectum (chlamydia, gonorrhea,

herpes, anal warts, hepatitis, intestinal infections and syphilis)
- common diseases of the anus and rectum (hemorrhoids, fissures, fistula, constipation, diarrhea and Irritable Bowel Syndrome)
- guidelines for self-healing
- finding a physician or alternative practitioner

Feel free to go directly to areas of greatest personal interest, but I suggest a quick read-through of the entire appendix. Obviously it's not any fun to read about all the things that might go wrong. Initially, you may even feel a bit disturbed by it. But I predict that you'll come away with a greater appreciation of this complex area of the body—and what's necessary to protect and care for it.

Keep in mind that when you have a serious anal health problem, or you're not sure, none of the information here is a substitute for the expertise of a competent and sensitive physician. Nonetheless, basic knowledge about common medical problems can help you decide when to consult a professional, how to describe your problem as clearly as possible, and what questions to ask.

HIV and AIDS

These days, the sexually transmitted disease (STD) that everyone is— or should be—talking about is AIDS (Acquired Immunodeficiency Syndrome). The first ominous cases appeared in the U.S. in 1981 when a few otherwise healthy gay men in New York and California developed life-threatening illnesses from microorganisms that would pose no threat to people with normal immune systems. Soon, similar cases were also identified among intravenous drug users, as well as some recipients of blood transfusions and other blood products, such as the clotting factor used by hemophiliacs to prevent uncontrollable bleeding.

* For a scathing indictment of the scientific establishment and politicians, and an edge-of-your-seat documentary of the early epidemic, see Randy Shilts' award-winning book, *And the Band Played On*.

Research efforts were distressingly slow to get off the ground in the early years.* In 1983, however, French and American scientists discovered almost simultaneously a retrovirus—HIV (Human Immunodeficiency Virus)—that has now been established as the primary cause of AIDS. Epidemiologists suspect that there were isolated cases of HIV infection in the U.S. and Europe as early as the 1960s. Analysis of stored blood samples from central Africa has found HIV infections in the late 1950s. No one knows how HIV originated, but one hypothesis is that a similar virus found in certain monkeys may have been transmitted to humans and gradually evolved into HIV.

HIV infection is now clearly a worldwide epidemic. In November 1997, the World Health Organization estimated that 30 million people had been infected with HIV and that nearly 12 million had already died. The Centers for Disease Control and Prevention (CDC) estimated that approximately three-quarters of a million Americans had been infected through June 1997, with about 40,000 new infections each year. By mid-1997, 379,258 Americans had died of AIDS, making it the second leading cause of death among 25–44 year olds, second only to accidents.*

HIV is passed from one person to another when tiny amounts of virus-infected body fluids—especially blood, semen, and vaginal secretions—gain access to the recipient's bloodstream. This can happen in a number of ways:
- during anal and vaginal intercourse (and occasionally other sex acts)
- sharing contaminated needles for injecting drugs
- transfusion of contaminated blood products (very rare now, thanks to effective blood screening procedures)
- during fetal development, childbirth, and breast feeding
- accidental punctures with contaminated needles by health workers

Once inside the bloodstream, HIV infects and destroys two types of cells which are crucial for proper immune function: CD4 T-cells and

* The CDC analyzes trends in the epidemic and reports its findings in regular "Surveillance Reports" available on the World Wide Web at *www.cdc.gov*.

macrophages. Shortly after infection a person may have flu-like symp-
toms, most commonly fever, joint pain, and night sweats. These symp-
toms go away, but the virus continues replicating silently. From this
point, the course of the infection is quite variable, but it commonly
takes ten or more years for T-cell counts to fall from a normal level of
approximately 1,000 per micoliter of blood to fewer than 500, the point
at which a person begins to become vulnerable to a host of opportu-
nistic infections including many types of parasites, certain cancers, yeast,
fungal, viral, and bacterial infections. Opportunistic infections may
affect the lungs, skin, gastrointestinal tract, lymph nodes, eyes and brain
(HIV can directly infect brain and spinal cord tissue).*

An AIDS diagnosis is given when an HIV+ person has fewer than
200 T-cells and/or has at least one of a long list of serious opportu-
nistic infections. Another important way to monitor the progression
of HIV infection besides T-cell counts, is to look at the "viral load"—
the amount of virus in the blood. In general, the more virus there is,
the faster the progression of the disease.

Almost all infected people develop detectable antibodies to HIV within
weeks or months after infection—six months is usually the maximum
time needed. At one time there were debates about whether people
should get tested for HIV antibodies, but now there are effective ways to
slow the progression of the disease. When T-cells fall below 500, treat-
ment with antiviral drugs is considered standard in developed coun-
tries. Before T-cell counts fall below 200, preventive treatment should
begin for life-threatening illnesses such as *Pneumocystis carinii* pneumo-
nia, the most common AIDS opportunistic infection.

Early antivirals such as AZT had moderate benefits at best, and
tended to lose their effectiveness after about 18 months, because HIV
is very adaptable and can mutate quickly. Nowadays, three or more
antivirals are usually combined for greater effectiveness. Results are
especially impressive when one of them is a fairly new type of drug
known as a protease inhibitor. There are now widespread examples

* For those who want a more detailed discussion of HIV and its consequences, I
recommend Lyn Frumkin and John Leonard's excellent book, *Questions and
Answers on AIDS* (3rd Ed., 1997).

of very sick people rebounding to near-normal health, with rising T-cell counts, and undetectable viral load levels.

These developments are truly worth celebrating. For the first time in the history of the epidemic, the CDC announced in 1997 that new AIDS diagnoses dropped 6% in the U.S. between 1995 and 1996. And during the same period there was a 26% reduction in deaths. But the good news isn't distributed evenly; reductions in deaths were far smaller among women, blacks, and Hispanics. In addition, the new drug "cocktails" don't work for everyone, may cause severe side effects, and often require taking dozens of pills per day—presumably forever, because HIV rebounds when the drugs are stopped. This regimen is also very expensive, making it impractical for widespread use in developing countries.

The search for a cure, not just treatments, remains an elusive dream. Consequently, focused efforts at prevention are still our best hope for limiting the scope of the epidemic. There are disturbing signs that some people, especially younger ones, are growing weary of the safer sex practices that have made such a dramatic difference, especially among gays. Others cling to the belief that because of the new treatments, safer sex is no longer that important. No self-affirming person can afford to succumb to such deadly thinking.

Making Safer Sex Work: Developing Your Personal Policy

All sexually active people—except for those in strictly monogamous relationships, and who have both tested negative for HIV antibodies—owe it to themselves to develop and implement a personalized and freely-chosen safer sex policy designed to reduce dramatically the chances of contracting HIV. In order to work over time, this policy must make sense and clearly define the fundamental parameters necessary for safe, yet satisfying sex. Once the policy is established and becomes second nature, you can grant yourself and your partner(s) full freedom within the defined safety zone—think of it as a playground in which you can let yourself go free.

Safe or very low risk sexual activities

Sexual activities that involve only skin-to-skin contact, without the exchange of any body fluids, make it virtually impossible for the AIDS virus to be transmitted. These activities include:

- hugging and cuddling
- dry kissing
- stroking, rubbing, and massaging
- body licking (on healthy clean skin)
- wrestling (no blood or bruises)
- masturbating yourself, your partner, or each other
- using personal sex toys (not sharing them)
- fantasy role-playing (no body fluids exchanged)
- water sports (contact with urine) on unbroken skin

These activities can be enjoyed without concern about being exposed to HIV. The potential for transmission may increase somewhat if there are breaks in the skin at points where contact might occur with infected blood, semen, or vaginal secretions.

Low risk sexual activities

This category of sexual behavior is less clear-cut due to conflicts between what's theoretically possible and what appears to happen in actual practice. Generally speaking, these activities are considered quite—but not 100%—safe:

- French (tongue) kissing
- fellatio (oral-penis contact) without ejaculation
- cunnilingus (oral-vaginal sex)
- anal or vaginal intercourse practiced with a condom *every single time*
- rimming (oral-anal contact) with a barrier
- anal finger play with a latex or plastic glove

Some people are concerned that pre-ejaculatory fluid or vaginal secretions encountered during oral sex might contain tiny amounts of HIV, but the risk of exposure this way appears to be very low, especially for those with good oral and genital health. Smart lovers naturally monitor the condition of their mouths and genitals and note

any sores or bleeding gums that might introduce blood into an oral sex scene.

All of these activities, although probably safe, are somewhat in the "gray zone" because there are many unanswered questions. Scientists discuss probabilities; regular people want definite answers. It is here that an individual's own judgment must be exercised. Life is filled with a never-ending array of risks and dangers. And some people are naturally more cautious than others. If a particular activity produces fear, then it will be difficult to enjoy—even if other people think it's perfectly safe. There is no such thing as a one-size-fits-all approach to safer sex.[*]

High risk sexual activities

Sexual behaviors with the highest risk of exposure to HIV involve the exchange of semen, blood, vaginal secretions, or feces. Such activities include:

- giving or receiving anal or vaginal intercourse without a condom
- swallowing semen
- rimming (oral-anal contact) without a barrier
- anal or vaginal fisting without a latex or plastic glove
- sharing menstrual blood
- sharing needles or blood while body piercing or injecting drugs

Some people are under the mistaken impression that being the inserter (top) in unprotected anal or vaginal intercourse is relatively safe. While it is true that the risk is lower for the inserter, the mucous membranes around the urinary opening of the penis may be exposed to small amounts of blood during either anal or vaginal intercourse, to feces during anal intercourse, or to vaginal secretions during vaginal intercourse. Vigorous intercourse can also cause tiny breaks in the surface of the penis, allowing another route for exposure. There is no such thing as safe unprotected intercourse, except in monoga-

[*] *The Complete Guide to Safer Sex* (McIlvenna, et al., 1992) offers sensible, sex-positive guidance for those who wish to create a "safer sex lifestyle."

mous relationships between individuals who both test negative for HIV. But even here, people are notoriously dishonest about outside sex, *especially* when they've made a monogamous commitment. This is why many monogamous couples wisely continue to use condoms as added protection.

Making Safer Sex Work: Confronting the Challenges

It is clear that many people, especially gay and bisexual men, have made significant changes in their sexual behavior. But too many people try not to think about safer sex, abandon their intentions in the heat of passion, cloud their judgment with alcohol and other drugs, convince themselves that they're invulnerable, or hope that they'll be saved by the new AIDS drugs.

Many other factors can make it extremely difficult for even the most well-intentioned among us to sustain a safer sex policy consistently for the foreseeable future. Many who decide to give up or restrict a favorite sexual activity—intercourse, most notably—experience a sexual "limbo state" in which some or all of the fun seems to have gone out of sex. Feelings of loss and anger can be quite intense and must be recognized, honored, and worked through.

One's commitment to safer sex can also be undermined by deep, sometimes unconscious, feelings of self-loathing. After all, someone who feels essentially worthless is far less inclined to believe that their long-term survival is worth very much effort. For instance, people with low self-esteem are more likely to put their own interests in second place, perhaps caving in to pressure from a partner for unsafe sex. We also know that some people are so driven by their erotic urges that their capacity for free choice is seriously impaired.

There's no denying the fact that exchanging body fluids is something that human beings like to do—and always have. In many ways, avoiding fluid exchanges during sex is contrary to what we naturally desire. Consequently, campaigns directed at getting us to believe that "safe sex is the best sex" or that sticking to it is easy are ultimately doomed to failure—because they're simply not true. It *is* true to say that safe sex activities can be intensely exciting. But those who see

intercourse as the ultimate or only "real" sex act and who hate condoms are unlikely to change their minds, at least not quickly or easily.

We must also acknowledge openly the importance of danger as a powerful aphrodisiac for many people. Sex has always been unpredictable, risky and potentially life-changing. How often have humans risked it all for a mere chance at profound erotic satisfaction? Careers, wealth and family solidarity—all have been sacrificed at the altar of sexual passion. In many ways, "safe sex" is a contradiction in terms. Sex isn't necessarily supposed to be safe; riskier can be hotter.* Those who enjoy a sense of erotic risk face a special challenge: to avoid real health dangers while enjoying fantasized, role-played, or emotional risks. Frankly, doing this requires a considerable amount of creativity and practice.

The most successful and satisfied safer sex practitioners are those who develop a special knack for focusing on the fundamentals and not confusing themselves with esoteric details. When people view safer sex as complicated and almost impossible to accomplish, they may eventually give up on the entire enterprise. On the other hand, those who commit themselves to doing just one thing—*always* using a condom for intercourse—have an excellent chance of remaining free of HIV, even if they're a bit less consistent about other aspects of their ideal safer sex policy.

Other Sexually Transmitted Diseases (STDs)

In this age of AIDS, other STDs may seem relatively inconsequential. Although it's understandable that public awareness and discussion of STDs has been largely dominated by HIV, we make a huge mistake if we fail to stay informed about *all* STDs.† For one thing, an estimated 56 million Americans—more than one in five—are infected with in-

* For an exploration of the importance of risk in high sexual arousal, see my book, *The Erotic Mind.*

† An excellent source of current information on STDs and other sexual health concerns is the Planned Parenthood site on the World Wide Web: *www.igc.org/ppfa/*.

curable viral diseases *other than* HIV, including herpes, human papilloma virus (HPV), and hepatitis (Donovan, 1993). These are major public health problems with consequences ranging from recurrent painful outbreaks, to chronic liver disease, to cancer, or even to death.

Furthermore, many STDs occur without any symptoms, or ones too minor to notice. This is especially true for vaginal and anal infections. In addition, these and other STDs can make a person more vulnerable to HIV because of the inflammations and lesions they cause. STD infections, especially repeated or multiple ones, can also weaken the immune system.

Many people believe that the high prevalence of STDs is evidence that sex is dirty, dangerous, or intended only for procreation in a monogamous relationship. I couldn't disagree more. The fact that STDs are as old as humanity proves one thing only: Certain sexual activities bring mucous membranes of the mouth, penis, vagina, and anus into intimate contact with each other or with infected skin lesions and body fluids such as blood and semen, thereby providing an entry point for a variety of disease-causing microbes. Preventing infection is a matter of gathering accurate information, respecting oneself and one's partner(s), and making health-promoting decisions.

The persistent feeling that they are particularly embarrassing or shameful actually contributes to the increasing incidence of STDs. For instance, it's not unusual for people to feel so guilty about the possibility of having an STD that they avoid medical care or are reluctant to be honest with their partners. As you might imagine, the anal taboo intensifies this negative charge further still.

The belief that STDs, particularly AIDS, are punishment for wrongdoing often skews the judgment of doctors and patients alike. Consequently, the precautions necessary to avoid spreading a disease often take on the aura of a moral imperative, rather than common sense or basic adult responsibility. At the other end of the spectrum, some people become deliberately or semi-consciously defiant, recklessly ignoring the facts as if doing so were an act of liberation and autonomy.

Fortunately, following safer sex guidelines provides broad protection against most STDs, not just HIV. But not all STDs are transmit-

ted in the same ways, and thus our sexual well-being requires us to supplement our commitment to safer sex with a clear-headed assessment of other risks and how to reduce them.

Chlamydia

A bacterial infection spread primarily by unprotected vaginal or anal intercourse, chlamydia is the most common of all STDs, with an estimated 4 million infections each year in the United States. When the urethra is infected in men, the majority have at least mild symptoms—such as pain or burning during urination—from one to three weeks after exposure. About one-quarter of infected men have no symptoms at all. When untreated, chlamydia can travel up the male urethra and cause infections of the prostate or epididymis (part of the sperm-producing apparatus attached to the testicles), possibly resulting in sterility. These undetected penile infections are also a major source of transmission to women, 75% of whom have no symptoms. Left untreated in the vagina, chlamydia infections can cause pelvic inflammatory disease (PID)—of which there are more than one million cases each year in the U.S.—or sterility (National Institute of Allergy and Infectious Disease, 1992).

When chlamydia infects the rectum, there may be no noticeable symptoms, but rectal discharge, soreness, and constipation aren't unusual.

Treatment is with antibiotics. All forms of intercourse should be stopped until the course of antibiotics is finished. Whenever possible, recent sexual partners should be notified and treated.

Condoms offer very effective protection.

Gonorrhea

Rectal gonorrhea is an acute infection of the mucous membranes of the rectum caused by the same bacteria that can also cause urethral, vaginal and throat gonorrhea. Gonorrhea infections of the throat are relatively rare, although they certainly do occur, but other forms of gonorrhea are more common. Rectal gonorrhea is especially prevalent among gay men, but women can get it too if they receive unprotected anal intercourse from a man whose urethra is infected. More

than one million new cases are reported each year in the United States. An increase in gonorrhea infections in recent years, particularly among 15–29 year olds, is a disturbing sign that the prevalence of unsafe sex is increasing.

Like chlamydia, gonorrhea often produces no symptoms (true of more than half of all cases of rectal gonorrhea). When the urethra is involved, symptoms usually include burning or a pus-like discharge. Acute rectal gonorrhea may cause discomfort or pain, a creamy discharge from the anus during bowel movements, constipation, and occasionally diarrhea (Lamont, 1995). If there are going to be symptoms, they'll usually be noticed within a week or two of exposure.

Diagnosis is made by a microscopic examination and culture taken from the infected area. Once diagnosed, gonorrhea is treated with antibiotics; penicillin resistance is increasingly a concern due to its overuse. Those with gonorrhea often have chlamydia as well, requiring simultaneous treatment for both. Sexual activity should be avoided until the infection has been eliminated as determined by a follow-up examination. Recent sexual partners should be notified and treated, if possible.

When rectal gonorrhea goes untreated, as it often does, complications such as a rectal abscess may follow. In the meantime, a male who has unprotected anal intercourse with this person stands a good chance of developing urethral gonorrhea. In some cases where gonorrhea remains untreated for quite a long time, the bacteria may enter the bloodstream and cause symptoms such as fever, chills, rashes, painful joints, heart problems and pelvic inflammatory disease (PID) in women.

Once again, condoms offer very effective protection.

Herpes

The threat of herpes infections burst into public consciousness during the sexually adventurous 1970s. Following a relatively brief period when antibiotics appeared to be triumphant over most STDs, here was an infection that invaded the body for life. The ideal of unfettered sex was shattered. In a sense, the herpes scare foretold the radical changes in sexual behavior that would soon become essential

for preventing HIV. More than 30 million Americans are currently living with herpes, about one in four.

Herpes is a viral infection caused by one or more of the herpes simplex virus (HSV) family.* HSV-1 is usually responsible for infections above the waist, especially cold sores, fever blisters, and facial herpes, but it can also infect the genital area. The vast majority of herpes infections below the waist are caused by HSV-2 because of its preference for the soft skin and mucous membranes of the genital and anal areas. Both types of herpes are spread by skin-to-skin contact with infected areas.

Typically within a week or two after exposure—but sometimes much longer—about one-third of those infected with HSV-2 will experience a primary outbreak with a wide variety of possible symptoms ranging from minor to severe. Commonly, a red spot appears near the point of infection, followed by bumps and fluid-filled blisters on or near the genitals, in the perineal area between the genitals and the anus, or on the upper thigh. About one in six have generalized symptoms such as fever, swollen glands, and a run-down feeling. A fissure may appear near the anal opening. Sometimes this swollen crack is mistaken for a hemorrhoid. Other anal symptoms may include pain and tenderness, a discharge, constipation or inflammation. During the primary episode, with or without symptoms, HSV is being shed and thus contact with the infected area(s) can easily transmit the disease.

Within a few weeks, any blisters will burst, crust over and heal. Other symptoms will also disappear. The herpes virus will then retreat to certain cells within the body and become dormant, beginning a period known as latency. During latency there are no symptoms and the person is usually not infectious, but the virus remains in the body. This first outbreak of herpes symptoms is usually the worst, and often the last.

Unfortunately, there's always the possibility that the virus will re-

* Other members of the herpes family include Epstein-Barr (the cause of "mono"), *Varicella zoster* (the cause of chicken pox in children and shingles in adults), and CMV (cytomegalovirus).

activate and cause another outbreak of symptoms, not always in the same place. No one knows for sure what causes herpes flare-ups, or why some people are troubled by them with distressing regularity while others are hardly bothered at all. Possible factors that may trigger herpes outbreaks include: physical trauma or friction at the point of infection, exposure to ultraviolet light (sunbathing), lowered resistance (which often occurs when fighting off another disease), emotional stress, or elevated body temperature (caused by sitting in a hot tub, for example).

Prior to a herpes flare-up, some people experience flu-like symptoms or itching at the point of infection. This pre-outbreak period is known as the *herpes prodrome*. HSV is contagious during this period and throughout the outbreak until the sores have healed completely. At these times, sexual interaction should be avoided, especially activities anywhere near the infected area. It is important throughout the outbreak to avoid touching the lesions and to wash one's hands frequently and thoroughly, because they can unwittingly spread HSV to other areas of the body, occasionally even the eyes. Eye infections, however, are almost always caused by HSV-1.

Another concern is that herpes can reactivate without any symptoms, causing contagious viral shedding at particular skin sites. Luckily, these "asymptomatic reactivations" usually last only about a day.

Since there is no cure for herpes, and treatment is focused on reducing the severity, duration, and frequency of outbreaks, acyclovir or other similar drugs are now standard treatment. When these drugs are given early during the first episode, it may be shortened by several days. These medications may also be taken orally or applied directly as an ointment to reduce the severity of subsequent outbreaks. Some people with frequent outbreaks take regular oral medication to help suppress them. Ongoing treatment for herpes may be crucial for people who also have AIDS because their immune systems are unable to control the virus and, consequently, their outbreaks are often especially severe or debilitating. Infections may even spread to unexpected places, including the internal organs.

Leading naturopathic doctors have reported benefits from vita-

min C, flavonoids, zinc, and lysine to help minimize outbreaks (Murray & Pizzorno, 1998).

Condoms offer some protection between outbreaks. But since the infected area isn't necessarily covered by a condom and people don't always know when an outbreak is coming, they may be contagious without symptoms and the protection is far from foolproof.*

Anal Warts

Anal warts are caused by the human papilloma virus (HPV) which is primarily spread through sexual contact, but sometimes result from non-sexual exposure to the virus. The strain of HPV that causes warts on or near the genitals or anus—collectively called genital warts—is different from the strain that causes warts elsewhere on the body. Each year there are approximately one million new genital HPV infections in the United States. Most of these infections do not involve the anus, but no reliable separate estimates are available.

Beginning as tiny, pink swellings appearing from two to three weeks after infection, anal warts often develop a soft, distinctive texture similar to that of a miniature cauliflower. Unfortunately, warts can spread—slowly or rapidly—around the anus and into the anal canal. Eventually they can form clumps that, if on the surface, are readily detectable by sight and touch. Although they may itch, anal warts are not painful unless irritated by friction or a secondary infection.

Some people have a few anal warts, even for long periods of time, without any spreading or discomfort. But even these non-troublesome warts should be removed to prevent future spreading or transmission to sexual partners.

Warts are treated in one of four ways: (1) by applying an acid to each wart or clump of warts, (2) by laser surgery, (3) by freezing the warts with liquid nitrogen (cryotherapy), or (4) by injecting inter-

* An excellent resource for those who are living with herpes or who wish to learn more about it is Charles Ebel's *Managing Herpes* (1994) published by the American Social Health Association. This group also operates the National Herpes Hotline at 919-361-8488. Or call their resource center at 800-230-6039 for information on other publications and herpes support groups.

feron into them. Warts are usually treated in the doctor's office. However, if spreading is extreme, a brief hospital stay may be necessary so that the warts can be removed all at once through standard surgery under anesthesia. Recovery is quite uncomfortable, especially during bowel movements.

Unfortunately, anal warts sometimes recur, even after they seem to have cleared up. This is because HPV, like the herpes virus, stays in the body for life. For this reason, the anal area should be re-examined periodically. Another reason for re-examination is that some HPV infections are associated with pre-cancerous changes in the cells of the infected area.

Condoms offer some protection against HPV, but contact with the virus is possible outside of the covered area.

Hepatitis

Hepatitis is a disease of the liver caused by a variety of different viruses, with symptoms ranging from hardly noticeable to extremely severe. These may include: loss of energy or appetite, depression, body or joint aches, nausea, diarrhea, abdominal pain, rashes or itching on the skin, swollen glands, fever, chills, sweats, reduction in tolerance for alcohol, dark urine or clay-colored stools. In more serious cases, there may be jaundice, in which the skin and eyes turn yellow. But even if there aren't any symptoms, the infected person is still contagious.

Hepatitis A can be transmitted through sexual as well as other forms of intimate contact. Since the hepatitis A virus is shed in stool, fecal-oral contact is the most common mode of transmission. Obviously, a very effective means of making oral contact with infected feces—only a microscopic amount is needed—is through oral-anal contact (rimming). Therefore, it's important to use a latex "dental dam" or plastic wrap for rimming, or at the very least to wash the anal area thoroughly beforehand. After a person becomes infected, he or she may be sick from one to six weeks and may remain infectious for many days after symptoms have cleared up.

A vaccine is now available; it's wise to discuss this option with your doctor.

Hepatitis B can be much more serious than hepatitis A. When a person is infected, the virus is present in all body fluids, especially semen and blood, but also in saliva, vaginal secretions, tears, feces, and sweat. It is most commonly transmitted by sharing infected needles and by unprotected vaginal and anal intercourse. Being exposed to infected semen during unprotected anal intercourse is an especially effective means of transmission because microscopic breaks in rectal tissue offer the virus direct access to the bloodstream (similar to HIV). Since fisting is even more likely than intercourse to cause rectal abrasions, it is also a high-risk activity for contracting hepatitis B, particularly if fisting is followed by unprotected anal intercourse.

Symptoms of hepatitis B usually persist for a month or two; the person remains infectious throughout this period, sometimes even longer. Ninety to 95% recover completely, but about 40% develop the chronic form of the disease and are ill for many months. In a small percentage of cases the disease persists for years, sometimes leading to cirrhosis of the liver and a higher risk of liver cancer. Some people become hepatitis B carriers and remain contagious long after their own symptoms have disappeared, perhaps for the rest of their lives.

Once a person recovers from hepatitis B, he or she will develop immunity and won't get that form of the disease again. However, it is still possible to contract another form of hepatitis. The good news is that there is a vaccine available which can provide immunity against hepatitis B. All non-monogamous adults should discuss the advantages of vaccination with their physicians.

Especially for hepatitis B, condoms offer a high level of protection.

There are many other types of hepatitis, with new variations being discovered regularly. Hepatitis C, for example, is a growing concern. It, too, is transmitted through contact with infected blood, so sexual transmission is certainly possible.

Intestinal Infections

A variety of organisms make their home in the gastrointestinal (GI) tract and most of these cause no problems. However, some bacteria and parasites can be very troublesome if they enter your digestive

system. Amoebas and giardia are parasitic infections caused by pro-
tozoa (single-cell animals). Shigella, salmonella, and campylobacter
are bacterial infections. Technically speaking, these intestinal infec-
tions are not diseases of the anus and rectum. The infecting organ-
isms settle higher up in the GI tract. However, when someone is
infected, the bacteria or the protozoa are carried in feces.

Intestinal infections are widespread in Third World countries
where these organisms may contaminate the water supply. In the U.S.,
giardia is the most commonly identified parasite (Hill, 1995) and con-
taminated water, usually encountered during travel, is the most fre-
quent mode of transmission. In some instances, infected food handlers
spread the disease by contaminating food with feces when they don't
wash their hands adequately after bowel movements. Bacterial infec-
tions can also be spread through contact with raw or undercooked
foods, most notably poultry, eggs, and raw milk. However, in the
U.S. generally, and among gay men in particular, intestinal infections
are, in the vast majority of cases, STDs.

Sexual activities provide many opportunities for tiny amounts of
contaminated feces to find their way into the mouth of a sexual part-
ner. The most direct transmission route is oral-anal contact (rim-
ming) without a barrier. But oral-genital contact with a penis that
has recently had contact with infected feces can have the same effect.
Such indirect infections can obviously occur if unprotected anal in-
tercourse is followed by oral sex. An even more indirect avenue for
exposures occurs when a finger is inserted anally, and then a penis is
touched with the same finger, followed by oral contact with that pe-
nis. A similar scenario can also lead to vaginal infections.

There have been some reports of the protozoa surviving outside
of the body for days, so it's conceivable that sharing sex toys, or even
towels, could spread these diseases. It's also possible for protozoa to
be passed along by anal lubricants in open containers into which
fingers are repeatedly dipped.

As much as 50% of the time, parasitic infections produce no symp-
toms at all, or ones too mild to notice. With or without symptoms,
though, the person's feces are still infectious. When there are symp-

toms, they range from vague abdominal discomfort, bloating, gas, or loss of appetite, to severe cramping, nausea, intense diarrhea (sometimes containing blood and mucous), fever, malabsorption of nutrients, weight loss, and malaise. Fever and bloody diarrhea are more likely to be symptoms of bacterial rather than parasitic infections. Many symptoms, especially the intense diarrhea, are especially pronounced in HIV patients with weakened immune systems.

Diagnosis is made by examining stool samples in the laboratory. For greatest accuracy, multiple samples are usually necessary. Some infections, especially giardia, may never show up in stool tests. In spite of the difficulties, accurate identification of the infecting organism is necessary for effective treatment. Medications that are effective against one organism may be ineffective against another. Sometimes, inexperienced physicians treat suspected intestinal infections with general antibiotics that suppress some of the symptoms temporarily, but do not cure the underlying infection. Some diseases and situations—for example, salmonella in generally healthy people—are best left untreated, since drugs may actually prolong the infection. Also, in generally healthy patients, most amoeba infections clear by themselves over a period of months. Therefore, it is important that diagnosis and treatment be directed by a physician who is experienced with intestinal infections.

Preventing intestinal infections is a matter of reducing the chances of oral-fecal contact. Consistent use of condoms for anal intercourse is a must for preventing most STDs among all but healthy and strictly monogamous partners. In gay male casual sex settings, condoms have the added benefit of keeping feces off of penises and, in turn, out of the mouths of oral sex givers. Rimming should be practiced only after thorough washing of the anal area, and with a latex dental dam or piece of plastic wrap used as a barrier. Fortunately, safer sex guidelines for HIV prevention are also effective for preventing intestinal infections.

Syphilis

Syphilis is caused by a microscopic organism shaped something like a corkscrew, a spirochete called *T. pallidum* that can survive only in

warm, moist areas of the body. During penis-vagina, oral-genital, or penis-anus sexual contact, the spirochetes pass from an infected person through a partner's mucous membranes or perhaps a skin abrasion, usually somewhere on the genitals, mouth, or anus.

Within three months of exposure, a round, dull red ulcer called a chancre appears at the point of infection. The chancre is virtually always painless when it occurs in the genital region, but in and around the anus it is sometimes painful and accompanied by a discharge. This is the primary stage of the disease. Since a rectal or vaginal chancre probably won't be visible, a person may not know that he or she has been infected. Even without treatment, the chancre (there may be more than one) becomes hard around the base and eventually heals.

If the infection isn't treated, the secondary stage begins anywhere from weeks to months after the appearance of the primary chancre. This stage typically involves a rash anywhere on the body. In cases of anal-rectal syphilis, flat wart-like lesions develop in and around the anus or perineum (Lamont, 1995). Syphilis is extremely contagious during this stage. In some cases, other secondary symptoms such as fever, swollen glands, headaches, nausea or constipation may appear. Most people are motivated to seek treatment during this stage. Without treatment, however, secondary symptoms will also eventually disappear and a latent stage (no symptoms) may last for many years. The tertiary stage, extremely rare in North America, can produce serious damage to major organs such as the heart or brain.

Syphilis is diagnosed by microscopic examination of fluid or scrapings from a chancre or rash. Blood tests are also used, but they tend not to detect the disease as reliably during the early primary stage. Treatment is with penicillin or another antibiotic. Follow-up examinations are required to assure a complete cure. During treatment, sexual contact should be avoided and recent partners should be notified and examined whenever possible.

Because *T. pallidum* can enter the body at virtually any point, the use of a condom can only reduce, but not eliminate, the risk of infection. Thorough washing after sex may also reduce the risk somewhat.

Common Diseases of the Anus and Rectum

A variety of diseases can disrupt the health of the anus, rectum, and lower GI tract. Although some physicians believe that these diseases are more frequent among people who participate in anal sex (especially intercourse) there is no convincing evidence, other than anecdotes and opinions, that this is the case. It is no doubt true that reckless anal stimulation, like any other bodily mistreatment, can result in medical problems. In fact, virtually everyone I've talked to with anal problems caused or aggravated by anal stimulation had simply ignored the pain warning them to stop. Sensitive, gentle anal stimulation without pain is more likely to *contribute* to anal health by promoting relaxation, muscle control, and self-awareness.

One of the keys to anal-rectal wellness is having a basic knowledge of diseases and symptoms to which the area may be vulnerable. This understanding greatly increases your chances of recognizing problems long before they become serious. Then self-healing measures can be quickly undertaken and, if called for, professional attention sought.

Hemorrhoids

Hemorrhoids are one of the most common persistent health problems in Western industrialized societies. Experts estimate that between half and three-quarters of all adults in the U.S. will experience them at some point in their lives, especially as they get older. Hemorrhoids can occur just inside the anal opening, in the anal canal, or the lower rectum. As you may recall from Chapter 7, the anal cushions just below the surface of the anal canal are filled with numerous blood vessels and cavernous spaces that can fill with blood, almost like the erectile tissue of the penis or clitoris. When the internal sphincter muscle is chronically constricted, bowel movements require straining and pushing. Over time, the anal cushions engorge with blood and become stretched out of shape to form hemorrhoidal bulges. The relationship between hemorrhoids and excess sphincter tension has been noted since the 1940s (Turell, 1949).

These blood-filled bulges may be small and barely noticeable or

large and impossible to ignore. The more severe ones protrude (prolapse) beyond the anal opening, especially during bowel movements. Most will go back in by themselves afterwards, but others require a gentle push. The worst ones protrude all or most of the time. Hemorrhoids often bleed, leaving bright red stains on toilet paper. Generally speaking, larger hemorrhoids are more painful. Some hemorrhoids temporally grow larger because of blood clots within them. Usually, however, the clots dissolve on their own in a week or two.

External hemorrhoids are located in the anal canal itself, very near the anal opening. *Internal* hemorrhoids develop in the lower rectum, near the junction of the anal canal and the rectum. When viewed by a physician through an anoscope—a small, clear plastic instrument gently inserted into the anal canal—internal hemorrhoids tend to look like a single dilated and elongated vein and can be quite long. Both types are often associated with constipation, diarrhea, and pregnancy because all three conditions can cause pressure, irritation, and tension in the anal area.

Most hemorrhoids respond remarkably well to the seven-step self-healing program that I'll describe later in this appendix. The steps are based on the same gentle approach to relaxation and awareness advocated throughout this book.

If you try the program, but your symptoms don't improve noticeably over a period of several weeks, or especially if they get worse, it's time to consult with your physician or a specialist about your treatment options. For moderately severe and persistent hemorrhoids, *rubber band ligation* might be an option to consider. Easily done in a doctor's office with the help of an anoscope and special device, a band is wrapped tightly around the base of the hemorrhoid, depriving it of blood. Within a couple of weeks it then withers and falls off. Discomfort is usually mild. This approach works only with certain types of hemorrhoids, but patient satisfaction is reported to be about 90% (Barnett, 1995).

Cryosurgery freezes the hemorrhoid with liquid nitrogen. Because this method also affects healthy tissue, healing takes longer, there may be more complications, and patient satisfaction is lower. *Electrocoagulation* burns off the hemorrhoid with an electric needle. It's far

less precise, sometimes causes injuries, and healing may be prolonged and uncomfortable. *Lasers* are gaining in popularity because they're more precise and therefore cause fewer complications.

Some doctors recommend the use of progressively larger dilators to encourage sphincter relaxation. The concept behind this approach is right on target. But why not get the same results at a fraction of the cost by using your own finger or a series of butt plugs?

Two more drastic surgical options—*sphincterotomy* and *hemorrhoidectomy*—are very traumatic to the anus, yet you should know about them in case they're suggested to you. A sphincterotomy involves cutting the internal sphincter so that its ability to contract is severely impaired. A hemorrhoidectomy involves using a scalpel to cut off the hemorrhoids and suture the surrounding tissues back together. These procedures are very invasive, with painful recoveries, and they often cause so much trauma that the anal-rectal musculature becomes even more constricted than before, setting the stage for future recurrences. Scarring is also a problem which significantly reduces the flexibility of anal-rectal tissues. I believe these approaches should be considered, if at all, as a very last resort. Unfortunately, hemorrhoidectomies have historically been among the most over-performed of all surgical procedures. If a doctor suggests one for you, get a second opinion—or maybe a third.

I've noticed a fascinating phenomenon among some of my clients with hemorrhoids: After declaring that self-healing methods aren't working for them, they discuss treatment options with a physician. Contemplating these procedures—especially the more draconian ones—becomes so distressing that they recommit themselves to self-healing with revitalized motivation. Most soon realize that their previous efforts had been inconsistent and haphazard. In the vast majority of these cases, including some very severe ones, the hemorrhoids heal.

There are many alternative therapies worth considering as adjuncts to self-healing or to standard Western medical treatments. Acupuncture can be effective for general stress reduction or for reducing spasms of the digestive tract. A few of my clients who've had trouble using their finger to gather information about their anal muscles have

responded well to biofeedback devices that clearly show pelvic muscular activity with visual and/or auditory signals. Body-oriented therapies that emphasize therapeutic touch, breathing, and movement can expand bodily awareness and help loosen the grip of long-established patterns of muscular holding.

Herbalists and naturopathic doctors can also offer invaluable suggestions for a variety of digestive disorders. Recommendations commonly include extra vitamin C, flavonoids, and a plant extract known as "butchers broom," which is said to help strengthen swollen and enlarged (varicose) veins.*

Fissures

A fissure is a tear or crack in the tissues of the anal canal. Fissures cause burning and pain, especially during and after bowel movements, and may also bleed. As with hemorrhoids, fissures are usually caused by straining to pass hard stools through a constricted anal opening. In some cases, fissures result from rough and insensitive anal sex play, especially when pain warnings are ignored or when drugs numb a person's awareness.

Treatment for fissures includes a bland, non-irritating diet, the use of stool softeners, and warm baths several times daily. Medicated ointments may also ease the discomfort somewhat. The self-healing program I'll outline shortly can speed recovery. Fissures that won't heal naturally are sometimes cauterized chemically or with an electric needle to stimulate healing. In some cases, accompanying conditions such as intestinal parasites, rectal gonorrhea, or herpes prevent a fissure from healing. A fissure may become infected, in which case antibiotics are necessary.

Fistula

A fistula is a tiny passageway leading away from an abscess in the deeper rectal tissues. This passageway usually opens into the lower

* See Murray and Pizzorno's *Encyclopedia of Natural Medicine* (2nd Ed., 1998) for a comprehensive look at the use of natural substances for a wide variety of diseases. Castleman's *Nature's Cures* offers a briefer summary of natural healing practices.

rectum near the anus. Occasionally, the passageway also leads into the urethra or vagina. Fistulas often go unnoticed unless drainage is either detected as a discharge or blocked, thus producing pain. Treatment typically involves resolving the underlying infection, the application of antiseptic solutions, and the use of stool softeners. Warm baths ease discomfort and promote healing. In some cases when a fistula still doesn't heal, surgery is necessary.

Constipation

Constipation is a difficulty having bowel movements or having them with reasonable regularity. Small, dry, and hard stools are almost always part of the problem. Two primary factors contribute to constipation: (1) inadequate fiber and water in the diet and (2) chronic anal, rectal, and intestinal muscle tension. Healthy stools are bulky and moist (but not too moist) because bulk is necessary to trigger the "rectal reflex," which relaxes the anal-rectal muscles and initiates natural muscle waves (peristalsis) that move fecal material through the lower GI tract. Chronic tension locks up the digestive process so that stools accumulate and cause a bloated or lethargic feeling.

Because constipation results from similar conditions as hemorrhoids, the two frequently occur together. Hemorrhoids can cause constipation by making bowel movements so uncomfortable that a person avoids them by tensing up. And constipation is a major cause of hemorrhoids because of the straining necessary to pass the hard stools. Thus, the two problems often perpetuate each other in a vicious cycle.

Other factors can cause or contribute to constipation, including certain medications for depression and hypertension. Sedentary people are more prone to the problem, as are pregnant women. When constipation becomes a problem for a person over forty when it wasn't an issue before, especially if there's rectal bleeding, it could be a sign of another disease. Chances are you're only dealing with a hemorrhoid or fissure, but get it checked by your doctor.

A good indicator of the large number of people bothered by constipation is the steady stream of advertisements for laxatives. Natural

bulk laxatives can indeed help, as can stool softeners. But the regular use of stimulant laxatives is itself a major factor contributing to constipation. Not only do many people develop "lazy bowels" as they become dependent on laxatives, but the stimulants cause the muscles of the colon to contract, intensifying the fundamental cause of constipation—muscular tension—even further (Plaut, 1982).

The only real cure for constipation is a diet rich in fiber (25–30 grams per day is recommended) and plenty of water, along with a reduction of muscular tension throughout the whole body, especially the digestive system. Regular exercise is also important because it improves circulation, muscle tone and elasticity, and helps to discharge emotional stress. For some people, a warm water enema helps to relieve occasional episodes of constipation.

Diarrhea

Diarrhea is an increase in the fluidity of the stools to the point where they cannot hold together. Sudden attacks are usually caused by the flu or other viral infection. Diarrhea also results from overuse of magnesium-based antacids. Antibiotics can also be a cause. People with a lactose intolerance are also inclined to have the problem. As I mentioned earlier, intestinal bacteria infections usually cause diarrhea, which is a curse for many travelers. Diseases that damage the intestinal lining—inflammatory bowel disease, for example—tend to impair the absorption of moisture during digestion.

One of the most important treatments for diarrhea is drinking plenty of fluids to counteract dehydration. It's also a good idea to avoid dairy products during bouts of diarrhea. Over-the-counter anti-diarrhea drugs can be helpful, but aren't intended for long-term use.

Irritable Bowel Syndrome (IBS)

Irritable Bowel Syndrome (IBS) is one of the most common health problems in the Western hemisphere (Peikin, 1991). Some gastroenterologists (physicians who specialize in disorders of the digestive system) estimate that IBS is the second most frequent cause of absenteeism after the common cold (Haler, 1995). Another popular name

for IBS is spastic colon. Sometimes it's mistakenly called colitis, but IBS does not involve any inflammation.

The symptoms of IBS vary, but usually include unpleasant shifts in bowel habits, with or without abdominal pain. For reasons that remain something of a mystery—rarely is there an obvious structural abnormality—the bowel contracts either too much or too little. For instance, it may go into spasm right after a meal, producing cramps, diarrhea, and an intense urge to run for the nearest toilet. Or weaker-than-usual contractions may lead to constipation and bloating. In some cases, mucous is noticeable on the stools. IBS episodes may be occasional or distressingly frequent.

As you might imagine, an episode of IBS typically obliterates any interest in sex of any kind. Even those who normally like anal stimulation will usually recoil at the thought. Some people who are especially prone to IBS have told me that anal stimulation can trigger an episode—presumably by setting off intestinal muscle spasms—even when they were feeling fine immediately before. However, most IBS sufferers who enjoy anal sexuality can accurately sense when receiving anal stimulation is a good idea, and when it should be avoided.

The most common treatments for IBS are fiber preparations to help stabilize the consistency of the stool, and antispasmodic medications to help calm the gut. Anti-diarrhea preparations may also be useful. But harsh laxatives only make matters worse by disrupting the natural function of the colon even more.

Nowhere is the brain-gut connection more apparent than with IBS. A fascinating observation is that people are rarely awakened by IBS attacks, which we would expect considering the level of waking distress they cause (Peiken, 1991). It's as if the relaxation of sleep is sufficient to calm the gut. At the same time, high levels of emotional stress can definitely trigger IBS attacks. Once a person starts having IBS—usually during early adulthood—it tends to become a self-perpetuating, life-long concern. The neuro-muscular "wiring" of the gut becomes predisposed to react with hair-trigger sensitivity to certain foods, situations, and emotions.

I'm not at all suggesting that IBS is "all-in-the-head"—quite the

contrary. IBS is a powerful example of how emotions and body constantly interact, sometimes with devastating results. In my own practice, I've worked with several dozen clients with IBS who were surprised to discover that they had accumulated a tremendous amount of unacknowledged anger and/or fear in their digestive systems and that, in turn, their distressing symptoms made them feel even more angry and afraid. I'm pleased to report that many of these clients found considerable relief when they became conscious of and expressed their most difficult emotions. Daily use of virtually any relaxation technique can be highly beneficial, as is the seven-step self-healing program that follows.

Guidelines for Self-Healing

At the very first sign of anal irritation or distress, I suggest that you begin a simple, seven-step program to help mobilize your body's innate capacity for self-healing. If you've tried the exercises suggested throughout this book, you're already familiar with this awareness and relaxation-based approach. The only difference here is that you're simultaneously applying a variety of methods to the singular goal of promoting anal wellness.

This program works best for any of the tension-related health problems I've just described, from hemorrhoids and fissures, to constipation and irritable bowel. If you don't notice improvement in your symptoms within a few weeks, or whenever you're in a lot of pain, it's wise to consult a physician. But be sure to continue with the self-healing program, and tell him or her about your activities. If you decide that a medical procedure is necessary, your ongoing commitment to self-healing will speed your recovery.

Step 1: Examine your anus visually and, unless it is too tender to touch, gently explore your anal opening with your fingers. Doing so will give you invaluable information about what's really going on back there.

Step 2: Suspend all anal sex play until the problem is resolved or

sufficiently understood for you to make informed decisions about which activities, if any, are consistent with healing. External anal touch—tenderly provided by yourself or a sensitive partner—can be soothing and help promote relaxation. Gently stroking around the anal opening or even inserting your own finger into your anus may also help you relax, as long as there's no pain involved. Use a water-soluble lubricant for easy cleanup.

Step 3: Take frequent warm baths—two or three times per day is ideal—especially after bowel movements. Warm water contributes to relaxation, increases blood flow and removes irritants from the area. If it's comfortable, do a little gentle stroking of the anus while bathing.

Step 4: Pay special attention to your diet.* First of all, stay away from items that might irritate your GI tract, such as spicy foods, nuts, and other items that may not digest completely and thus leave rough edges. It's also smart to take a break from alcohol (which irritates the digestive system) and caffeine (which can exacerbate constipation or diarrhea). At the very least, keep consumption to a minimum.

At the same time, actively develop a high-fiber, low fat diet. Good sources of fiber are fresh fruits and vegetables, whole grains, and legumes (unless they give you gas). You can also use fiber supplements such as psyllium (Metamucil) or oat bran. And don't forget to drink plenty of water (8-10 large glasses per day are recommended). Fluids are as important as fiber for optimal stool consistency and bowel function.

Step 5: Learn to have natural bowel movements free of all straining—a major cause of hemorrhoids and other anal health problems (see Chapter 7).

Step 6: Apply something soothing to irritated anal tissues. The marketing of preparations for hemorrhoids is a multimillion-dollar industry, which indicates just how widespread the problem is. Some preparations simply soothe the area by keeping it moist.

* For an innovative nutritional approach to many digestive disorders, see Steven Peikin's excellent book, *Gastrointestinal Health*.

Others contain mild anesthetics to temporarily reduce the pain. Still others claim to help reduce swelling, but their effectiveness is limited. Witch hazel or aloe vera usually work very well without the chemical additives (Castleman, 1996). It's also a good idea to use moistened pads, available at all pharmacies, for cleanup after bowel movements.

Step 7: To help reduce stress, set aside at least two fifteen-minute periods each day to practice deep, slow breathing combined with any other relaxation techniques you have found useful in the past, such as meditation or progressive relaxation. If you haven't yet tried any relaxation techniques, now is a good time to begin. During deep breathing and warm baths, visualize your anal muscles relaxing, as the pain and irritation recede, and the anal tissues become warm and healthy (see Chapter 6). Moderate exercise is also an effective stress-reducer. But avoid weight lifting or other activities that involve straining, and thus may put pressure on anal and pelvic muscles.

Finding a Physician or Alternative Practitioner

An important aspect of maintaining anal health is finding a competent, nonjudgmental physician and/or alternative practitioner with whom you can freely discuss questions about anal health with a minimum of embarrassment (a little is inevitable, of course, especially at first). If you're conducting some of the experiments recommended in this book, or plan to in the future, it could be a real asset to let your physician in on your activities so that he or she can function as a health advisor.

I've just described an ideal situation that, unfortunately, is relatively rare in the real world. For one thing, doctors often *are* judgmental about anal sexuality. Many of my clients with anal health problems report being questioned in accusatory or condescending tones. Sometimes admonitions are explicit: "If you'd use your anus for its intended purpose, you wouldn't be having this problem!" More frequently, judg-

ments are implied rather than openly stated. Unfortunately, when you need medical attention for an anal health concern, you may have to settle for the basics: someone competent who won't scold you.

Of course, another big problem is that under today's "managed care," an oxymoron if there ever was one, doctors are so pressed for time that they can't focus on much of anything except your immediate symptoms and getting you out the door. One advantage of consulting alternative practitioners is that they tend to take a greater interest in the whole person, not just malfunctioning or diseased body parts. Many will want to talk about your life circumstances, overall stress and emotional state—in other words, to understand your problem within a larger context. This can be especially important when there's no clear-cut medical explanation for your symptoms.

If you need advice or treatment for an STD, most major cities maintain clinics specializing in these diseases. Employees usually have a nonchalant attitude and strict policies help protect your privacy (you can even use a phony name). Your local Planned Parenthood may also be a good resource.

Those who are coping with HIV have the best chance of finding competent care at a university medical center or teaching hospital. Most larger urban areas also have clinics and private medical practices with extensive experience treating HIV and AIDS.

When it comes to finding a supportive primary physician or specialist, asking friends about their experiences with particular physicians can be a good start. Depending on the friendship, however, it may be difficult even to describe your needs honestly. With or without a recommendation, I suggest an assertive approach. Whenever you consult with a new physician or alternative practitioner—or if you haven't yet raised the subject with your current one—ask *directly* about his or her attitudes toward anal sexuality. Try not to be intimidated, but even if you are, ask anyway. Listen very carefully; if he or she dodges your question, squirms uncomfortably, or looks at you like you're an idiot, find someone else.

Many, but by no means all, doctors will relax their professional aloofness a bit if you make it clear that you want to be treated like an intelli-

gent person who is capable of understanding and actively participating in any treatment efforts. The best doctors already appreciate the value of informed and involved patients so you won't have to convince them.

Most primary care physicians are internists and are quite capable of conducting a basic anal-rectal examination, or even treating some or all of the diseases I've just discussed. If you need a referral to a specialist—perhaps a proctologist or gastroenterologist—use the same assertive approach when you first meet with this person.

You might want to consider the fact that many gay and gay-friendly physicians who see lots of gay male patients are almost as experienced with common anal-rectal problems as most specialists. And the odds are better that such a doctor will have more practice discussing anal sexuality. Most of these physicians welcome all kinds of patients regardless of their gender or sexual orientation. Obviously, these openly gay physicians are much easier to find in large urban areas.

Investigating alternative treatments can be a bit more complicated. Whereas Western doctors will vary considerably in the types of treatments, if any, that they suggest, they generally choose among well-established treatment options supported by at least some medical research. Alternative practitioners draw on healing traditions, professional experience and intuition. And they may also be more inclined towards experimentation. Their methods are less likely to be scientifically tested, although this is changing as alternative treatments skyrocket in popularity.

The greater flexibility of alternative healing methods is, in short, both a strength and a weakness. Wise consumers read about a variety of options,* ask plenty of questions about a particular method, inquire about its rationale and outcomes in other cases, understand the possible risks and side-effects, and make sure a plan is in place for evaluating effectiveness. Come to think of it, this is undoubtedly the best approach to any healing endeavor.

* A lucid overview can be found in William Collinge's *The Complete Guide to Alternative Medicine*.

Summary of Research and Findings

T HIS APPENDIX provides researchers, clinicians, and interested lay readers with detailed information about the research process upon which this book is based. The purpose of the research was to evaluate the effectiveness of a short-term therapy process that I had developed for reducing anal spasm and enhancing the capacity for anal pleasure. I expected that short-term therapeutic interventions would effectively reduce anal spasm and enhance the capacity for anal pleasure with an overall effectiveness of at least 70%. In addition, I wanted to look for any measurable variables that might have significantly influenced the impact of therapy. I hoped that an awareness of such variables could maximize effectiveness.

Preliminary observation during the pilot study suggested three specific variables that appeared to affect the course of therapy. First, both observation and common sense supported the expectation that a generalized pattern of anal tension would be more resistant to change than a situational pattern. When anal spasm occurs only in certain situations, it seems reasonable to expect that removing or reducing the anxiety associated with those situations will allow the anal muscles to return to their normal "baseline" state of tonicity. On the other hand, when anal muscles are always or almost always tense, there is no baseline state of relaxed tonicity to which the muscles

may return. Consequently, I expected that research participants manifesting generalized anal tension would respond to therapy more slowly and with less overall success than participants manifesting situational anal tension.

The pilot study also suggested that a person's motivation for entering therapy was a crucial variable influencing outcome. Some research participants sought therapy for anal spasm not because of their own hope of enjoying anal stimulation, but because of pressure from their sexual partners. Such people frequently resisted change by not doing homework, missing sessions, or dropping out of therapy altogether. Those who stayed seemed emotionally less involved or even bored. Therefore, I expected that therapy would be significantly more effective with participants who were primarily motivated by their own desire for pleasure rather than by a desire to meet the demands of others.

Finally, there was some indication during the pilot study that participants who were involved in ongoing sexual relationships would progress through therapy more easily. Presumably, such a relationship could provide support for anal exploration. In addition, an ongoing sexual partner would be available on a regular basis for experiments that required the participation of another person. Therefore, I expected that participants involved in ongoing sexual relationships would respond to therapy more quickly and with more overall success than participants who were not involved in such partnerships.

I also collected data that would allow me to look for correlations between therapeutic effectiveness and the variables of sex, age, sexual orientation, race, onset and duration of concerns about anal spasm, and sexual relationship patterns. Throughout the process I made careful clinical observations about the nature of anal tension, relaxation, and pleasure.

Research Design

Over a two-year period, 164 people participated in the research. Twenty-one of these people did not complete the therapy process. I consider this drop-out rate (13%) to be somewhat low considering the highly charged nature of anal exploration. It's interesting to note, however, that over 20% of the men and women who initially expressed interest in therapy dropped out, as it were, before they even started. While many reasons were given, it is reasonable to assume that most became too threatened as the start of therapy approached. In no case did a man or woman report that his or her concerns about anal spasm had resolved. Some eventually entered therapy several months, or even years, later. Of those who dropped out of therapy, 16 were men and 5 were women, which is close to the same gender ratio of those who completed therapy.

One hundred forty-three people completed therapy. One hundred fourteen were men, ranging in age from 21 to 62, with a median age of 30. Twenty-nine of the participants were women, ranging in age from 25 to 44, with a median of 32. The fact that the study involved so many fewer women than men raises important questions. Why was there such a discrepancy? First, because of frequent presentations about my work to gay male groups, there was more awareness of my work among gay men. Second, gay men in general seem to be more open to anal sexuality; they hear about it more often from friends and acquaintances, perhaps see anal activities in sex clubs, or read about it in gay publications. Overall, anal intercourse is more likely to be viewed as a natural sexual activity in the gay community. Reports from women participants suggest that they are far less likely than gay men to discuss anal sexuality with friends. Finally, it is probable that some women are reluctant to consult a male therapist, understandably fearing male bias.

Because the research sample was self-selected, the participants, although they probably have a great deal in common with all people troubled by anal spasm, should only be considered representative of those who (1) have been unable to solve problems of anal spasm on their

own and (2) are inclined to seek professional help for such concerns.

Of the 143 participants, 62 responded to public announcements for eight-week "Anal Awareness and Relaxation Workshops." Another 43 were referred by medical and mental health professionals who were aware of my work. Eighteen had heard me lecture on the subject. The remaining 20 were friends or acquaintances of men and women who had previously participated in therapy.

The following information was recorded for each participant during the first session.

Sexual Orientation

In categorizing sexual orientation I used the seven-point "Kinsey Scale" (Kinsey, et al., 1948), which takes into account both internal responses (attraction and desire) and behavior. There was rarely any discrepancy between desired and actual sex partners in this group. For simplification, I refer to points 0 and 1 on the scale as "straight." I refer to points 2, 3, and 4 as "bisexual." I refer to points 5 and 6 as "gay" or "lesbian." I was concerned only with the last five years of participants' experience. Following is the sexual orientation of the research participants according to their gender (percentages, in parentheses, are of the total research sample):

	men	women	totals
straight	9 (6%)	17 (12%)	26 (18%)
bisexual	27 (19%)	10 (7%)	37 (26%)
gay	78 (55%)	2 (1%)	80 (56%)
			143 (100%)

Clearly, gay and bisexual men, and straight and bisexual women, were far more represented than straight men or lesbian women.

Goals

During the first session, I asked each participant what he or she hoped to get out of therapy. Some wanted to be able to enjoy receiving anal intercourse. Others did not. However, all were clear that they wanted

to experience more pleasure from anal stimulation. Toward the middle of therapy (usually the fifth session) I asked participants to re-evaluate and restate their goals. I believed that new information and experience might result in clarifications or modifications.

By the middle of therapy 80% expressed a desire to be able to enjoy receiving anal intercourse. The lesbians had no such desire, nor did the straight men except for two who felt that this would be an interesting experience that they hoped to have at least once in their lives. Other straight men were open to the idea of being penetrated by a woman using a hand-held or strap-on dildo.

During the first half of the therapy process there was some increase in the percentage expressing a desire to receive intercourse. This was no doubt due to personal goal clarification as well as the general supportive attitude conveyed throughout therapy. This shift, however, was quite small (7%), suggesting that participants usually began therapy with a clear idea of what they hoped to gain. During the course of therapy, only a few who originally wanted to explore anal intercourse changed their minds. However, there was a tendency for all participants to become less focused on anal intercourse and more self-respecting about when and how they wanted it.

Race
Among the women, 27 (93%) were white and 2 (7%) were black. Among the men, 91 (80%) were white, 11 (10%) were black, 7 (6%) were Asian, and 5 (4%) were Latino.

Sexual Involvements
Thirty-two percent of the men and 54% of the women lived with a lover or spouse. An additional 25% of the men and 32% of the women were involved in primary, non-living-together relationships. Almost 80% of the unattached gay and bisexual men regularly or occasionally enjoyed casual sex, as did about half of those involved in relationships. A similar interest in casual sex was expressed by more than half of the single straight men, but by fewer than 30% of the married ones. Irrespective of their sexual orientation, about one-fifth of the

unattached women engaged in casual sex, as did about 10% of those in relationships. Keep in mind that this data was collected pre-AIDS. Casual sex figures would probably be lower now.

Past Anal Sexual Experience

All participants had tried receiving anal stimulation from a partner and most had found it anxiety-provoking and/or physically uncomfortable. Ninety-five percent of the gay men had attempted receiving anal intercourse. Of these, 80% said their experiences were always or nearly always unpleasant; 20% reported some positive anal sex experiences, but said they were infrequent and unpredictable. Among the women, slightly less than 60% had tried anal intercourse; all found it unpleasant. Over half of the participants avoided all anal touching because they feared it would be perceived as a prelude to intercourse. Eighteen men and 4 women had previously been forced or very strongly pressured into anal intercourse.

Patterns of Anal Tension

Anal spasm manifests itself differently in different people. It may be either *general* (chronic) or *situational*. When the tension is general it is present all or most of the time and is not strongly dependent on circumstances, although particularly stressful situations make it worse.

Situational anal tension occurs only under specific conditions such as during moments of high anxiety or emotional distress. Often an anticipated demand for anal sex triggers the spasm. The specific situations are highly variable. A person might be quite relaxed while touching his or her own anus but become tense when touched by someone else. Others remain anally relaxed when touched by a partner, and go into spasm only in response to the insertion of a finger or object. In still others, spasm occurs only when intercourse is attempted. A few others become tense only when receiving anal stimulation from specific people, in specific positions, at particular times, and so forth.

In addition to this distinction between general and situational tension, anal spasm may be either *primary* or *secondary*. Muscle constric-

tion is considered primary when it has always or almost always been a problem for the person. Anal tension is secondary when it occurs either gradually or suddenly after a period of relative relaxation. There are four possible tension patterns, with the percentages and numbers for each shown in parentheses:

- primary, general anal spasm—always been tense in all or most situations (49%, n=70)
- primary, situational anal spasm—always been tense in only some situations (34%, n=49)
- secondary, situational anal spasm—used to be relaxed, but now tense in some situations (12%, n=17)
- secondary, general anal spasm—used to be relaxed, but now tense in all or most situations (5%, n=7)

Both forms of secondary tension were relatively rare among participants in this research. In part this reflects the lack of support and accurate information available for people who want to experiment with anal sexuality. As a result, early anal experiences are likely to be clouded by guilt, uncertainty, and physical discomfort; a pattern of negative expectations is set from the start.

It could also be that relatively few people with secondary anal tension seek therapy because they have an easier time resolving their concerns on their own. However, this explanation for the low frequency of secondary patterns in this group of therapy-seekers seems unlikely because there is no indication that secondary tension patterns are, in fact, easier to change.

Onset and Duration of Concerns

The existence of any of the four anal tension patterns does not necessarily constitute a problem. For example, even those participants with primary, general anal tension did not always consider it problematic, though some remembered vague anal discomfort since adolescence or even earlier. With a few exceptions, participants reported that they first became concerned about anal tension under one, or occasionally both, of two conditions. Attempted or considered anal intercourse motivated more than 80% of participants to think about

the negative effects of anal tension. The remainder began to think seriously about anal tension as a result of pain not related to anal intercourse or medical problems (anal touching by another often made them aware of the pain).*

The length of time participants had been concerned about anal spasm varied from less than six months to more than ten years. A higher proportion of men than women had been concerned about anal spasm for longer periods of time. One explanation is that there is, and always has been, more awareness of and desire for anal sex activities among gay and bisexual men. Only recently has it become more acceptable for women to talk about and experiment with anal stimulation. On the other hand, gay and bisexual men tend to be seen by themselves and others as sexual outsiders. Once they venture beyond the bounds of convention, sexual experimentation often becomes the new norm. In addition, the tendency to equate "real sex" with vaginal intercourse has left some gay and bisexual men feeling that anal intercourse is the only "real sex" available to them.

Before seeking therapy, many participants had attempted to reduce anal tension on their own in a variety of ways including anal exploration with fingers, or practice with dildos or butt plugs. The most common approach was to attempt anal intercourse repeatedly, even if that meant enduring considerable distress. Many had finally given up until deciding to enter therapy. While no data is available on the experience of men and women who do not enter therapy, informal discussions with dozens of these people suggest that such methods often *are* eventually successful. This was definitely not the case with the research participants, almost all of whom viewed therapy as a last resort. A similar attitude is usually expressed by men and women entering sex therapy for other concerns.

In short, pleasure-limiting anal tension, once established, tends to be stable over time and resistant to efforts to change it. This was

* In the many years since this original research, this situation has changed considerably. Now nearly half of the people who consult me for anal spasm want to resolve medical problems first—and consider sexual pleasure later. This change is mainly due to increases in referrals from physicians.

particularly evident among those who had to (or chose to) wait, sometimes as long as six months, before beginning therapy. With only one exception, their concerns were not alleviated either by the passage of time or with continued personal effort.

Anal Medical Problems

Fourteen percent of the women and 20% of the men had anal-rectal medical problems serious enough to require professional treatment. Of these, almost half did not know for certain that they had these problems until a medical examination was scheduled early in therapy. The fact that a smaller percentage of the women had anal-rectal medical problems may be simply coincidental. However, it appears that men are more likely than women to receive anal intercourse in spite of persistent pain warnings. This may be yet another manifestation of the extreme pressure that some gay and bisexual men feel to be able to receive anal intercourse whether they like it or not. Although women often express the same intensity of desire to please their partners, even at their own expense, they are obviously able to initiate an alternative similar to anal intercourse—vaginal intercourse—when anal stimulation is uncomfortable.

Following is a list of the most common anal-rectal medical problems and the number of participants affected by each:

	men	women
hemorrhoids	13	2
fissures	3	1
anal infections	2	1
anal warts	5	1
anal gonorrhea	2	–
fistula	1	–
herpes	1	–
total	27	5
percent	24	17

Not surprisingly, all of these problems, except for two cases of anal

warts and one case of anal gonorrhea, were found among men and women with primary, general anal tension. In addition, all 14 men and 5 women who said they were frequently bothered by constipation (but did not seek medical treatment) were also in this primary, general tension group.

There were only five instances in which medical problems appeared to be in any way related to anal sexual activities: two fissures and three cases of hemorrhoids that were apparently aggravated by anal intercourse. In each case, however, there were clear pain warnings that the person ignored or tolerated or, in two cases of anal rape, was forced to endure.

Motivation for Seeking Therapy

In the pilot study it was obvious that some people sought therapy in order to expand the ways in which they could give pleasure to themselves or share it with a partner. Although others may have wanted these things, they were primarily concerned about being available to meet their partner's expectations.

During the first session I asked each participant about his or her reasons for entering therapy. Distinguishing pleasure-focused from performance-focused motivations was less difficult than I had anticipated. Most were quite willing to state candidly why, and for whom, they had sought therapy. In cases where there was doubt, I found that motivation could quickly be clarified by asking: "If your partner really wanted to stimulate your anus and you were not in the mood, would you rather (a) be able to say 'no' comfortably or (b) be able to go ahead and please him or her as long as it didn't actually hurt you?" This question translated the respondent's motivational stance into behavioral terms.

As therapy progressed there was an unmistakable shift among many participants away from a performance orientation and toward a pleasure orientation. In many instances, this was clearly due to their discovery that anal stimulation actually could feel very good, whereas they had originally felt that neutral toleration was the best they could reasonably expect, given their past experiences.

At the beginning of therapy 54% (n=77) of the participants ex-

pressed more concern about satisfying their partners than they did about discovering new options for pleasure. During the course of therapy, 22% (n=31) made a clear shift in emphasis. They spoke less and less about how they would be able to measure up to what their partners wanted and more about their own enjoyment. However, 32% (n=46) retained an unmistakable performance orientation throughout therapy and follow-up.

There was no discernable relationship between people's motivation for seeking therapy and their gender or sexual orientation. Those who wanted to be able to receive anal intercourse tended to be more performance oriented.

Data Gathering During Therapy

All participants completed a therapy process that included most of the information and all of the practical suggestions contained in this book. In addition, of course, there were regular dialogues with the therapist, individualized suggestions and additional therapeutic interventions as needed. Almost 90% (n=94) of the gay and bisexual men and one straight man participated in an "Anal Exploration and Relaxation Workshop." Each of these groups consisted of 8-12 participants who met for two hours each week for eight weeks. The groups offered the added benefit of interaction with a variety of people with similar concerns.

The other participants, including all of the women and all but one of the straight men, experienced the same process in the context of individual or couple therapy. Fourteen of the straight and bisexual women were in couple therapy with a lover or spouse who, in many cases, was also interested in anal exploration. Although I employed essentially the same treatment approach with individuals and couples as I did in the workshops, there was considerable variation in the length of therapy outside of the workshop format, especially since nearly 20% of those who saw me in individual or couple therapy were concurrently concerned about other sexual problems in addition to anal spasm.

In order to monitor the movement of participants toward or away from their goals, I relied on weekly, verbal self-reports. During the

last session each person was asked to evaluate in detail his or her current experiences in light of earlier-stated goals.

In spite of the difficulties inherent in self-reports, they are the best mechanism available for evaluating therapy effectiveness. It would have been possible, with medical assistance, to make objective measures of anal tension levels at various points during therapy. But participants' self-evaluations, while clearly related to anal tension levels, are primarily concerned with the subjective experience of pleasure while receiving anal stimulation. Only the participant can provide data about the perception of pleasure or, conversely, discomfort or pain. These are not quantifiable phenomena.

Success Criteria

In order to determine the effectiveness of therapeutic interventions, some guidelines are necessary for interpreting and evaluating self-reports from participants. How thoroughly does a client have to meet his or her goals in order for therapy to be considered successful? What if, for example, a person wants to be able to enjoy receiving anal intercourse and, as a result of therapy, learns to do this, but only under certain conditions? For this research I established this standard: Participants were considered to have reached their goals when anal stimulation—of the type desired—was experienced positively at least 75% of the time when the individual wanted that experience.

It should be noted that this standard is not as clear-cut as it may appear. Even though it is widely assumed that Masters and Johnson led the way in solving criteria problems in evaluating sex therapy success, this is not the case. Nor have these problems been resolved here. In fact, the desire for quantifiable indices of sex therapy success or failure will probably never be fully satisfied. This is true, to a large extent, because successful sex therapy, like all other psychotherapy, virtually always combines increased self-acceptance with concrete behavior change. For example, many sexual problems are solved easily and effectively when the client redefines his or her experience in a less performance-oriented or self-critical way.

One of the research participants, Valerie, expressed this phenom-

enon perfectly. In a follow-up interview I asked if she felt she had reached her goals. As we discussed her experiences she explained:

> I guess it all depends on how you look at it. Take last night. Pete [her husband] wanted me to try anal sex but I wasn't really in the mood, so I knew I couldn't enjoy it. I wished I was in the mood, but only because he seemed so turned on by the idea. I have a tendency to think of this as a failure on my part, even though I know it's not. So I would say that I've reached my goals in the sense that I enjoy anal sex a lot when I'm truly wanting it. Pete wishes I wanted it more often.

Valerie and I agreed that she had reached her stated goals, but not necessarily her *unstated* desire to be able to deliver her anus on demand for the pleasure of her husband. She estimated that she enjoyed anal sex, including anal intercourse, over 90% of the time when she truly desired it.

In addition to the problem that success criteria pose for any clinical researcher, the entire issue is often troublesome for therapists and clients as well. This is because success criteria, whatever they are, tend to fit better into a performance-oriented model of sexual health—precisely the model that many sex therapists view as a crucial contributor to sexual problems. Thus, while clear, sensible criteria are needed to evaluate therapy effectiveness, care is required to avoid codifying old performance ideals or generating new ones.

Data Gathering After Therapy

During the final evaluation session participants discussed plans for continuing anal exploration on their own. They were encouraged to proceed at their own pace and to avoid both self-imposed and external pressures to hurry up or do anything they were not ready to do. This emphasis on individual timing, including reassurances that they did not have to accomplish everything in a couple of months, was incorporated throughout therapy.

Those who did not reach their goals by the end of therapy were contacted by telephone between two and four months after the end of therapy. Each was asked these questions:

1. Do you still have the same goals that you stated during therapy?

2. Have you continued anal exploration since therapy ended? In what ways?

3. How close do you now feel you are to reaching your goals?

They also were given an opportunity to discuss, in retrospect, feelings and thoughts about the therapy process.

Clinical Observations

To help me in making clinical observations, almost half of the small group sessions were recorded in their entirety on audio tape. Nearly one-quarter of the individual and couple sessions were also recorded. I reviewed the tapes, made notes on the exchanges I considered most significant, and transcribed verbatim representative statements of participants. The tapes were then erased according to agreements I had made with participants.

In addition, 20 participants (14 men and 6 women) who had reached their goals by the end of therapy were contacted by telephone between two and six months after the end of therapy. They were asked if they were still satisfied with their experiences of anal stimulation. Their retrospective comments on the therapy process were also invited.

Results

Overall Therapy Outcome

During the final evaluation session, 71% of the participants (n=101) reported that they had reached their goals. In follow-up telephone interviews with 20 (14 men and 6 women) of these participants, conducted between two and six months after the completion of therapy, all of the women and all but one of the men reported that they continued to enjoy anal stimulation of the kind they had originally desired.

Of the 40 participants who had not reached their goals by the end of therapy, I interviewed 33 by telephone between two and four months after they had completed therapy. Seven participants could not be reached and were presumed not to have reached their goals even though some may, in actuality, have done so.

Of the 33 participants who were interviewed, 17 reported that they had continued the anal exploration processes which they had begun during therapy and had, by the time of the interview, reached their goals. They represented an additional 12% of the total research population. Therefore, a total of 118 or 83% of all the participants who completed therapy reached their goals within four months of the conclusion of therapy.

Anal Tension Patterns and Outcome

I had expected that participants who originally manifested either of the two general anal tension patterns would be less likely to reach their goals than participants with either of the two situational anal tension patterns. Graph 1 shows the number and percent of participants who originally manifested general and situational anal tension (both primary and secondary) according to whether they reached or did not reach their goals.

Graph 1: Anal Tension Patterns and Therapy Outcome

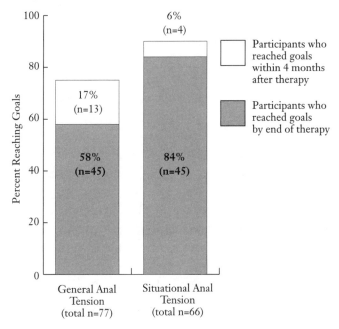

Seventy-five percent of participants who originally manifested general anal tension reported reaching their goals within four months after the end of therapy, versus 91% of participants with situational anus tension. Thus, whether participants originally manifested general or situational anal tension was significantly related to therapy outcome (p <.02), confirming my expectation.

I had expected that participants who originally manifested either of the two general anal tension patterns would be less likely to reach their goals, but that those who did reach their goals would be more likely to reach them sometime after therapy than participants who originally manifested either of the two situational anal tension patterns. Graph 1 also shows the number and percent of participants who originally manifested general and situational anal tension according to whether they reached their goals by the end of therapy or within four months after therapy.

Among all the participants who did reach their goals, 22% of those who originally manifested general anal tension patterns did so sometime after therapy as compared with 7% of those who manifested situational anal tension patterns. Thus, whether participants originally manifested general or situational anal tension was significantly related to the timing of therapy outcome (p <.02), confirming my expectation.

Whether participants originally manifested primary or secondary anal tension was not significantly related to therapy outcome (p <.30).

Motivation for Seeking Therapy and Outcome

Graph 2 shows the number and percent of participants who were motivated by pleasure and performance according to whether they reached their goals by the end of therapy or within four months after therapy.

Eighty-nine percent of those motivated by pleasure reached their goals as compared to 67% of those motivated by performance, indicating a significant relationship between motivation and outcome of therapy. Motivation for seeking therapy was not significantly related to whether goals were reached by the end of therapy or within four months after therapy.

Graph 2. *Motivation for Seeking Therapy and Therapy Outcome*

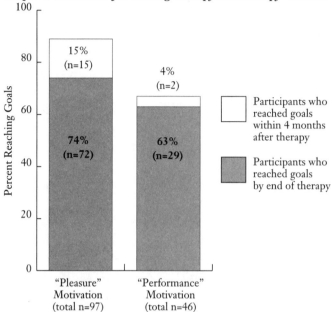

Graph 3. *Ongoing Sexual Relationships and Therapy Outcome*

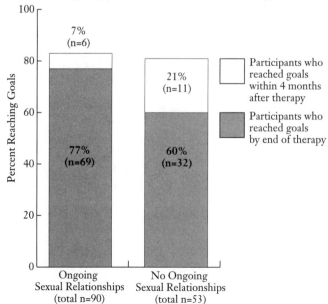

Ongoing Sexual Relationships and Outcome

Graph 3 shows the number and percent of participants who were or were not involved in ongoing sexual relationships according to whether they reached their goals by the end of therapy or within four months after therapy.

I had expected that participants involved in ongoing sexual relationships would be more likely to reach their goals than participants not involved in such partnerships. However, whether or not participants were involved in ongoing sexual relationships was not significantly related to therapy outcome (p >.70).

I had also expected that participants not involved in ongoing sexual relationships who did reach their goals would be more likely to take longer to do so. Among all participants who eventually did reach their goals, 8% of those involved in ongoing sexual relationships did so sometime after therapy as compared with 26% of those who were not involved in ongoing sexual relationships. Thus, whether or not participants were involved in ongoing sexual relationships was significantly related to the length of time required for them to reach their goals (p <.02). No other variables for which data were collected proved to be significantly related to therapy outcome.

Discussion

My central contention that short-term psychotherapy can effectively reduce anal spasm and enhance the capacity for anal pleasure is strongly supported by the data. Eighty-three percent of participants reported reaching their goals, 71% during the eight weeks of therapy and another 12% during the four months following therapy.

Anal Tension Patterns and Therapy Effectiveness

In order to understand the full meaning of the findings related to anal tension patterns, it is necessary to look beyond the quantitative data and examine the nature of anal tension. To do so inevitably involves a certain amount of speculation. However, working closely

with the research participants as they explored anal tension, relaxation, and pleasure provided me with a unique opportunity for making observations, asking questions, and drawing tentative conclusions.

Where does anal tension come from? I have observed a variety of factors that contribute to the development and maintenance of anal tension. In some cases, people are very aware of the factors contributing to their anal tension. In others, the factors exert their disrupting influence largely outside of consciousness until anal exploration brings them into awareness. Following is a list of what I consider to be the most common factors, starting with the most simple and proceeding toward the more complex:

Improper diet. Lack of fiber in the diet assures that feces will be of insufficient bulk to trigger the rectal reflex, resulting in straining during bowel movements and, in turn, a chronic pattern of anal-rectal muscle constriction.

Physical pain. Anal tension can be a direct, reflexive response to physical pain.

Fear of pain. The anus tenses to fend off anticipated or feared pain or bodily damage. This reaction is exacerbated by negative past experiences.

Learned tension patterns. Families teach their children, probably through body language, to store excess tension in particular zones. The anus, negatively charged by the anal taboo, is a popular tension zone. This factor contributes particularly to general anal tension.

Tension-produced tension. Chronic tension causes irritation and pain, which results in more tension, which causes even more pain—a classic vicious cycle.

Performance anxiety. When a person fears that he or she cannot deliver what is expected, self-consciousness soars and the entire body, including the anus, tenses up. Strong performance anxiety quickly turns potentially pleasurable experiences into hard work.

Unrealistic expectations. Tension is often triggered by exaggerated ideals, such as the belief that one should be ready to receive anal intercourse whenever a partner wants it.

Threats to self-image. Any threat to a person's self-image—such as worries about being bad or perverted, not being sufficiently masculine or feminine, or being labeled queer—generates protective tension.

The Nice Person Syndrome. Those who are overly anxious to please other people and consistently put their own needs in second place often have trouble creating the conditions necessary for their own enjoyment.

Interpersonal conflict. Accumulated resentment or hurt in intimate relationships sometimes expresses itself in anal tension.

Concerns about power. Many people associate the receptivity necessary for anal intercourse with submissiveness, loss of control and inferiority. Although these associations are arousing for some, many others find that they prevent relaxation. Similarly, some women and gay men feel angry about expectations that they will assume a receptive position whether they want to or not.

Pleasure anxiety. Tension in the anal area is sometimes a means of avoiding pleasurable sensations in the entire pelvic area. Here, anal tension is incidental to a larger discomfort with all sexual pleasure.

Fear of intimacy. Ambivalence about emotional or physical closeness can be expressed in anal muscle contractions. This factor seems to be pronounced among those who view anal intercourse as an especially intimate act.

General insecurity and rigidity. If a person does not feel safe in the world the anus is likely to be tense. Some people specifically describe anal tension as a feeling of grasping for grounding or security.

Other factors could be added to this list, and many overlap; rarely is there just one cause of anal spasm. The more complex factors toward the end of the list are more likely to operate subconsciously and, consequently, are more difficult to explore in short-term therapy. However, it is not uncommon for anal exploration to elicit memories and feelings from early in life. For instance, a number of research participants were able to recall specific occasions during early childhood when perceived threats of losing mother's or father's love were accompanied

by extreme and excruciatingly painful anal tension.

In therapy there was a tendency for inhibiting factors to enter consciousness naturally in the course of anal exploration. Participants who attempted to figure out logically how they had become so alienated from their anuses were usually unsuccessful. However, when they allowed themselves simply to experience how they felt, memories often emerged, shedding light on the evolution of their problems.

Among those who became aware of the emotions and experiences related to their anal tension, I was unable to find a single instance supporting Freud's view about the etiology of chronic anal tension. Freud thought that children learn to save up feces because of the pleasure derived from holding back followed by the release of one big bowel movement. In Freud's own words:

> ... the retention of fecal masses, which at first is intended in order to utilize them, as it were, for masturbatic (sic) excitation of the anal zone, is at least one of the roots of constipation so frequent in neurotics (Freud, 1905).

Although there are obviously many instances in which children and adults use muscular contractions and relaxation to enhance anal pleasure (whether or not feces are involved), no one has ever reported to me that the severe, chronic muscular holding necessary to produce constipation is anything but unpleasant. In fact, my clients who are troubled by constipation and other tension-related medical problems invariably report an unusual lack of feeling in the anal area. In my view, chronic anal tension initiated in childhood is rarely, if ever, a means of producing pleasure. On the contrary, it is one of the most effective means of *restricting* pleasurable sensations.

Turning again to the four patterns of anal tension, I found that both forms of secondary anal tension are usually traceable to specific experiences, such as an especially painful encounter, a medical problem, or a problematic relationship with a lover or spouse. This research suggests that the combination of secondary and general anal tension is the most resistant to therapy of all the tension patterns. Although this finding was not statistically significant (perhaps due to the small size of this part of the sample), I believe it to be very impor-

tant clinically. In most cases in which secondary tension was also generalized, the triggering event was highly traumatic. Five of the seven people in this group reported traumatic instances of anal coercion. The other two had undergone painful anal surgery from which recovery had been slow and difficult. As a result, these people's anuses were always or almost always tense, as if on guard against further trauma.

Primary, general anal tension appears to be related to many interacting factors including subtle, longstanding fears and behavioral patterns that are usually not readily brought into awareness. I think this is why participants who manifested this tension pattern were, overall, less successful in therapy than people manifesting either of the two situational patterns. Still, 77% were able to reach their goals, although they were likely to take somewhat longer. Most cases of total anal numbness were found in this group.

Participants who originally manifested primary, situational anal tension were, overall, the most successful in therapy, although the difference between primary and secondary situational tension was not statistically significant. This form of anal tension was usually traceable to fears of specific situations or experiences which, in many instances, had never actually occurred, at least not in a traumatic way. These participants were likely to report fears of being hurt or violated during anal intercourse. Most moral concerns about the rightness of anal intercourse or specific medical questions were expressed by participants with primary, situational tension. Accurate information was probably the most important aspect of therapy for these people. Also, giving them permission to stay away from specific tension-producing situations (usually intercourse) allowed them to relax and enjoy other forms of anal pleasure with relative ease.

Motivation for Seeking Therapy and Therapy Effectiveness

My expectation that therapy would be significantly more effective with participants who were primarily motivated by their own desire for pleasure rather than by a desire to please others was supported by the data. I am convinced that the difference between those motivated by pleasure and those motivated by performance would have

been even greater if I had discovered a better way of penetrating the facade of sexual sophistication worn by many of the research participants. I have no doubt that many participants were reluctant to admit their true motives for being in therapy because of the popularity of the idea that people should enjoy sexual activities for themselves. Sexual self-sacrifice is "out" in theory if not in practice.

There is a greater tendency on the part of those motivated by pleasure to continue their anal exploration after the conclusion of therapy. Performance-oriented participants were more inclined to give up after therapy, perhaps having placated a lover (or themselves) by having given anal exploration a try and failed. Actually, some of these people fully intended to fail and therefore succeeded at what they really wanted.

It should be noted, however, that 63% of the performance-oriented participants reached their goals in spite of their motivation. Many of these people genuinely wanted to please their partners and obtained a great deal of pleasure by being able to do so, even though they probably would not have come to therapy just for themselves. Those who did not reach their stated goals were not simply motivated by performance, but were probably also resentful toward whomever they felt obligated to please.

Sexual Relationships and Therapy Effectiveness

There was very little difference in overall success between participants involved in ongoing sexual relationships and those not involved. However, people in sexual relationships were more likely to reach their goals by the end of therapy. Only an additional 7% reported reaching their goals during the four months after therapy. People without ongoing relationships had essentially the same overall results, but it took them longer. Twenty-one percent did not reach their goals until sometime after therapy had ended.

People without ongoing sexual relationships often did not have easy access to a trusted partner with whom they could experiment comfortably. On the other hand, people with ongoing sexual relationships usually did have a partner for anal exploration, but this was

not always a trusted and comfortable partnership. Particularly with participants in couple therapy, it was clear that some of the relationships actually got in the way of positive anal exploration. Many of these relationships were scenes of intense vulnerability, anger and power struggles. It is not the existence of an ongoing relationship per se, but rather the quality of that relationship which contributes to positive outcomes.

Implications

This research has a variety of implications for clinical practice and research as well as for men and women exploring on their own. The most important overall implication is that both anal tension and the capacity for the enjoyment of anal pleasure are profoundly influenced by experience and learning. Many people troubled by anal tension and blocked from anal pleasure can, in a relatively short period of time, learn to release anal tension, even of long duration, and rediscover or enhance the capacity for anal pleasure.

This finding has important implications for professionals, particularly those in the fields of sex education, counseling, therapy and research. I hope that sex educators will begin talking more openly about anal stimulation as a legitimate and healthy avenue for personal and interpersonal self-expression. Likewise, sex counselors and therapists are likely to be called upon with increasing frequency to discuss anal sexuality comfortably with their clients and offer specific suggestions for those who wish to explore further.

Sex researchers need to learn more about anal tension and pleasure among people in this country and all over the world. I suspect that other cultures that have not so thoroughly embraced the anal taboo have a great deal to teach us about this hidden and feared part of the body. In our own society, a great many people enjoy the anal area as an erogenous zone without requiring therapy to do so. I hope that sensitive and accepting investigators will, at some point, ask these individuals what their experience has taught them.

Physicians have a responsibility to become more informed about and at ease with anal erotic behaviors so that they can provide accurate information and advice to their patients. Physicians who feel that anal sexual activities are inherently dangerous need to reconsider this belief and understand that the anal awareness necessary for the enjoyment of anal pleasure is also conducive to anal health.

Careful, unbiased research about the medical aspects of anal tension and pleasure is seriously needed. For example, would the correlation between anal tension and anal medical problems, so evident in my research, also be demonstrated in a large population of patients with anal-rectal medical problems? I feel certain that it would. If so, the medical community has an obligation to inform its patients of what they can do to facilitate their own healing. The suggested treatment for anal medical problems should, in the vast majority of cases, include self-exploration and touch.

About the Author

Jack Morin, Ph.D., has been studying the
erotic adventure as a clinician and researcher
for more than two decades, often delving into
uncharted territory. He is the author of
The Erotic Mind (1995, HarperPerennial), a
radical new psychology of what turns us on—
and why. He is a diplomate of the American
Board of Sexology, a board-certified sex
therapist, and a licensed psychotherapist
practicing in the San Francisco Bay Area.

Bibliography

Barbach, L. G. (1975). *For Yourself: The Fulfillment of Female Sexuality*. New York: Signet.

—— (1982). *For Each Other: Sharing Sexual Intimacy*. New York: Signet.

Barnett, J. L. and S. E. Raper (1995). Anorectal diseases. *In* Yamada, T., D. H. Alpers, C. Owyang, D. W. Powell, and F. E. Silverstein. *Textbook of Gastroenterology, Vol. 2 (2nd Ed.)*. Philadelphia: Lippincott.

Blank, J., Ed. (1996). *First Person Sexual*. San Francisco: Down There Press.

Blumstein, P. and P. Schwartz (1983). *American Couples*. New York: Pocket Books.

Brame, G. G., W. D. Brame, and J. Jacobs (1993). *Different Loving: The Worlds of Sexual Dominance and Submission*. New York: Villard.

Califia, P. (1993). *Sensuous Magic*. New York: Richard Kasak Books.

Castleman, M. (1996). *Nature's Cures*. New York: Bantam.

Clark, D. (1997, 3rd Ed.). *Loving Someone Gay*. Berkeley: Celestial Arts.

Collinge, W. (1996). *The Complete Guide to Alternative Medicine*. New York: Warner Books.

Davenport, W. (1965). Sexual patterns and their regulation in a society of the Southwest Pacific. *In* F.A. Beach, Ed. *Sex and Behavior*. New York: Wiley.

Davis, M., E. Eshelman, and M. McKay (1995, 4th Ed.). *Relaxation and Stress Reduction Workbook*. Oakland, CA: New Harbinger.

Dawson, L.H., Ed. (1963). *Sexual Life In Ancient Greece*. New York: Barnes and Noble.

Donovan, P. (1993). *Testing Positive: Sexually Transmitted Disease and the Public Health Response*. New York: Alan Guttmacher Institute.

Dodson, Betty (1996). *Sex for One: The Joy of Selfloving*. New York: Crown.

Drew, W.L., M. Blair, R.C. Miner, and M. Conant (1990). Evaluation of the virus permeability of a new condom for women. *Sexually Transmitted Diseases*, *17* (2):110–12.

Ebel, C. (1994). *Managing Herpes: How to Live and Love with a Chronic* STD. Research Triangle Park, NC: American Social Health Association.

Feigen, G. M. (1954). Proctologic disorders of sex deviates. *California Medicine*, *81*, 79-83.

Ford, C. S. and F. A. Beach (1951). *Patterns of Sexual Behavior*. New York: Ace.

Freud, S. (1900). The interpretation of dreams. *In* James Strachey, Ed. *Standard Edition of the Complete Psychological Works Of Sigmund Freud, Vols. 4 & 5*. London: Hogarth Press and the Institute for Psycho-Analysis.

——— (1905). Three essays on the theory of sexuality. *Complete Works*, Vol. 7.

——— (1913). Totem and taboo. *Complete Works*, Vol. 13.

——— (1915). Introductory lectures on psychoanalysis. *Complete Works*, Vols. 15 & 16.

Frumkin, L. R. and J. M. Leonard (1997, 3rd Ed.). *Questions and Answers on* AIDS. Los Angeles: Health Information Press.

Gebhard, P. H. and A. B. Johnson (1979). *The Kinsey Data: Marginal Tabulations of the 1938–1963 Interviews Conducted By the Institute for Sex Research*. Philadelphia: W. B. Saunders.

Haler, W. H. and C. Owyang (1995). Irritable Bowel Syndrome. *In* Yamada, T., D. H. Alpers, C. Owyang, D. W. Powell, and F. E. Silverstein. *Textbook of Gastroenterology, Vol. 2 (2nd Ed.)*. Philadelphia: Lippincott.

Heiman, J. R. (1975). The physiology of erotica: women's sexual arousal. *Psychology Today*, 8: 90–94.

Herrman, B. (1991). *Trust, the Hand Book: A Guide to the Spiritual Art of Handballing*. San Francisco: Alamo Square Press.

Hill, D. R., W. A. Petri, and R. Guerrant (1995). Parasitic diseases: protozoa. *In* Yamada, T., D. H. Alpers, C. Owyang, D. W. Powell, and F. E. Silverstein. *Textbook of Gastroenterology, Vol. 2 (2nd Ed.)*. Philadelphia: Lippincott.

Holmes, G.W. and R. Dresser (1928). The use of amyl nitrite as an anti-spasmodic in roentgen examination of the gastrointestinal tract. *American Journal of Roentgenology*, 19: 44.

Hunt, M. (1974). *Sexual Behavior in the 1970s*. Chicago: Playboy Press.

Jung, C. G. (1951) *Aion. In* Collected works, Vol. 9, Part II (translated by R. F. C. Huff). Princeton University Press, 1959.

Karlan, A. (1971). *Sexuality and Homosexuality*. New York: Norton.

Kegel, A. H. (1952). Sexual functions of the pubococcygeus muscle. *Western Journal of Surgery*, 60: 521-24.

Kinsey, A. C., Pomeroy, W. B. and C. E. Martin (1948). *Sexual Behavior in the Human Male*. Philadelphia: W. B. Saunders.

Kinsey, A. C. and Gebhard, P. H. (1953). *Sexual Behavior in the Human Female*. Philadelphia: W. B. Saunders.

Lamont, J. T. (1995). Bacterial infections of the colon. *In* Yamada, T., D. H. Alpers, C. Owyang, D. W. Powell, and F. E. Silverstein. *Textbook of Gastroenterology, Vol. 2 (2nd Ed.)*. Philadelphia: Lippincott.

Laumann, E. O., J. H. Gagnon, R. T. Michael, and S. Michaels (1994). *The Social Organization of Sexuality*. Chicago: University of Chicago Press.

Leeper, M. A. and M. Conrardy (1989). Preliminary evaluation of Reality, a condom for women to wear. *Advances In Contraception*, 5: 229-235.

Leiblum, S. and R. Rosen, Eds. (1989). *Principles and Practice of Sex Therapy*. New York: Guilford.

Lever, J. (1994). Sexual revelations. *The Advocate*, August, 1994.

Loulan, JoAnn (1990). *The Lesbian Erotic Dance: Butch, Femme, Androgyny and Other Rhythms*. San Francisco: Spinsters Book Co.

Lowry, T. P. (1981). Bracioproctic eroticism. *British Journal of Sexual Medicine*, 8: 32-33.

Marrou, H. I. (1956). *A History of Education In Antiquity*. New York: Sheed and Ward.

Marshall, D. S. and Suggs, R. C. (1971). *Human Sexual Behavior*. New York: Basic Books.

Masters, W. H. and V. E. Johnson (1966). *Human Sexual Response*. Boston: Little, Brown.

———— (1970). *Human Sexual Inadequacy*. Boston: Little, Brown.

———— (1979). *Homosexuality In Perspective*. Boston: Little, Brown.

May, R. (1972). *Power and Innocence*. New York: Delta.

McIlvenna, T., Ed. (1992). *The Complete Guide to Safer Sex*. Fort Lee, NJ: Barricade Books.

McWhirter, D. P. and A. M. Mattison (1984). *The Male Couple: How Relationships Develop*. Englewood Cliffs, NJ: Prentice-Hall.

Michael, R. T., J. H. Gagnon, E. O. Laumann, and G. Kolata (1994). *Sex In America*. New York: Little, Brown.

Moore, Thomas (1990). *Dark Eros: The Imagination of Sadism*. Dallas: Spring.

Morin, J. (1995). *The Erotic Mind: Unlocking the Inner Sources of Passion and Fulfillment*. New York: HarperPerennial.

Murray, M. and J. Pizzorno (1998, 2nd Ed.). *The Encyclopedia of Natural Medicine*. Rocklin, CA: Prima Publishing.

National Institute of Allergy and Infectious Disease (1992). *Pelvic Inflammatory Disease Fact Sheet*. Bethesda, MD: National Institutes of Health.

Peikin, S. (1991). *Gastrointestinal Health*. New York: HarperPerennial.

Peterson, J. R. (1983) The Playboy readers' sex survey, part I. *Playboy*, 30: 108.

Plaut, M.E. (1982). *The Doctor's Guide to You and Your Colon*. New York: Harper and Row.

Schnarch, David M. (1991). *Constructing The Sexual Crucible: An Integration of Sexual and Marital Therapy.* New York: Norton.

Shilts, R. (1987). *And the Band Played On: Politics, People, and the AIDS Epidemic.* New York: Penguin.

Singer, Barry (1984). Conceptualizing sexual arousal and attraction. *Journal of Sex Research*, 20: 230–40.

Stoller, Robert J. (1979). *Sexual Excitement: Dynamics of Erotic Life.* New York: Simon and Schuster.

Stubbs, K. R. (1991). *Erotic Massage: The Touch of Love.* Tucson, AZ: Secret Garden.

Thompson, M., Ed. (1991). *Leatherfolk: Radical Sex, People, Politics, and Practice.* Boston: Alyson.

Tripp, C. A. (1987, 2nd Ed.). *The Homosexual Matrix.* New York: New American Library.

Turell, R. (1949). *Treatment in Proctology.* Baltimore: Williams & Wilkins.

Williams, W. L. (1992). *The Spirit and the Flesh: Sexual Diversity In American Culture.* Boston: Beacon Press.

Zilbergeld, Bernie (1992). *The New Male Sexuality.* New York: Bantam Books.

Index

A

Abcess, rectal, 214
Acupuncture, 225-226
Advocate (The), survey of preference of various sexual activities, 12
Age. *See also* Children
 aging and anal pleasure, 198-199
 as power dynamic, 174-176
Aggressiveness
 relationship of aggressiveness to frequency of anal sex, 189
 relationship of male aggression to berdaches, 14
AIDS. *See* HIV/AIDS
Alcohol and other depressants, 127-128. *See also* Drugs
American Psychological Association (APA) database, 26
Amphetamines, 129-130
Amyl-nitrite, 130
Anal anatomy. *See* Anatomy
Anal awareness. *See also* Anus
 breathing and anal awareness experience, 60-61
 breathing and muscle awareness experience, 53-54
 including the anus in cleansing routine, 194-195
 including the anus in masturbation, 85-99
Anal douching. *See* enemas
Anal health. *See* Medicine and health
Anal intercourse, inserter vs. receiver roles, 11. *See also* Partners; Power dynamics
 orgasm during anal intercourse, 166
 preference for role, *Advocate* study, 12
 special concerns of inserters, 167
 top vs. bottom power dynamics, 181-183

traditional relationship of receiver to femininity, 13-15
Anal penetration and intercourse. *See also* Anus; Lubrication
 an overview of anal intercourse, 149-153
 anal contractions during excitement, 89, 166
 anal curvature and penetration, 101-106, 109
 anal intercourse, condom education, 153-158
 anal intercourse experience, 158-162
 anal intercourse, positions (figure), 160-161
 anal intercourse, variations of response, 162-169
 anal secretion as lubrication, 88-89
 inserting finger experience, 78-80
 inserting objects experience, 109-111
 intercourse vs. oral and manual stimulation, 11
 length of rectum and entry into colon, 101, 106
 loss of erection during anal stimulation, 90-92, 98
 muscle control and dilation, 71-76
 objects for rectal stimulation (figure), 110
 orgasm during penetration, 166
 prostate stimulation by finger insertion, 89-90, 140
 relationship of anal intercourse to same-gender partners, 11-12
 reported frequency of anal intercourse, 10-11
 terms for anal intercourse, 9
Anal phase, Freudian psychology, 26
Anal pleasure. *See also* Motivation, performance vs. pleasure
 analingus (rimming), 9, 147-148
 attitudes toward anal stimulation, 115-133
 forms of, 9

To Order Down There Press Books

_____ **Anal Pleasure & Health, revised 3rd edition,** *Jack Morin, Ph.D.* $18.00

_____ **First Person Sexual: Women & Men Write About Self-Pleasuring,** $14.50
Joani Blank, editor. Men and women share their masturbation experiences
in forthright anecdotes and essays.

_____ **The Playbook for Men About Sex,** *Joani Blank.* Exercises for better com- 4.50
munication with partners, sexual self-image and attitudes.

_____ **Sex Spoken Here,** *Carol Queen & Jack Davis, eds.* Cutting edge erotic $14.50
prose and a sprinkling of verse from the San Francisco and Berkeley
Good Vibrations Erotic Reading Circles.

_____ **Exhibitionism for the Shy,** *Carol Queen.* Learn how showing off, dress- $12.50
ing up and talking hot can add a spark to your sex life and boost your
confidence.

_____ **I Am My Lover,** *Joani Blank, ed.* Over 100 exquisitely explicit duotone $25.00
and b&w photos of twelve women celebrating self-sexuality.

_____ **Femalia,** *Joani Blank.* Thirty-two stunning color portraits of women's $14.50
genitals by four noted photographers.

_____ **Good Vibrations: The Complete Guide to Vibrators,** *Joani Blank.* $6.50
"...explicit, entertaining....encouraging self-awareness and pleasure."
L.A. Times

_____ **Good Vibrations Guide: Adult Videos,** *Cathy Winks.* Everything you $7.00
wanted to know about selecting and watching X-rated flicks: interviews
with the stars and other industry insiders, reviews, and more!

_____ **Good Vibrations Guide: The G-Spot,** *Cathy Winks.* Explore the ultimate $7.00
pleasure spot and demystify female ejaculation.

_____ **Sex Toy Tales,** *Anne Semans & Cathy Winks, eds.* Thirty-five short stories $12.50
that expand the erotic imagination, featuring vibrators, dildos, com-
puter scanners, fishing lures and other unexpected accessories.

_____ **Herotica: A Collection of Women's Erotic Fiction,** *Susie Bright, editor.* $10.50
"A forerunner of the current femchismo sex writing....Explicit, kinky...."
Playboy. Celebrating its 10th anniversary in 1998.

_____ **Sex Information, May I Help You?,** *Isadora Alman.* "An excellent model $9.50
on how to speak directly about sex." *San Francisco Chronicle*

_____ **Erotic by Nature,** *David Steinberg, editor.* Luscious prose, poetry and sen- $45.00
suous duotone photos, in an elegantly designed cloth edition.

_____ **The Playbook for Women About Sex,** *Joani Blank.* Activities to enhance $4.50
sexual self-awareness.

Catalogs

_____ **Good Vibrations.** Many of the wonderful items available at the San
Francisco vibrator store: massage oils, dildos—and of course, vibrators!

_____ **The Sexuality Library.** Over 350 informative and entertaining sexual
self-help and enhancement books, videos, audiobooks and CDs.

Buy these books from your local bookstore, or order directly from:

Down There Press, 938 Howard Street, San Francisco CA 94103

Include $4.50 shipping for the first book ordered and 75¢ for each additional book.
California residents please add sales tax. We ship UPS whenever possible.

Name _____

UPS Street Address _____

_____ ZIP _____